Scratched

Scratched

A MEMOIR OF
PERFECTIONISM

Elizabeth Tallent

HARPER

An Imprint of HarperCollins*Publishers*

Grateful acknowledgment is made to *The Threepenny Review*, where parts of this work first appeared in slightly different form, and to *The Best American Essays 2014* for the inclusion of "Little X."

HarperCollins books may be purchased for educational, business, or sales promotional use. For information, please email the Special Markets Department at SPsales@harpercollins.com.

FIRST EDITION

Designed by Joy O'Meara

Library of Congress Cataloging-in-Publication Data has been applied for.

ISBN 978-0-06-241037-5

20 21 22 23 24 LSC 10 9 8 7 6 5 4 3 2 1

Gloria

In theory, the self-presentational style of the self-critical perfectionist should be characterized by a defensive concealment of an imperfect self.

—PAUL L. HEWITT ET AL.

I think perfection is ugly. Somewhere in the things humans make, I want to see the scars, failure, disorder, distortion. Perfection is a kind of order, like overall harmony, and so on. These are things someone forces onto things. A free human doesn't desire such things.

—YOHJI YAMAMOTO

And then to want and not to have—to want and want—how that wrung the heart, and wrung it again and again!

—VIRGINIA WOOLF

Part I

Notoriously, we can't finish a thing. The truest perfectionist, the one I'm failing to be, would still be rewriting this sentence. As a perfectionist I leave a lot to be desired, and if you leave a lot to be desired, you're unlikely to run out of desire. You might even be said to have found a way to live and breathe desire, because if the price of never-ending desire is never getting to the end of anything, perfectionism willingly pays up. Is it a raw deal? In a boon rare among afflictions, to name yourself its sufferer is to flatter your own character as uncompromising, bound to impossibly high standards: "I'm *such* a perfectionist" fails to sound *sick*. Fails, transparently. The end all striving aims for shines from its name: *perfection*. To which the individual *ist* is attached. What kind of wound is obsession if its object deserves every ounce of effort expended in its pursuit, what damage is done? From a detached vantage point perfectionist agitation might seem less a disorder than the consequence of carrying ardor for (let's say) beauty

to an exhausting extreme. But I'm not very detached about perfectionism, I'm like a person whose house is on fire writing a book about fire, it's been present, a factor in my life, since my first breath—labor, then, is considered an experience a woman will want to forget, and when a voice says *Wake up, Mother, and meet your little girl,* my mother hears her own mother summoned, but that's impossible, the little my mother knows about the world she has just been returned to includes the certainty that within it her mother is far away, and she suddenly wants her, and follows her (could almost catch hold of the hem of her dress) out of the dark—the dark has not been *dispelled*; it furs in from either side till there is nothing left of her mother, and she wants her, and she wants her, and she wants her, and she wants her, and she wants her. *Twilight sleep*, the doctor's nickname for the dark. *You will be awake throughout but won't remember a thing.* Without her glasses my mother is drastically nearsighted but her gaze implies conformance to the nurse's wish that my mother behold _____. The nurse is fooled, after all in another feint at compliance my mother has managed to sit up, how can my mother fade back into hiding if she's being monitored by this person in charge of needles and pulses. As so often when confronted with a person who assumes their superiority to her, my mother experiences the temptation to flatter and if need be shore up a superiority she secretly rejects, in this case the temptation to flatter is compounded by the other's having cornered my mother in bed, where she is by definition the weaker, at the mercy of others' decisions. Even as my mother's nearsightedness keeps _____ at blurred bay, her

defiance sharpens. *Go away,* she thinks dangerously. In my mother's experience what people most loathe having pointed out is the specific manner in which they are annoying you, and though her perfectionism specializes in exact descriptions of others' transgressions, she long ago learned to keep these to herself, besides which *Go away* would suggest a power my mother's role as patient is assumed to have stripped from her, the power of determining what shall and shall not happen to her. My mother is cross-stitching *x*'s of silence across the loophole in self-control the words want to burst through when *Go away* fizzles out and in its stead looms a wobbly readiness, my mother reaches for the cat's-eye glasses on the bedside table and fits them on, the world teeters on the brink *of, of, of,* the pink corner is folded back on a face no more familiar than if the nurse were offering her a root pulled from the ground.

The nurse's expression is pure *supposed to.*

What?

Supposed to reach for it.

The nurse's expression declares this scene *will* unfold.

My mother has to get out of this.

How.

Tell me how.

She's trapped.

For my mother a great deal has changed since she put on her cat's-eye glasses. She's, at least momentarily, bewildering to the nurse: because so natural a gesture is meant to occur instantaneously, my mother's failure to lift her arms is starker than she would have deemed possible, more arresting; in the minds of both women, my mother is noticeably *not* holding

out her arms. Until now the nurse has been unaware that a mother's declining to take her newborn is even possible, but if the nurse has learned one thing in her first week on the ward, it's that the unforeseen is best absorbed blandly. Astonishment is reserved for the instant you're safely out of the patient's ken; and what is the look on the mother's face, the nurse wonders, how exactly would you describe it, in recounting this episode to the other, more experienced nurses she's going to want to be able to say it was a look of this, it was a look of that; of, of—*revulsion*, she tries; *Really?* say the colleagues in her head; she's new, she's not going to want to confess *I had no idea what the look was of*, no idea what to do next—but she does, oh she does, ventriloquizing for the baby *Hello, Mama*. The tense origami cap on the nurse's updo emanates more authority than resides in my mother's entire vacated body. My mother has suffered before from the spruce correctness of the immaculate, their entitlement to your future, their indulgent needling—the nurse says again, puzzledly: *Hello, Mama*— the implication of your being deficient, having forgotten or neglected or otherwise missed the boat, and when the nurse imbues the third *Hello, Mama* with playacted desperation, my mother responds with expressionlessness. With a person as nice as this nurse, you can't give an inch, my mother knows, or niceness will eat you alive, and by continuing to gaze in the general direction the nurse wants her to look in my mother fends off creeping, intensifying niceness. But this strategy backfires, gazing *in the general direction of* lets details squeeze past my mother's defenses, damp cowlicks, skin of briny crimson, why's it *so dark*, my father likes to say my mother's as

white as if she's never seen the sun, he's the proud curator of the details of her, certain aspects he likes to repeatedly announce, like the never-seen-the-sun whiteness she may have failed to notice about herself, in praise of her skin the Tennesseeism *never seen the sun* is trotted out and he either can't tell or doesn't notice its leaving her cold, where is my mother living in the metaphor, underground?; the parting between its lips so tiny an apple seed could barely slip through; it is *scratched all over*; it manages a rasping note; the gesture my mother is required to make is re-hung in the air by the nurse's hope that now, surely, now the baby has issued its little plea the mother's heart will melt, but the *No!* of revulsion is harsher than ever, it hurts to swallow, from twilit obscurity she drags a fact—if her throat is raw she must have been screaming. Was she alone? In a blazing room? Hands in restraints? Is this remembering? They said she wouldn't. To her own surprise the nurse finds she has other tricks up her sleeve, the situation is—sure is!—far from hopeless, *You mothers like to count fingers and toes*, she offers, unwrapping, revealing the gauze mitts lollipopping its fists, its feet lounging over the nurse's arm like the heads of tulips whose stems kept growing in the vase, its thighs flayed with scratches, the tone of shame and consternation in which my mother is talking about it to herself is private, as are its incoherencies, almost beyond private, virtually sacred to my mother in the sense of being all she has, all she can come up with, the non sequiturs of her thought-shambles echoing the non sequitur of _____, she can't believe this is happening, meanwhile poise must be preserved despite her hospital gown, she's good at that at least, immune

to the spontaneity her husband criticizes in colleagues' wives, of whom he remarks *She sure likes running her mouth* or *She keeps flying off the handle*, the handle of what?, in the chasteness of her discretion my mother amazes my father, he can't overstate how different she is from most women, it's unusual, a wife who can be relied on to this extent, my mother teasingly agrees, and inwardly profoundly agrees, she's invaluable to him, her wittiness, her reserve are pleasures enlarged by his expressions of astonishment at being in possession of her. It's this coolly invaluable self she's astounded to hear herself betray by asking *What is wrong with it?*

The head turns toward her voice.

At this movement the nurse says a gay downward *Oh!*, the *Oh!* of recollecting you are there, before addressing a different *Oh!* to my mother, the *Oh!* of rising to the occasion, domesticating my mother's question's strangeness, for the second *Oh!* to be an efficient broom for my mother's shame, casual naturalness is needed, assuring all parties of the nice truth announced next, *Nothing! Nothing's wrong with her*, so nice it deserves the more studied repetition *Nothing is wrong with her*, when this meets with disbelief the nurse tries a variation, *She's completely fine*, when that doesn't do the trick the nurse says *I promise*, and feeling this is getting away from her the nurse infuses the next *Completely, completely fine!* with sunshine, adding *You have a very healthy baby girl!*, awaiting the smile the nurse continues to believe has to come, it's this suspense the baby interrupts with another plaintive note, honestly this encounter has been a strain, the baby's needing to be fed comes as a relief to the nurse because it is definite, a need

she can meet, with a view to wrapping up their two minutes' awkwardness she adopts the first person plural of blithe reproach customary in failed nurse-patient encounters, saying *Well, maybe we'll do better next time*, gathering too late from my mother's averted gaze, her formal, if motionless, withdrawal, the painfulness for my mother of the implication that she has done badly so far.

To leave that first page alone is to obscure how much time I lost in pursuit of the beautiful beginning of this book—my long confinement in closed-circuit viciousness designating every attempt *error fuckup mistake hideous miscarriage*. What was it like, wrong sentence after wrong sentence engendering abuse more exciting than the sentences ever were? How bad was that perfectionist seizure, how different *really* from the impediments writing presents to most writers?—after all *A writer is someone for whom writing is a problem*, and as for ego-wrecking fugues of deletion, most writers have to go through those before they can get anywhere, meaning the difference between ordinary thwartedness and perfectionism could be harder to divine in regard to writing than it is in more fluent activities like heart surgery, but I don't really believe that, for me perfectionism is set apart from other forms of trouble by the inflamed genius of its self-abuse, and its pleasurableness. As a personality disorder perfectionism is spookily stable. Researchers—I don't want to mislead you, I'm not incredibly well-read in their work and they're not going to turn up here very often—but researchers confronted with the degradations

of its harangues sometimes marvel at perfection's persistence, as in "Perfectionism and Emotion Regulation" by Kenneth G. Rice, Hannah Suh, and Don E. Davis:

> *Why do those with high standards blended with self-criticism hold on so dearly to what seems to be a self-punishing, discouraging, and depressogenic combination of personality factors? Although maintaining a punishing style of perfectionism seems highly costly to the individual, we suspect that many resist changing this maladaptive form of perfectionism because it would result in some other form of substantial loss, such as losing or disrupting an important relational connection.*

"Some other form of substantial loss": the loss of love, this must be, and if it is, then this skeptical affliction is rooted in the soppiest gullibility, perfectionism a love letter the psyche sends to an unresponsive Other, swearing *I'll change everything if you will only come back.*

If four books, the first appearing when I was twenty-seven, books published by the house whose cachet I revered, Knopf, books that had the luck of certain reviewers' calling them *luminous*, not that I understood what *luminous* meant, did the work of male writers get called luminous or was it a girl word, was the vagina luminous and the penis brilliant, but if those books add up to a good-enough start for a writer, then mine

was a fortunate experience, the private seriousness of what I *was after* carried me through the fourth; and then, without my faith in what I was after faltering, without relinquishing the identity *writer*, without acknowledging I had lost anything, for two decades I did what's known in a writer as disappearing.

The vehicle for my first stories was the hunky olive-green electric typewriter in the Santa Fe bookstore where I changed the sign from *Open* to *Closed* and went around turning off lights in case the owner drove by, or my fellow clerk, even more possessive about the store than the owner. They were elsewhere in the city. With luck, they were asleep. With luck, everyone was. In the dark length of the dreaming store only the desk's gooseneck lamp glowed. I rolled a sheet of paper into the platen, whose *runkuh runkuh runkuh* signaled *Now comes the good part*. I have always loved hiding. Stealth—the need for every stolen minute to be used to the utmost—was requited by the machine's responsiveness: it ran through a sentence with me chasing after; often two or three of its letter-tipped praying-mantis forearms pounced simultaneously, snagged together just shy of the page, and had to be teased apart. Somehow slight criminality and quickness of execution fused into the *feeling of writing*. What I mean is that when I started out, writing was irresponsible immersion. The deal between me and that typewriter was simple: when I sat down at it, it was ready for anything. It had no idea what was going to happen next and neither did I, what appeared on the

page could be good or not good, could turn out to be a story or peter out into a dead end, but whatever wanted to appear, the machine made visible. I was typing along in hidden entrancement, I was playing.

The Smith Corona of my first elation buried five cars deep in some New Mexico junkyard.

I want it back.

Book by book, perfectionism hamstrung writing. You'd think this curtailment would be painful. That it would raise loud alarms for a writer. But the crippling approached with anesthetizing softness. For a long while this rise in perfectionism seemed *smart*, a corrective to the naivete of those nights at the bookstore typewriter. Quickened self-consciousness, elevated standards came with publication, and how could that be a bad thing?—in my hands, it could. In my hands a little fanfare could be twisted into injuriousness. I don't want to downplay how implicated I was in taking a fortunate beginning and bleeding luck and delight from it. But I would not have believed anyone who told me that was what I was doing. The obsessiveness perfectionism encouraged dovetailed with my image of a serious writer, that outline I wanted to live inside. It didn't *stop* writing, it merely diverted it into feats of repetition—of, to be more exact, replication: the same paragraph typed over and over. Sometimes I was down to as little as a single sentence monomaniacally typed out word for word in the hope of its transforming, though no breath stirred through the repetition; it was fearfully self-enclosed, the

sentence enacting the plight of its writer. Being dissatisfied
with anything less than perfection was so satisfying a state,
the claustrophobic drudgery of ad nauseam repetition failed
to nauseate me. Look: I *was* working. The very perfection-
ism that was shutting down writing imbued the process with
a thrilled momentousness, gratifying in itself: in my Zeno's
arrow's flight I was always closing in on the most beautiful
thing I'd ever written.

My credulousness in relation to perfectionism's proffer of
the flawless page approaches absolute.

And—another con perpetrated by myself on myself—this
delusion of being about to write something incredibly beauti-
ful *of course* means *appearing* in print. Effortlessly. In the very
near future. This hallucination of the next book's inevitably
appearing infused even my most flagrantly futile writing.
Actual and highly fortunate experience had taught me how
arduous and prolonged is a manuscript's progression to pub-
lished volume. But just as dreams collapse the dreary inter-
val between the wish for a thing and its manifestation, so did
perfectionism. Supposedly within the unconscious time does
not exist, or rather all times, infancy, adolescence, age, exist
simultaneously. Some parallel exemption from chronological
order held true within perfectionism, because its exalted ob-
ject, the incomparable book the poor just-typed sentence dies
in comparison to, always already exists. To my psyche, the
book I was making no progress on was *already done*. The *need*
for it to be completed was not available to be *felt*. Five, fif-
teen, twenty-two years passed frictionlessly, without a book
of mine appearing in print.

The fitful realness a writer senses in a living, breathing work-in-progress had been replaced by a radiant, ultra-real changeling.

Moreover the retreat from the challenge of publication into the Wayfarback of literary disappearance suited me. Within its privacy, beyond the ken of editors and readers who would have rooted for that next book, perfectionism could burn bright. How many never-written books, exactly, would sate its appetite? Had I always wanted to see how much it could take?

In "Perfectionism and Personality" Joachim Stoeber et al. explain:

> Hewitt and Flett's (1991) tripartite model of perfectionism . . . differentiates three forms of perfectionism: self-oriented, other-oriented, and socially prescribed. Self-oriented perfectionism reflects beliefs that striving for perfection and being perfect are important. Self-oriented perfectionists have exceedingly high personal standards, expect to be perfect, and are highly self-critical if they fail to meet these demands. In contrast, other-oriented perfectionism reflects beliefs that it is important for others to strive for perfection and be perfect. Other-oriented perfectionists have exceedingly high standards for others, expect others to be perfect, and are highly critical of others who fail to meet these expectations. Finally, socially prescribed perfectionism reflects beliefs that striving for perfection and

being perfect are important to others. Socially prescribed perfectionists believe that exceedingly high standards are being imposed on them. They believe others expect them to be perfect, and think that others will be highly critical of them if they fail to meet these standards.

As Hewitt and Flett calmly note elsewhere, these are three heads of the same Cerberus: "We believe that each of these dimensions is an essential component of overall perfectionistic behavior."

In the faraway future my son will come home from an afternoon at day care, tip over his cup, and look up from the spill to say *Everybody makes mistakes.* Using the voice he uses for testing out other adults' assertions on me.

But the sentences—two decades' worth—written in pursuit of transcendence were dull. For the sake of perfection I took a voice, my own, and twisted until mischance and error and experiment were wrung from it, and with them any chance of aliveness—stories thrive on exactly those risks perfectionism forecloses. On behalf of beauty, stiltedness and inhibition broke the back of every sentence. Aversion, the approved response to imperfection, suffused my pages, even when the mistakes were gone the aversion remained, my prose broadcast the deadness instilled by infinite tiny acts of killing-off. At times the whole rigid apparatus of my self-excruciation

became visible and I was scared of myself for having *invented* it. Because it's still going on, this squelching, these disavowals, I'm not writing from the loftiness of triumph or authority. My view is partial, inexpert, immersed. If you don't have the clarity to disavow the perfectionism deforming your life, where do you start? I guess I will start here: confronted with, ashamed of, my enthrallment. It doesn't matter what it's cost me, perfection's destined deliverance is what I believe in, unerring rightness, beauty the barest millimeter beyond this page.

The hospital is submerged in night. My mother has always loved hiding, she resolves to stay as hidden as a person can be in a hospital bed, a natural magnet for intrusion regularly encroached on by strangers bearing trays or gadgets or clipboards, each arrival entailing niceties my mother is too wrung out for, their expectations of being heeded and answered and smiled at constellated around a shared conviction of being welcome, whenever they appear and whatever they want, welcome, *Can you do* x, y, *or* z *for me* and *I need to take a quick look at*, so highly regarded are they, so revered their competence in whatever it is they are up to, they cross the threshold in a nightlong sequence of intrusions she can't help but play hostess for, the instant the switch's switched on she's charming, my mother's pretty-comedienne self-deprecation disarming in this context of professional rousings and tappings and proddings, their smiles have a surprised edge, their laughs, it's not hard so long as none of them brings what she doesn't ever want to see again. What's crept up on her is a sense of

needing to salvage the twilit hours, to travel through them alertly, interpreting as she goes, listening, piecing together in order to understand how she ended up shorn of memory, isn't that the saying, her pubic hair razored away, *that* shearing she was present for, politely spread-legged, and while it was evident she was not supposed to intrude on the procedure by watching it, she'd craned to see past her belly to the grime of wet curls scooted off the blade by the nurse's napkin-wrapped thumb into a stainless steel basin. Subsequent ministrations can be conjectured from bruises and aches. Surely it's not necessary to know everything that has happened to you. Perhaps of all the twilit minds only hers emerged from the cloud enraged. What does rage have to do with *her*? How punishingly, without her consent, it bends toward remembrance, it wants and wants and wants. She closes her eyes. From its psychic aftermath—atomized brilliance drizzling through vacancy— she identifies terror. That's real, she's salvaged a scrap, she's asleep.

When I'm at a loss perfectionism is available for me to fall back on. To take refuge in, because however I characterize perfectionism now—as affliction; as personality disposition— it first arose as a defense against despair. It is a cure turned ravenous wound. It's a wound I don't know how anyone lives without. *Everybody makes mistakes*, says my son looking up from his spill. Waiting.

———

Deep in the clockless night a different nurse comes with the baby. *Here she ii-iiiiis*, the nurse sings as if in tickled acquiescence to my mother's demand, but it's a trick, a deception the nurse hopes my mother will sleepily consent to be fooled by, there was no such demand, my mother had not implored, as has been implied, *Bring her to me*, my mother finds her cat's-eye glasses on the table by the bed, and when the blanket is pushed back it's the same dankly preserved bog-burial face with its drench of hair, sleeping with tight-fisted solitariness, its gnarled aloofness alien as its ugliness, my mother's disconcerted by the baby's having continued to exist, the scratch near its eyelid causes my mother to scratch the inside of her own wrist with a scratch exactly as long, a preventive sharpness in lieu of empathy, in this dreamlike opening in the night only the three of them are left on earth. Of this three, two of them want nothing to do with each other. Only the third, the nurse, is confused and hopes for connection. *It's in your chart you plan to breastfeed*, the nurse says. This close she smells of Ivory, starched cotton, hairspray. My mother fears she smells of perspiration, iodine, blood. When the baby mews the nurse frowns downward double-chinned and says *Hold your horses, you.* Her manner of holding the baby does my mother vicarious good, she is a little bit held herself, the nurse has a warm voice and is wearing lipstick and my mother feels she could almost talk to her but worries how unkempt she must appear, the curls of her recent permanent askew, no lipstick, my mother in her aqua rayon bed jacket with the lace-edged peter pan collar has to evade the baby, all she can think of to want that she might be able to have is a cigarette, on the table

beside her bed an aluminum ashtray gives permission for the cigarette she longs for, she's a Washington, DC, wife and understands the delaying grace the gestures of smoking afford in even intensely embarrassing public plights, which this is, and the nurse says, again missing the point entirely, *Such a sweet mood she's in, this's when you want to try,* the baby stirs and mews but the nurse looks exclusively at my mother. A scrap of harsher sound emerges from the baby. My mother shakes her head with a finality that should do the trick. The nurse doesn't get it. Genuinely does not. She's going to need my mother to put it in words: *I don't want her.* Can that be said. The nurse doesn't mind standing and waiting for the desired response, and at her smile my mother looks away and looks back hoping for understanding but ready to resist more plainly if need be, open defiance not exactly a mode she's well versed in, fraught with the risk of being disliked, the inevitability of judgment if she persists in refusing to take the baby dawns on her, she should probably have thought of that sooner, and my mother startles them both by asking *But what's wrong with her?*

The nurse echoes *What's wrong with her?*

The—scratches?

Oh those! Jeez, never mind those, sometimes just Baby's nails grow too long in utero, after the due date it gets to be a tight fit, never mind those, they go away, leave no trace, she's fine, lusty pair of lungs, I can vouch for that, good appetite, jeez, I can vouch for that, and if the nurse's consideration in touching the baby, smoothing her black hair as if to reassure her that her mother didn't mean it, implies the baby is worth something, if the nurse's manner conveys *Glad I could clear that up,* the whole amounts

to a friendly insistence that my mother take the baby, the nurse hasn't lost the thread, and my mother, who will all her life prefer the mutable insinuations of sentences left unfinished, says *Please can you—*

But the nurse's disinclination to fill in the rest extorts the conclusion:

—take her away.

The nurse leaves a lull sufficient for my mother to change her mind, an optimistic space my mother appreciates even as she declines its invitation, such discretion constitutes good manners between women and she hasn't made my mother feel ashamed, though that's incredibly easily done, the nurse tells the baby *You'll have a nice bottle, we'll let Mama rest now won't we,* and at her voice, its lowness, its confidence, the baby blinks. The nurse revolves the baby so that its gaze radiates outward, as fused to its moment as light is, without moving so much as her little finger my mother eludes the gaze, unclouded by personness, awaiting whatever the world will offer, whatever the world's going to offer doesn't include her, my mother remains apart, neither focused on nor recognized, a mitted fist, worked free of the blanket, lifts and bobs, the nurse takes advantage of the flailing to pinch the forearm and cause the mitt to wave bye-bye, the nurse takes the baby with her and closes the door as the wailing begins.

How beautiful after all is an intimation of beauty that declares every sentence dead on arrival? Isn't aliveness the ball game, in prose, and not beauty, not perfection, whatever that is? I

wish questions like that, questions I can hear myself hypocrit-ically posing to a student fettered by perfectionism, actually mattered to me, but I have subsisted on the unobtainable so long the wise alternative *This is good enough* pierces me like a lie when I say it to myself.

The amoeba of spilled milk snouts toward the table's edge.

Midmorning of the second day yet another nurse appears with the baby. Is this their usual rotation of shifts, or are they testing which nurse my mother might like and therefore give in to? This third nurse, the youngest, proves harder to deflect, but my mother prevails, and when after several hours the door opens and it's the third nurse again, my mother is really almost angry to have to sit there in the narrow bed mustering the energy for resistance—it feels, too, as if the simplicity of bare refusal is being drained, overture by overture, of its le-gitimacy and may before long acquire the taint of sullenness, to ensure the nurses' goodwill cleverer, more ingratiating forms of *No* are called for, an almost nuclear-arms-race-like parity of charm in response to their improvisations, if they are improvisations rather than scenarios plotted in advance, as my mother is beginning to suspect, the winsome beggary of the nurse's *Just hold her for one minute, then I'll take her* ap-pears rehearsed, as does the blithe follow-up *One minute!* With the baby's weight slung in an arm the nurse draws her sleeve back, meaning she'll track the sixty seconds on her wrist-watch, medically; she'll honor the bargain; my mother need not fear that the act of receiving the baby in her arms will roll

out into an infinity of holding, of sickened intertwinement, but the nurse might as well be assuring my mother that the boa constrictor she's draping around her shoulders can't possibly wrap itself around her throat, *obviously* that minute is never going to end, its skin-to-skin revulsion crawling across my mother's nerve endings far into the future, the actual, incapacitating loathsomeness of the baby remains invisible to the nurse, with her pretty wristwatch exposed by her tugged-back sleeve she awaits what must seem to her the simplest of yesses, the consent communicated up and down this ward dozens of times a night, hundreds of times a week, in her next, even more beguiling *One minute?* my mother hears a promise akin to *You will only be obliterated for one minute.* With her chin up, my mother gives a fractional shake of the head. *One minute?*—sharply. My mother holds the nurse's gaze, aware of the threshold that can be imperceptibly crossed, on whose far side the designation *irrational* awaits, and what then? They must talk among themselves of her refusal, weighing its import. *Poor thing*, they must say, of the baby.

If I say perfectionism cost me two decades of writing, I intend a description of measurable loss, as if the pages of unwritten books can be numbered, their weight calculated. But the more elusive losses were of boldness, of amplitude. Of the generosity that, put into continuous practice, could have enlarged my work. Perfectionism is a form of *being terrified of*, and what follows that *of* is a blank every perfectionist would probably fill in differently, but whose large, generalizing term may be *loss*.

In external reality the loss may already have occurred. Suppose what is feared is the retraction of parental love: this may have occurred over and over, and been denied by the child for whom the retraction of a parent's love amounts to a mortal threat. From a purely logical perspective, a loss that has already happened—a loss that *long ago* did its worst; a *completed* loss—might seem deprived of its mojo, irrelevant to the ongoing business of consciousness. But it's as if the news of the loss's being over travels through the psyche in the pouch of the friar charged with getting the letter about the faux poison taken by Juliet into Romeo's hands. If the perfectionism lasts for a lifetime, that loss so long ago feared achieves mortal immortality: a whole life may be lived in relation to it.

In my experience of it perfectionism's worst cost eludes quantification. It lies in the diminishment of my share of reality, which perfectionism starves down to a joyless, manageable minim.

Right here, a paradox lurks, because why would my mind, or anyone's, *come up with* a defense against loss that inflicts such losses? To the psyche implementing it, what can possibly justify the expense of perfectionism's deadening of vitality? The first answer that comes to me is *Of course nothing can ever justify it. Perfectionism is a terrifying mistake of the mind.* But does that judgment, righteous though it may be, downplay the threat perfectionism arose to defend against? Is it equivalent to saying *Hey, you should have saved your life more efficiently, without all this collateral damage*?

Should've devised a form of rescue with a clear expiration date?

My son and I collaborate, mopping up milk. I've just said

It's so cool you know that. My response bears expanding on—
clearly he's interested in this question of mistakes and who
makes them and how to feel about them—but I leave it there.
Within my family each mistake was fingerprinted by its
maker's personality. Each was a unique indictment. A mis-
take confined to the moment of its materializing, dispatched
with a reassuring phrase, would be a mistake deprived of cha-
risma. Of its power to haunt—and who, unhaunted, is safe
in *this* world? To offer this notion of a bland pool of mistakes
fed by blameless *everybody* feels like an instance of caregivers
inadvertently transgressing against a belief the parent holds
sacred. To believe it, as he seems about to, will mean a part-
ing of ways, subtle, at first, at first small, bearable, necessar-
ily bearable, but hateful nonetheless and tending to widen,
because it will widen, nonperfectionism will carry him off.
And will end a certain lineage extending back god knows
how many generations, to boot. I fear the rift that will come
of his being free of the perfectionism binding one of the fami-
lies he comes from, mine, in which only the lusty prosecution
of mistakes—one's own, others'—proves one's integrity. He
won't speak our language.

Thinking: *This is one of the ways he will be himself. His
own self.*

Thinking: *Come on! Come through for him.*

The summer my mother told me the story of how she had not
been willing to take me I was nineteen, just back from my
first archaeological dig, a grid of square meters staked down

the length of a terrace carved into the flank of a gulley rich in the ghost flora and fauna of once-thriving Pleistocene wetlands. August in the Texas Panhandle branded the parting in my hair into my scalp and seared my back, where the slippery strap fastening my bikini top was edged with pale alternative stripes like the haze of profiles when the sitter ruins the daguerreotype by glancing away, the same phenomenon showed where my leather gloves ended at my wrists and my cutoff Levi's frayed into thread, basically wherever edges lay against skin, first the private, very white white against which veins show turquoise, then the dimmed white of intermittent exposure, then the hard-won color I was proud of but that failed to offer protection, burns blistering up even where my skin was darkest. I wanted to get in closer to the skull I was working on, but the bill of my faded baseball cap got in the way, and my sunglasses slipped down my zinc-oxided nose. Brushes of real fur whisked grains of sand from its teeth, crowded forward at a slant suggestive of the dewed doeskin muzzle. Quivering whiskers had rayed out from that nose. I felt hidden, and expert, and as if, if I could dig with enough love, an eye would gleam from the bone. Returned from the dig I lurked through my mother and father's house, awkwarder than any guest. In that single square meter of ancient lakeside, my life had burned bright in me, and I could hold on to that, or its companion sensation, by exposing my skin to the light of the nearest star. By now the pink bikini I'd worn all summer long was bedraggled, the two triangular scraps covering my breasts supported by fraying strings over my shoulders, the seat of the bottoms bagged out. I loved the

bikini, I wasn't about to give up its mojo, but its scantiness was offensive to my mother, who said my father said it was *barely there*, who said the neighbors could see when I sprawled my baby-oil-marinated self across the striped beach towel to read for hours on the second-story redwood deck the kitchen's sliding doors opened onto, and it was one afternoon when I came in from a session of slow-motion Midwestern August heat and slid the glass door through the familiar glitches in its transit till it clicked closed and turned around barefoot and burned, glorious to myself, alight as I had probably never been before where my mother could see, she was on the couch facing the sliding glass doors, sitting where we never sat, and from the dread that undid my gloriousness I understood she had been waiting, I repented the pink bikini's droop and cling, my oiliness, the sunglasses whose opacity could read like superiority to her, the towel I was holding was clean and I wrapped myself in it before I sat down on the couch, we'd never sat there before, none of us ever sat there, I'm not sure I ever had sat on one end of any couch with her at the other end, it wasn't how we talked in our family, not a way we arrayed ourselves, but she'd beckoned, the couch had a faux woven texture but was really plastic and baby oil couldn't hurt it, when I took off my sunglasses she said *Did you know when you were born they couldn't get me to take you* and I made a sound in my throat, actual words might derail her, she could be quick to bristle at a wrong intonation, and it was unusual for her to tell a story of any kind, barely had she begun spinning the thread before I feared its abrupt severance, it didn't matter that I knew full well I should dread what she was about to say, her tone would

have alerted me even if the preface *Did you know* hadn't, hurt-fulness from her was often prefaced by a dodgy *Did you know* when there was no chance you did, but this, the soft, urging vowel I kept low in my throat, surely wouldn't strike her as either impudence or excessive interest, either extreme was to be avoided, and I must have avoided it because she went on. *They kept bringing you in and I kept telling them to take you away.*

 Don't ask why, I warned myself.

This Thursday morning, while I'm writing, it feels to me like the most contemptible thing about this book is how cowed I am by my affliction. *Cowed* meaning: I have failed to hate it. Even when I opened my mouth to inform one therapist after another perfectionism was killing me, its deprivations suited me to a T, ailment as apology: so sorry I never lived up to my brilliant promise. Psychically, perfectionism is *home.* Out-wardly my history of therapy resembles an arduous grappling with the disorder, but did I ever believe *I* could live without it? For a synesthetic instant I tune in to Mick Jagger howl-ing "Under My Thumb," ventriloquizing the tyranny of my weird disease. But it is modest, the bureaucracy administer-ing the cosmos between my ears: it would never howl for glee at having crushed me.

Why? I asked.
 You were all scratched.
 What?

Scratched, all over.

Scratched, how?

You did it to yourself. Inside.

Affectlessness had been replaced by an experimental almost-hostility, to me a worrisome change because I wasn't sure who or what my mother was feeling hostile to—the nurses; me, now; me, the baby in the story?—and in general her experiments in so-called negative emotions solidified fast, she was vulnerable to becoming entranced by hostility, once she had started in on someone or other's slighting behavior toward her the slight was magnified, she could be consumed by wrongs, her exaggerated woundedness often made it hard to figure out the truth of what you were hearing, how accurate her portrayal of injury was. Though I was afraid of what she would say next, I wanted the story, it had started off more interestingly than any story I could ever remember her telling me about herself, *One scratch came right to your eyelid*, though I well knew her to be a superb noticer in the realm of the visual, and in social dealings one of the ultra-exposed whose mood could be capsized by nuances those around her failed to register, when it came to talking about herself she might as well have passed blindly through her existence, her stories were uninteresting partly because of this weird detail-void, also because she would have considered it presumptuous to use any sort of metaphor while recounting an experience, as if a metaphor amounts to making a scene, as if to voice a detail would poison the self-deprecating wittiness of her self-presentation with show-offiness, the context for *One scratch came right to your eyelid* was this habitual disinclination, so

when she presented a detail, as she just had, it loomed large, it demanded interpretation and I sat there picturing the scratch by the eyelid, its alarmingness, non sequitur was one of her favored modes of deflection and what she said next was *There was an anesthetic called twilight sleep*, whatever was happening between us was more bare-bones, less defended, than my mother ever was, *or not an anesthetic really because the woman feels everything while it's happening, all the pain, but afterward can't remember anything, that was what they gave me*, and I said *Oh no*, inadequate little *Oh no*, close to meaningless, but I was feeling disoriented and for some reason exasperated by my bedraggled bikini, not that she could see it but she knew it was there under the towel I was wrapped in and she loathed it and we both knew she loathed it and I couldn't exactly leave to take it off while she was telling this story, however much more she was going to tell I was going to have to continue to be present with my breasts cupped, if barely, in faded pink slips of fabric, often my sense was whatever I became self-conscious about, she had been for some time critically aware of, and now it was as if I had been caught in the act of possessing this body, I was busy keeping to myself my sense of being loathed by her, if I didn't acknowledge it sometimes I had a little power over it, or so it felt, after a second I thought to add *That sounds terrible*, wrapped in the striped towel I had no idea how to take care of her, no idea what could account for her spectacular lack of apology in telling me she had refused to touch me as a baby—was I supposed to agree that I had been repellent? I mean I could; it wasn't hard to believe in the baby's dark maroon, black-haired hideousness, it was

only hard to believe that baby was me; the emotion I was a little wrecked by, which she appeared free of, was pity for the baby, but this wasn't pity for myself, I didn't feel a bond to that long-ago baby, and neither it seemed did she; what she was telling me appeared to strike her as a strange story involving only herself, unlikely to have any effect on me; or was her intention entirely different, in her own mind did this explain everything that had gone wrong between us? She said *The baby on the Gerber's baby food jar, do you know the one I mean? Babies came out like that, was what I assumed—perfect, smiley, those great big eyes. I had no idea the Gerber baby was six months old.*

I didn't ask aloud *You had never seen a newborn?* But hadn't she, a nurse's daughter—ever?

The nurses wouldn't give up, she said. *They kept coming back with you. Kept wanting me to take you. I kept not taking you, they'd take you away, but they'd come back, you know, they never*

They must flirt with her husband when they hand over the baby, dimple when he calls her *little bit,* when he extends a forefinger for the tiny hand to clasp, scoffs *That grip could use a little more pine tar,* his teasing the baby stirs the nurses, has them freshening lipstick before they emerge from the nursery carrying the little nobody, when the first nurse wonders *Pine tar?* my father says *Helps the batter get a good grip,* the narrowness of his black tie, the decorum of his white shirt attest to government employment, when the second nurse asks he says *Chemist—came straight from the lab,* and at his pleasure in the assertion, his feeling there's no time to waste in getting

back to the baby, the second nurse falls in love, the third nurse
laughs when he mourns the narrowly lost first game of the
doubleheader the White Sox played the night the baby was
born, every fumble grieved, every error, the black-and-white
television a campfire the waiting-room husbands tended, bent
forward, couches and armchairs shuffled from their backs-to-
the-wall starting position into a clannish half-moon—*Right
down the line and it's* .
streeeeiike three! concerted squeaking of the seats' plastic as
husbands sprawled back defeated, commiserating, lighting
up. My father's gestures when agitated: fists driven into trou-
ser pockets (if standing), jangling coins in pockets (standing),
tugs intended to close the shin gap exposed by a pants cuff
riding up (seated), tilting the pack till cigarettes steeple out,
instead of choosing he rights the pack, cigarettes slide from
view, a tic noted by the fifth nurse, whose much older psychia-
trist lover prefers tutorials to sex, who told her it takes balls to
describe the sexuality of a child to a world that would rather
not hear it, at *balls* the nurse had laughed, telling him men
were always saying it takes balls to do *x, y,* or *z,* and he teased
back *What do you ladies say it takes to do* x, y, *and* z, then *Hey!
Freud says of the maternal body "There is no other place of which
one can say with so much certainty that one has already been there."*
My father tears himself away from the baby to spend an hour
with his wife. Loyalty to their antagonist prevents the nurses'
telling him his wife has been refusing to take the baby, much
less feed it, it's in her chart, this eccentricity of breastfeeding,
doctors discourage it, she's unlikely to have told her husband
she'd dissented from her doctor's advice, it would only have

worried him to have his wife deviate from the norm, jeopardizing the baby's health with unsanitary nipples, showing herself to be subversive—he doesn't know the half of it, he comes in with his jacket slung over his shoulder, with flowers, my mother caught him admiring her bothersome new breasts and he grinned, the twilight she passed through isn't the kind of thing they can talk about, despair not the kind of thing, he might be trying, when he says *You're a little down in the dumps* that's him trying, giving her an opening, but how can she even begin, can he bring her favorite lipstick next time, she asks, he says *I like the one you're wearing*, takes off his glasses, says with the vague tone he uses when his glasses are off, *It suits you*, he can't locate his handkerchief, his fumbling, patting search of himself makes her want to jump out of bed and run to him, *Suits you*, he says, *being a mother*, puts his glasses back on, rolls down his shirtsleeves as if his work here is done, finds his hat, when she says *Wait! Wait!* he does, brows lifted in *What can I do for you?* patience. What can he do for her? He leaves whistling. With him goes my mother's soul, pinned to his lapel. What's it going to take, how long can my mother hold out in the face of lilting lectures on the inevitability of her loving the baby once she has it in her arms, doses of disapproval passed under her nose like smelling salts. The nurses come boldly into my mother's room, fortified by their consultations with each other, convinced she is fixable. The tale of my mother's resistance must find a lot of listeners, rising to fame within the hospital, or notoriousness, deviations from normal, inexorable mother love are spellbinding, intimating the precariousness of the whole deal, when my mother pulls down her panties

to urinate the shavenness has grown an itchy five o'clock shadow, babies of senators are born here, babies of presidents, the nurses must know what they're doing, in other matters relating to my mother's body the nurses are deft and pitiless, only with the baby in their arms do they seem unscrupulous, appearance by appearance its skin pales from skinned rabbit to bitten lip, but its hair stays black as ever and it's disconcerting, as if the baby should fade slowly all over, a Polaroid left in the sun, at its first cry the nurses hustle it back to the nursery as if full-blown wailing would strengthen my mother's refusal but it's already final, her refusal is a glacier, it's the Berlin Wall, *If she had her way*, the second nurse tells the third, *that baby would be abandoned in an alley, I don't think so*, says the third, *she'd want somewhere with wolves*, the second nurse stays on after her shift to hold the baby, they are a little sick at heart at how long this has gone on, at the last minute someone has the bright idea of brushing the baby's black hair into a spit curl sticking up from the top of her head, fastening it with a big black bow, comically outsize, the nurses consider their handiwork, one of them says *Who's going in?* and the second nurse says *I will.*

gave up, finally one of them got the bright idea of brushing your hair into a spit curl right on top of your head and tying it with a black bow and she carried you in like that and I

I will, and as if the mother's having taken the baby and settled back into her pillows is nothing out of the ordinary, the second

nurse leans in but not too far, not close enough to crowd them, if only the mother in her cat's-eye glasses would think of unbuttoning her buttons, it'd be lovely if the mother thought of that by herself but the act of reaching for the baby seems to have exhausted her initiative, though she's looking down at the baby, the second nurse takes that as a good sign, the mother hasn't willingly looked at the baby before, the baby begins to thrash, startling my mother, and to prevent the thought of handing the baby back from crossing my mother's mind the nurse says *She's really ready to latch on, there's a trick to it.* When she taps its cheek, the baby's head pivots, its mouth gapes, two dimes of wetness appear in the aqua rayon of my mother's bed jacket, blots slowly enlarging, sodden rayon outlining her nipples before the nurse can say *See?*

As far as I know, my mother entrusted the story of her refusal to hold me only to me. Her chaste tendency was to keep any and all bodily experiences to herself—by way of chiding me for the mess of bloodied Kotex in a wastebasket he'd ended up emptying, my father told me *I've lived with your mother two decades without seeing even a trace of blood.* While she was alive there was never a moment when I could have asked why she told the story to me and what if anything she hoped would come of having told it, never between us the remotest chance of sweetly dumbfounded confession, despite my fantasies of being able to say, and be laughed at for saying, *But your affect was weird!—so cold!—it freaked me out!* And why then, that day,

why, with no preface, start right in? Later I was to think it was the apparition of my nineteen-year-old sensuality that did it, my unscratched nakedness. To my letting myself in through the sliding door, was her response *I didn't want you then, I don't want you now*, or is it too dark to believe she may have meant that, unjust, just wrong? Could she have intended the story as *background*, context that could inform my understanding of my later troubles, thus: *This happened to you, you should be aware it happened, I'm the only one who can tell you?* Because it's true, I value having the story, it feels to me like a necessary piece of my life, she could have known it would be valuable, could have thought *how* it got told—detachedly—was going to end up mattering much less than its necessariness. In our lives, silences abounded. Does the very act of telling—by a secretive person, a perfectionist disinclined to confide her deviations from the norm—count as love? As bravery? As she told it to me on the couch I was aware of not having a clue what the story meant to her. As I write it I am aware of still not knowing, of trying to hold the story right, of there being a version that might strike her as the truth, which would amaze and move her, because I carried it in for her to see, to reach out for. What I want are tears in her eyes.

Everybody makes mistakes. A caregiver, someone he trusts, has confidently told him so, maybe in the course of reassuring my son for a mistake he made during the day, I can't tell, I don't know the circumstances, only that when my son looks

up from his spill it's in order to test whether it's true or not, this thing he's never heard from me.

When I was eleven I became obsessed with my face.

The font of this obsession was a foxed mirror in a dim upstairs bathroom, exceedingly narrow, ornately high-ceilinged, tiled in chilly pink.

As was true throughout the house, the bathroom's renovation had *run out of gas*. In one corner crouched a Victorian radiator shaped like an accordion squeezed to utmost compression; its heat fumed to the distant ceiling, and all you got was its dusty boiled-metal smell. The fifties-era tub and the toilet shared the walls' Pepto pink, the floor was quarter-sized white hexagonal cells grouted with black grime, then it was back to the thirties for the sink, whose white porcelain HOT and COLD faucet handles, chubby four-fingered Mickey Mouse gloves, each morning fooled me into turning the wrong handle, since HOT ran cold and COLD ran hot and I invariably believed what I read. Over that basin hung the old mirror with, across its top, a ghostly fleur-de-lis flanked by rippled ribbons.

If I stood just so, the fleur-de-lis sprouted from the crown of my head, a pale brain-flower. The fleur-de-lis was a given— just *there*, nothing to do with me. And so, I felt, was the face below.

The face was *nothing to do with me.*

I can't *be* it.

Instant, transfixing: *can't.*

My father believed my reflection held for me an insatiable enchantment. Before breakfast his slippers would pause in the hallway outside the heavy oak door long enough for the droll recitation *Vanity, thy name is woman*, and I would say *Okay, Dad*. If I had risked a smart-ass comeback like *If you say so*, there would have been trouble. If I had said something close to the truth, like *Is it vanity if you hate what you see*: trouble.

He would have turned my hating what I saw in the mirror into a critique of him—at least, that was what I feared. In a perfect household no child would suffer from revulsion at what the mirror held, no child would need to stand staring for hours, seeking to dispel disbelief, to achieve the psychic equivalent of holding her arms out to what was there. My heartbeat might as well have been translated *can't-CAN'T, can't-CAN'T*. If a child was immobilized by the need to stare, if what the child was staring at was her inassimilable self, the craziness of the whole rigamarole had to imply the father's failure to lay the groundwork for inevitable happiness. All-encompassing, never-failing responsibility was his *job*. Insanely, the time asked this of men, *and so*, I might write, *and so no wonder he assumed everything was about him*, but some other, non-public belief pertained, a belief or beliefs he held about me, which menaced me by seeming inscrutably unjust. This year, the year of my turning thirteen, was a year of confrontations with his wounded conviction that I was out to wound him. This year I was often in trouble with him, and often when I least expected to be. In general he was prone to interpreting

things I said or did as covertly malicious. I would listen astounded as, in his parsing, remarks of mine were revealed as subtle contrivances meant to inflict mean little injuries. *No! No! That's not what I meant!* I would say.

The answer was somber. He was grieved to confront this fresh deviousness, denial. *I know what you were thinking.*

Dad! No! I didn't think that!

What he could do, and undo, with a shake of his head.

Astounded, I wrote above, but *astounded* doesn't begin to cover the violence of my objection, and the panic-grief, and the passionate shame of futility at each wasted uprising against his casual slaughter of my sense of myself.

Whose outcome could have been my adoption of his sense of me. How I loved him; how easily his word could have become law. The law would have involved the corkscrewing self-betrayal of my beginning to lace stray remarks with mean double meanings, enacting the covert viciousness he attributed to me. Instead, with ardent futility, I committed to honesty, and I will put a ghost finger lightly down on this page: there. There. A writer begins there.

I can't write *To my credit, I kept trying* without wondering: credit? Does wanting to live free of perfectionism reflect well on you, or is that like a drowning person taking credit for craving air? Each consulting room was church, where I went to pray for writing. The intimations of freedom a long series of analysts shepherded me toward extended their brief reprieves. I married the last in the series, a psychiatrist whose

ruff of white beard tidied the heavy bones of his face into a complacent Persian-cat breadth, and whose joyous infatuation with me redacted objections to marrying one's former analyst. In connection to my account of the liminal allure of the perfect sentence, he told me a story:

Freud is sitting on a bench in the garden of Berggasse 19 with its famous upstairs consulting room (which my last analyst, big on pilgrimages, has visited). A notebook rests on Freud's knee. Down a gravel path, a high-wheeled baby carriage is parked in quiet shade. While their existence affords peripheral pleasure, carriage and child require no particular attention from the grandfather; they are an aspect of the reverie that is his summer afternoon. All is going well—that is, Freud is working—when concentration is broken by an unexpectedly distinct word of the boy's. *Fort*. It's a word whose English translation is *gone*. Over the side of the carriage, tossed from within, flashes an object. A toy, a painted top suspended from string, dangles down the wicker side of the carriage, almost touching the mown grass. From his bench patterned over with leaf shadow Freud observes in a state of bemusement. Pressed for a prediction, Freud would be compelled to confess uncertainty. Mild uncertainty, ordinary small-scale domestic puzzlement about what a child is up to, when had he ever had time for that with his own boys? Moreover, why is it pleasurable, the suspense of being unable to predict a child's next move? Yet it is, it's delightful; he would not intrude for the world; the toy continues to dangle on its string. *Da!* and it

bobs upward, reeled back in—*Da!* which means *Here!* The toy regained—perhaps turned this way and that; perhaps simply held. *Fort!* The toy leaps forth, hits the string's end, tick-tocks to a stop; gone, lost, dead, vanished; what can a child come up with; the leaves overhead quiver, *Da!*, here, saved, alive, back, *Fort!*, the train of the silk dress fishtailing out the door, down the stairs. *Da!*, the string reeled in, silk rustling across the threshold, perfume as she bends in for a kiss, the recognizing dilation of those pupils at the heart of the cosmos, the mother's gaze back from the dark, Freud on his bench turning a page to note down this news of the psyche's genius in pitting retrieval against disappearance, an insight fortuitously granted him by the fair-haired boy who will die (it can't be foreseen, it can't dim this revelation inked onto the sunlit page) of tuberculosis at five years old.

Bad days, everything falls within perfectionism's ken. The unaligned spines of a shelf of books, the phoniness of my handwriting. The mild humidity of my skin tends to kink the hair at my nape, and though the kinks are hidden under my long hair, they have to be ironed to the pin-straightness of the rest. My transparently insincere response to a greeting in the hallway, surely barely registered by my colleague, involves me in several hours' hate-reverie about my falsity and overall weirdness, *Why can't you why the fuck don't you know by now how to what is wrong with you what is wrong what is wrong will you ever get it right.* Rarely do I get through an afternoon's office hours without some lapse or other, the scald of my in-

adequacy burning below conversation like those fires suppos-
edly fuming in abandoned mines. Occasionally these failures
are serious—holes in empathy or generous-mindedness—but
mostly they're slivers of infraction only I'm aware of. But it's
strange, perfectionism's blindness to the size of mistakes. Its
indifference to any rational hierarchy of offenses means it
flays significant and trivial with equal gusto.

Perfectionism's swiftness, its emotionally intense discrimina-
tions, its power to disrupt, its addictive excitements—if only
writing felt like this, I would write all the time.

Down on my knees in Texas it had been a mistake, one I
couldn't talk myself out of, to believe in my connection to
the antelope that did all the seeing it was ever going to do
from that eye socket an inch from my sunburned nose—a
mistake to believe the last atoms of soul cradled in that eye
socket recognized *me*. But I did. The heat, closest of enemies,
inspired elaborate counter-harangues directed at internalized
detractors, including my faraway adviser, whose talent for
comic condescension made him in my mind as in reality an
incomparable scorner and derider, to whom it was possible to
say in fantasy as it would never be in reality that I was *right*
to devise a little religion, a sense of sacredness can't hurt, ar-
chaeology's dry, dry, pummeling rationality sought to reduce
once-gorgeous life to measurement and grids when intuition
might *see* more, learn more, hear something as faint as the

panicked pulse that had met death twelve thousand years ago. Right here. From the tamped ocher dirt the antelope had risen back into the light centimeter by centimeter, resembling, at first, a small alligator whose spine creases the silted pour of river. *Had risen!—ain't that the usual grounds for faith?* I imagined teasing my dad, who laughed the laugh it seemed I was always hoping for from him. With the finest brush that had been available at the hardware store in town, with what the clerk assured me was *real sable*, I whisked grains of sand from the business end of the skull: antelope jaws may be narrow, but they're arrayed with formidable deep-rooted teeth etched by hard use, very possibly embedded with analyzable motes of ancient pollen—with luck the samples I meticulously labeled would reveal what it had fed on its last day on earth. On this terrace carved into an ancient bank, mine was the only square yielding bones. The rest of the terrace, though still neatly gridded off with string, had been abandoned as unprofitable, and I was companioned only by a lanky boy from Kentucky, digging several meters away, whose conversation I was mostly able to avoid without, my hope was, much offending him. His long-sleeved plaid shirt amazed me, its pearl snaps fastened primly to his Adam's apple—I didn't want it to, but as soon as I saw him in that shirt my imagination started unsnapping. He was a Christian. Other boys on the dig wore Levi's and wifebeaters, girls some combination of swimsuit or halter top and cutoffs. My own state of partial nakedness I had adapted to as a child adapts to bathwater that starts off far too hot, but when courtesy compelled conversation with him, my nakedness heated up again and I had to wear it like a stupid

blush. I wished he had been assigned elsewhere; nonjudgmen-
tal though he seemed to be, his Christian-ness impeded the
quiet talking I would have done, the foolish songs I would
have made up if the antelope and I were alone. Above us, on
the rim of the tawny bluff, the boy's radio sang out the top
ten country hits in maddening rotation, another thing I held
against him. Now and then one of the complicatedly married
graduate-student directors, either the stocky bearded husband
in his sweat-drenched Texas Tech T-shirt or the wife with her
black yard-long braid tapering to the slimmest of tips and her
bikini top more faded even than mine, would appear on the
edge of the bluff to call down *How's it coming?* The boy would
stand, lift his hat to scrub at his sweaty hair, and he and which-
ever director would drawl through a seminar on the bloody
proficiency of the Clovis hunters. I have always loved hiding
and was happy to remain hunkered down with the antelope,
whose bones displayed none of the marks of butchering sorely
needed for the directors' dissertations. By the luck of the draw
this square was mine; they would have preferred it to be the
boy's, as his experience was greater, his talkativeness better
adapted to their anxieties than my crouched concentration.
The boundaries of my square were clear, the wooden stakes
at the corners connected by taut string powdered the ocher
of the carved-away bluff, and the single instant that pleased
me most in any given day was when I got to take that casu-
ally possessive step over the string into my plot: it was as if
I had always wanted a single square on the face of the earth
to be ruled off and entrusted to me, small enough so that ev-
ery task within its boundaries could be executed flawlessly,

the shaving of the trowel, the whisking of the sable brush cordoned off from the unruly rest of existence. Reeds would have rustled as the antelope legged it down to the water, ears pricked. When the lanky boy leaves for lunch, I bend close and ask *Did you see it coming?* The dig's finances are precarious, the directors have been seeking publicity. Early one morning before the heat gets too bad a magazine photographer, slung with cameras, asks me to pose with the antelope, and keeps asking until from his square the lanky boy declares *I'll come over.* The photographer shrugs okay to the boy in his straw-hatted pearl-buttoned uptightness—he's plenty picturesque, also professional, a nice combination, but exiled to the dry-grass edge of the bluff, I feel the anger peculiar to violated privacy. I'm exasperated by the sweat in my eyelashes, by the music caterwauling from the grass, by the boy squatting on his boot heels by the skull, by having bewildered myself by saying *No,* by having said *No* in the first place and then needing to say several more *No*s to back up that original *No,* each more convincing than the last, none entirely convincing, which is why the lanky boy piped up. From up here the volunteering pity of the boy pisses me off. He must believe I'm ashamed of the revealingness of swimsuit top and cutoffs, that ragtag impudent minim of clothing I'm actually proud of, as proof I belong here, but it's not me, it's him who's at home, down in my square; he tips his hat back, vaporizing long days on my knees imagining the numinous dark eye gazing back from the skull; *Great!* he is told; *You're a natural!*; at the click, I am well and truly out of the picture; *A natural!* for some reason stings, it's covetable, also infuriating—his having been called

that when his being down in my square is precisely *not* natural, that's my hard work the square displays, the delicacy of my brush cleaning orbits and sinuses, my patient laying-bare of the partly dovetailed, partly askew arcs of ribs; as the photographer's packing up the lanky boy says *Hey, want to swap squares awhile*, and I almost shake my head—almost; the hesitation's his opening; if I shook my head he wouldn't argue, wouldn't say another word, though we both know the antelope changed hands the instant I refused to be photographed sweaty and bold and in charge of my bones.

Perfectionism hits a perceived error hard, its scorn aura'd with eloquence, and it moves fast, faster than conscious thought, which might be why perfectionism in action feels more real than ordinary thinking, why perfectionism has this air of lightning-strike inevitability, because it's like the brainstem wordlessness of drives and reflexes, searing communicativeness suited to nanosecond life-and-death decisions. Like those reflexes, perfectionism *feels* unerring. Like you shouldn't distrust it or you'll die. The instant of consenting to perfectionism's excisions is a radiant alliance with grace. To resist perfectionism is hard for a number of reasons, but one of them is how lumbering and flat-footed conscious thought is revealed to be in any contest with instantaneous certainty.

Don't you know.
 Don't you know I thought you were going to be perfect.

———

Everybody makes mistakes is the notion my son announced, looking up from his spill, with an assurance he was only trying out, because it might be the wrong thing to say, because he had never heard, from me, any such thing.

Five syllables terminating with the smug spasm of *ism* make it sound like I know what I'm talking about. The very word *perfectionism* signals that this book knows what it wants to unfold, when what interests me is perfectionism's resistance to being narrated. So far I've been pretty much the opposite of a clear-eyed or articulate sufferer: I've acted as if its screwy mysteries were god's. As if it was a black hole any attempted description would be sucked into. The discrepancy between my intimate submission to perfectionism and my understanding so little about it makes me ashamed, and that shame is loamy, breeched by slim green shoots of story. That dirt smells of *finally*. Finally *wanting to tell*.

Part II

Was it partly the times?

If, according to Freud in "Thoughts for the Times on War and Death," written in 1915—

> [We find it difficult] to abandon the belief that there is an instinct toward perfection at work in human beings, which has brought them to their present high level of intellectual achievement and ethical sublimation and which may be expected to watch over their development into supermen. I have no faith, however, in the existence of any such internal instinct and I cannot see how this benevolent illusion is to be preserved. The present development of human beings requires, as it seems to me, no different explanation from that of animals. What appears in a minority of individuals as an untiring propulsion towards further perfection can easily be understood as a result of the instinctual repression upon which is based all that is most precious in human civilization.

———

—then does it follow that the ethical sublimations of certain eras may be more pervasive and rigorous than those of others, more excruciatingly productive of perfectionists?

Suppose you wish to design an epoch capable of instilling the "untiring propulsion towards further perfection" in the maximum number of individuals, how close did 1950s suburban America come to the ideal incubator?

Men then were more alike than they are now. In their alikeness, which the time required, they had a conscientious, replicable beauty—boy cleanliness, haircuts that showed their ears, white shirts, black ties. Ironed handkerchiefs. Shoes whose shine needed tending to. In winter, imposing overcoats that made them seem like soldiers in the army of seriousness and made it hard to tell them apart, especially from a distance, so that if a child saw her father far down the sidewalk she would have trouble knowing for sure it was her father and she would stand in her oversized rubber boots, using one mitten as a gas mask to diffuse the freezing air, until it was him or it wasn't. This was long ago, during the war known as *Cold*. The early-morning unison of the fathers' departure would have shamed a flight of blackbirds; under the vaults and domes of the capital, behind locked doors, at the fathers' gray steel desks, at the ends of their pencils, the war was going well, it was going badly, it was a matter of interpretation, it was work. The daylight absence of the men, the

fathers, imbued the suburb with the suspense of desertion. Every blade of grass in every lawn was waiting. Every wife was waiting, every dog with pricked ears was waiting, and each blade of grass, each wife, each dog and child, whatever else they did, held still. Whatever else it was for, the suburb was for holding still. Look: black circles have been cut from the lawns and into these circles have been inserted slim upward-striving trees. Against the possibility of their flying away to unite with other trees they are tethered to the earth with wires.

The explaining voice pauses; the pause is not a lull, not neutral, but active and soliciting; the voice belongs to the movie you are watching, and watching is what has been asked of you so far, but you learn from the pause that watching no longer suffices and some other engagement is required, but what that might be, you can't say, there isn't time. Over the Hiroshima of the black-and-white classroom movie, the bomb rolls from the belly whose riveted steel plates have a home-made frankenstein crudity: how strange to see how the plane is *made*; that clouds float by; how mutely the bomb peels away into the long arc of descent. In its revolving slowness it's left to its own devices; it's smaller and smaller and farther and farther behind; it can almost be forgotten about. Below, between parting clouds, a plain, the city branched through by rivers, a clutteration of tiny roofs, infinite holding still.

———

Saturday you might see your dad in a T-shirt, your brother
might be asked if he'd like to throw a ball around, and from
a corner of the lawn you might sit and watch, sick at the in-
justice of being a girl, *wild* with stoppered grace. Saturdays
your dad was his own man, he said. Whose was he when he
wasn't his own? Opposing the soft amused handsomeness of
his face, his glasses had an architectural authority, the naked
lenses dominated by the heavy black plastic bridge and ear-
pieces. His hair memorized its side part. On a high closet shelf
lived the hats forsaken when Kennedy took his oath of office
bareheaded, trusting in his rashness and eloquence, in how
confident he was, how his youth seemed to mean he could
face things without the old inhibition and correctness, with,
instead, brainy resourcefulness, undeluded cunning; and how
fear relented with the bareheadedness of JFK; how fear was
no equal for wind rifling the dark hair of a handsome man.

Deprived of my mother's attention, my father would narrow
his eyes and try to set something on fire, some dogma or
other, till she faced him to argue. His voter registration was
discreetly partyless to ensure his survival from administra-
tion to administration, but he was a Democrat. Pained by her
Republican convictions, offensive not only in themselves but
as the emblem of some ultimate elusiveness in his wife, he
persisted in the belief that she could be harangued into con-
verting. PhD or not, he came from a long line of forceful soul
savers, river-dunking, hellfire-extolling Baptists. When trou-
bled, he would take nail clippers from his pocket and excruci-

ate tiny parings from his already short nails. He didn't seem to regard this as a private act, and the fact that he couldn't tell this habit annoyed other people filled me with wretched solicitude, as if nothing stood between him and disaster. When he took his glasses off, it was like he lifted away his sly intelligence and left a face naive as a sleeper's. When he crossed his legs, the white calf with its corkscrews of black hair alarmed us all (my mother wondered aloud sometimes why no shank showed when JFK crossed *his* legs). He was an avid taker of offense. The word *hillbilly* overheard by chance—in a joke on TV—riled him like a just accusation. His gaucheness wasn't completely lost on him and in the right mood he could mock it with a kidding lightheartedness impossible to reconcile with his prevailing touchiness. My little brother and sister and I longed for these fits of clowning, but they were like weather, immune to coaxing. In the token sartorial task assigned him, his oxfords submitted to the polish-stained shoe brush. The happiness of buffing called for snatches of sinister, lilting country. *I know a girl lives over the hill/If she won't do it her sister will.*

On the coffee table: oversized magazines whose pages exacted from a usually slapdash child the delicate touch and visual insatiability of a curator. Whose arrival was an event—at dinner: *The new* LIFE *came today*—and whose disposal elicited an elegiac tone: *Are we done with that* LIFE? There was TV, of course, but TV watching was closely monitored: these magazines were the source of my knowledge of the world beyond

our suburb. These pages had held the bleakly unremarkable Book Depository, the knoll where a father had thrown himself into the grass, covering his crew-cut sons (there was so little touch in our family that I envied those boys, I wanted an instinctive arm to press me down while sirens careened, or maybe just to feel adrenalized protectiveness radiating from a male body, maybe it was Freudian, the wish to be toppled and yanked close while emergency wheeled through the air), Oswald's lean fox face, its expression not much different from the shamed, dissembling insolence of certain boys in my class, boys known for cornering and tormenting, whose viciousness was revered. There was Audrey Hepburn in a striped sailor shirt; there was the hammy smile of a chimpanzee in an astronaut suit, harnessed into the coziness of a space capsule; there was an American soldier, rifle on his knees, watching five slight Vietnamese men, hands bound behind their backs, step barefoot into the narrow boat with him. In those pages Jenny Small and I read that when police entered the apartment of a woman murdered by the Boston Strangler a record was still spinning on the turntable. From the hulking cabinet stereos in our living rooms we knew the grainy hiss and snap of the needle riding that last groove, the diamond of needle with its gliding listlessness and its failure to notice it had come to the end, and it came home to us on the rattly aluminum-framed faded turquoise-and-white plastic-webbing chaise longue in Jenny's backyard that as girls we were on the way to becoming wanted by rapists. We might *feel* cunning and self-sufficient and male, but look, *none of those things was true*. It was as if we had been two boys, till we read that. It was just

luck that we read it on Jenny's backyard chaise longue, me on the rickety end where a sunbather's feet belonged, Jenny sitting close to but not leaning against the cranked-up back support, the magazine spread across her lap, a flexing slippery V of glossy pages with, on each side, an island of brown knee. I seemed to see the left knee with the keenest focus I had ever brought to bear on any object. The horrifying page that rested against it made that knee exquisite in the composed human beauty of bone under skin. What did what we had read *do* to us? That it was terrible, Jenny and I acknowledged in silence. We were in this together, but what did being *in it* mean? Later that day, after supper when nobody cared where children went, we looked for and found each other (we were not best friends, and didn't possess best-friend telepathy) and went to Jenny's backyard again, behind an overgrown lilac where, with the Boy Scout knife borrowed from her older brother's drawer and singed for sterilization with matches also found there, Jenny and I nicked *x*'s in the palms of our hands and, sitting cross-legged, held our palms together, interlacing our fingers and gazing nobly into each other's eyes while the *x*'s bled into each other. Only they didn't. One of us noticed and said *Wait, there's not enough and it's not getting into each other.* From the edges of the cuts emerged little rubies, bead after luscious bead, but, true, it wasn't *flowing*, so we rubbed and smeared our palms, and that was the only thing that hurt, the edges of the cuts peeling back, the nervy insideness of one hand in electric contact with another, the streaky finger painting mess we were making of our palms, meaning bleeding into each other was not glamorous, but messy and

determined, amateur and startling. That didn't matter too much compared to the feeling that the ritual was working— that it was doing what we'd wanted it to, though neither of us could have said what that was.

Set apart: time of midmorning departure, time of highways' infinity, time of the gritty-glassy echoey unscrewing of the lid of the red plaid thermos usually reserved for the beach, time of lemonade a-tilt in the red plastic cup-cap. Time of that cup's rim, wiped between turns so no one would die from the other's germs. Time of children's immersion in the atmosphere of their parents' marriage. Time of getting lost and whose fault it was. Time of the hotel swimming pool with its confidence-inspiring stench of chlorine. Time of signs warning there was no lifeguard, of the cement margins where the chaise longues held sunglassed mothers and fathers whose wary nakedness causes the child's heart to thump in the child's skinny chest from delight at this exposure, which the child feels as a coming closer, a confounding of realities. Every unhappy family is periodically ransacked by joy. It is the way the family haunts itself, through the unknownness that is always, powerfully, in the parents' possession, the unknownness whose casual revelation on the chaise longues on the hot cement margins of the hotel swimming pool in a never-before-seen city suffuses a child's exaltation with fear. Time of the child comprehending why grown-ups say of something or other that it is *enough to break your heart.*

Where was this? The chain-link fence that warned there was no lifeguard, the mothers who called *No running, I mean it, no running.* The outlandish names of other children flung out, though our mother, a devotee of discretion, would never raise her voice in public. The not-so-distant freeway doing a steady business in semis, cumulus clouds brighter for the level radiance from the west, our shadows' legs staggeringly long, our sleek wet heads so alike we were tribal, except within that tribe were the sharper alliances of brother and sister, and in our wet swimsuits we were more brother and sister than we had ever been before, eagerly, competitively, near-nakedly brother and sister, and when, unpredictable in his boyness, my brother followed me up the fifteen-foot ladder whose rungs I remember for their wet-metal smell, the flattery of his following so close lit my skin like sunburn and drove my climb to the pinnacle, whose galvanized aluminum slide descended to a slapping, light-scattering heaven ringed with wavering child-bodies that left an open space for the next slider. My brother was right behind, and behind him came the oppressive almost-sexiness of other children's wet bodies clambering up the ladder. Maybe he wanted to impress these strange others, maybe too many cartoons whose victims rebounded laughing had led him to believe no real harm would be done (that was to be our parents' theory)—whatever causes converged in his shove, I was off balance, trying to correct the asymmetry of my pose there at the top, and thus went over the metal-pipe railing, the arm thrown in front of my face hitting first, then my knees, and I was slammed flat, silence closing in, circling as if I was a drain it wanted to go down. Through wet eyelashes I saw a

world peaceful down to the grains of sand or grit on the cement, each grain cherished by its shadow, the grains brightly lit and far apart and astounding as an array of boulders on the moon, and whose meticulousness placed them with this unearthly distinctness, what did that, and did it know about me? Then: voices, grown-up voices, grown-up feet, confusion, thrilled interrogation, solicitude. Dark fur against gaudy whiteness: those were my father's legs, this was my father crouching to ask questions, but the magnitude of my alertness crushed the desire to answer him. Nobody maintained in those days that you shouldn't move a person who'd fallen, rescue was a more casual prerogative, and I was carried back to our hotel room in my father's arms; this once, his arms; I was left alone on one of the double beds in the air-conditioned gloom while my mother and father conferred outside the door in the heat of early evening, other grown-ups stopping by, their questions politely deflected, their kids' voices ringing from the pool like clamor from a past life. Standing outside the room in his baggy swim trunks, assailed by well-meaners, my father would feel humiliated and full of blame, these emotions unrelievable by the surgery he habitually inflicted on his nails, but sufficiently disguised by his charm that only I, listening in the dark room, could detect the hazardousness of his mood, which sought, which had to seek, an object. At ten I believed nobody else had real insight into my father, not my brother or sister, who understood hardly anything, not my mother, whose adoration of him outwardly resembled suffering omniscience but who was in fact easily deflected by his contrarieties. Now it was she who intervened. My little

brother had not meant to hurt anyone, had he? That tender, harassing spell cast by adults coercing a right answer: it was surprising how instantly we welcomed that (their welcoming it was plain in their voices, and as for my welcoming it, I could feel that). Outside the door my brother was crying; he was (I closed my eyes and knew this for sure) shuddering, goose-fleshed, shaking his head no, no, no, no, no, no, and in that dark hotel room I was relieved that my mother knew how to manage the questioning by which he could be forgiven, and within relief a doorway opened into sleep.

Enormous suitcases, jade and beige and navy, jammed to-gether in a rattling bulwark smelling of sunstruck plastic, shade a narrow canyon lined with a flannel sleeping bag whose hunters and retrievers alternated with flushed pheas-ants. The fact that the pheasants are bigger than the hunt-ers and their dogs and if they flew at them instead of away could crush them with a few decisive wingbeats arouses an aesthetic revulsion intense to the point of nausea: I need to correct this, to write a letter to the sleeping-bag people, en-closing a pheasant-setter-hunter drawing so piercingly *right* they would wonder who this girl was and resolve to find her to hire her to design all future sleeping-bag-flannel vignettes. My forehead sweats, the roots of my hair sweat; sweat runs from between my shoulder blades down my spine with a feel-ing like being crawled on and not minding, and I close my eyes and coax that sensation to the center where it's the war of slow-sliding creepy arousal versus pain. If you have three

children in the back seat, one is always in the middle, nudged and bothered and taunted from the left and from the right. The answer is always no, but every trip begins with someone begging to ride in the rear of the station wagon, called in our family *the Wayfarback*, sweet as a vacant house is sweet, as only unclaimed spaces ever are, carpeted in clean scratchiness, offering what can be found nowhere else in our life, the ambiguity of being close yet unseen: a child in the Wayfarback can't be surveilled by glances in the rearview mirror. Can't be seat-belted in, either, making it appealingly dangerous. So why is it mine, this hot rumpled hidey-hole? Attuned to injustice—savage keeners of *no fair!*—my little brother and sister are quiet in the face of this travesty, gratified by their own quietness, which seems grown-up and inexplicable. Mother-and-father silence followed my saying plaintively, two or three times before we left the hotel room this morning, *Something's wrong.* With my left arm, with the little finger and the fourth finger and the thumb of my left hand—*something's wrong, it feels really strange.* To which no one said even *It'll be all right in a little while.* Wearing the same clothes as yesterday I was standing there saying *Look* with my whole incredulous body. My mother who didn't like to touch me helped me work my swollen arm out of the sleeve of my shirt, but even then she didn't do the thing I wanted, she didn't look, and because she didn't look it changed into something not quite mine, my arm, and I got a little divorce from it, like getting distance from a lie you're going to disown before long. I couldn't knot the cowboy bandana I was obsessed with, so she did, though she hated it and was always trying to talk me out of it on the

grounds girls didn't look good with rags around their necks. Then unforeseen license: *You can ride in the very back*. With the smashing of strictness, the air in the station wagon brightens, my father calls my mother *honey*, which makes everyone feel as if they've been called *honey*, my brother and sister trade the Etch A Sketch back and forth, and I lie on my stomach in the Wayfarback, turning the pages of *Smoky the Cowhorse*. It was my hand Smoky snatched the apple from, my sunburned neck the bandana circled, only now (I suddenly realized) the bandana could be used to wrap my forearm—a feverish cowboy would do that if he were shot with an arrow. When the wrapping seemed to help, I found the rag used to wipe condensation from the back window and swaddled my hand, figuring out how to encompass the outsize, yammering fingers, too, although the thumb remained an orphan with a big, throbbing heartbeat. I wished I had a scrap for it. Eternity could be broken into bearable slabs by the ritual of loosening the bindings and winding them tighter, the baseball game fading and reviving on the radio and my father calling out *Attaboy!* and the sun lasering between suitcases to ignite hot stripes on my legs while I slept, and I slept a lot, and when I woke there was a fraction of an instant when my old life rushed back and all was well, and that was snatched away. How wrong I'd been not to have loved my unbroken arm more. My mother unfolded the map of America with every Howard Johnson's on it. My father said *Shoes on, kids*. The back door swung up, me blinking at the loss of my cave, clambering out to the asphalt, where the bare-legged beauty of the other four struck me sharply. Glass doors opened into the mercy

of air-conditioning in a circus-bright barrage of orange and turquoise, the gauze bow in the small of the waitress's back led us in single file between tables of families, and I held my scarecrow arm close to my body, but more than one waitress raised her eyebrows and would have inquired if she hadn't, in time, registered my parents' unwillingness to engage. There was another hotel-room night; there was bacon and eggs and Tang that astronauts drank; *Look, kids, the Cumberland Gap, your great-great-grandpa rode through here on his way home after he lost his leg at the Wilderness, we'll go to that battlefield some-time*; *Rode home one-legged?*; *He could get a prit good hold, his stump was long enough, down to the knee*; *Bill! Don't go into de-tails!*; there was *prit* to evoke the ghost's voice and prove the Civil War had happened; there was fog, the headlights' shafts alive with rolling plumes, the dented guardrail the only thing between us and the abyss; there was my father's tale of the Model A he first learned to drive and the red mud it foundered in, and how it was pulled out with a neighbor's mule who could count and do tricks and would neatly, with its big mule lips peeled back, take an apple from between its owner's wife's teeth; there was my father imitating the mule's grimace and, when my mother didn't laugh, doing it again; there was my mother's Yankee reticence and delicacy and irony, about to become drawbacks in the encounter with my father's family. She was hard to make sense of, in Tennessee.

The dirty mummification of my arm impressed my cousins as if I had carried a filthy stray cat into their house and insisted

on holding it close. This was seen as boldness on my part:
the lawlessness they imagined for me was an outline I would
have poured myself into if I could. They wanted to touch and
poke and unwrap, and since that would earn me more atten-
tion of the kind boys pay only to what slightly sickens them,
I would have let them. But my aunt said Boys. *Now you leave it
alone.* My cousins stuck close, honoring the leprous *itness* of
my arm. Asked by my aunt about the pain, I don't think I was
constrained by loyalty to my parents' version, which was that
nothing was broken. The doubleness of my vantage point—
aware they were wrong but sure they were perfect—derailed
my awareness of them; where *what they want* belonged, there
was a blank. I was honest with my aunt, and relieved by the
distress she let show. Reined in only by my aunt's Southern-
lady-ness, that distress verged on an indictment of my parents,
especially my mother; but my aunt held her tongue and didn't
accuse her of anything, not where I could hear, and, I think,
not to anyone, because accusation wouldn't have served any
purpose, not really, or made it any easier to accomplish what
she right away determined to do, which was get me to a doctor.
My aunt had brown eyes so dark they were often described as
black, enviable eyes, as hers was an enviable high-cheekboned
drawling beauty that hadn't gotten her into too much trou-
ble, either because she was naturally sensible or had set out
to cultivate happiness. She'd married my father's droll, soft-
spoken, easygoing little brother, and their household seemed
miraculous to me, so much so that on previous annual visits I
had insisted on watching my aunt do every little thing, spell-
bound by her gentleness and determined to attract as much of

it as I could to myself. This greed of mine for my aunt's company didn't go unremarked, and it embarrassed my mother; if she'd liked my aunt less, she might have held it against her, or conjectured to my father late at night when they were finally alone that my aunt was egging me on in my ridiculous infatuation, with the secret aim of making Bill's Yankee wife look bad. My aunt's nature was equable and warm and self-effacing, qualities my restless hypercritical mother did not possess but religiously impersonated. As sometimes happens, two women who seem exactly positioned for mutual loathing ended up forging a spirited conspiracy, whose great staple was discussion of their men, those very different brothers.

At the hospital I was *sugah*'d and *sweetheart*'d, endearments good as opium. The dream of benevolence was pierced by my fear when the doctor bent close. I hadn't bathed since the accident and my skin radiated the stench of fever and chlorine, but the possibility that he would be repelled by me did not concern me—that wasn't it, though what I was afraid of was *like* smelling bad: it was present, like a taint, when the doctor leaned in. It was the possibility of being deeply shamed. With his mannerly Tennessee-slow inquisitiveness the doctor might assent to my parents' view that nothing was wrong, and attention-lover that I was I would be seen as having impersonated brokenness and spun a fable of pain. Could that be, could I have done that? Across a wall, at adult eye-level, ran the sequence of black X-ray sheets, and I gazed up at the frail light of my bones while grown-up voices took polite

turns, the longest, Southernest turn belonging to the doctor. *You know how if you take a little stick and give it a good twist it will splinter out with the strain but not snap clear through? What's called a greenstick fracture. Fractures here, here, and here, too.* The truth of x-rayed bone, the lifted-up feeling of rescue, the sensuousness of the expert winding of plaster-soaked gauze, spindly as layers of papier-mâché, around and around until the hurt arm vanished.

The opposite of hospital order and clarity and decisiveness is the velvet passivity of sinking into the high-backed seats of a darkening theater, but whose whim was this? Down at the thrilling level where children piece together rumors of what adults find *dirty*, this movie was a source of joking and awe and backyard reenactment: *This bad guy kills women by sneaking in while they're sleeping and painting them gold all over so their skin can't breathe. They die? If a person's skin can't breathe they die. Wouldn't it wake you up to be painted? They're just in real deep sleep. The painting happens fast. They used real gold. This one woman, while they were painting? They forgot to leave her a patch of bare skin to breathe through and she died. In real life, died, and you get to see her.* For my aunt and uncle as evangelicals, the corruption that could attend moviegoing wasn't taken lightly; how did they ever agree to 007? I can't explain it, unless the movie was meant as compensation for the ordeal of the hospital, which had left the grown-ups in a dangerous state of disillusion with each other. Maybe some unprecedented enchantment was needed, which could embrace them in its scandalous

arms—maybe it had to be scandalous or it wouldn't consti-
tute enough of a break, it wouldn't do the trick. Neither can
the adults' decision to sit apart from us children be accounted
for, unless their apartness seemed the route to undistracted
calm and unity. So: to the gilding and velvet and shushing
of Southern audience voices, to five cousins in thrall to each
other's nearness, alert to every flicker of an eyelid in a cous-
in's profile. The troubling parts *are going to go right over their
heads*, the grown-ups had murmured, a satisfying conclusion
all round, for them because it guaranteed them a respite from
the strained aura of mutual apology that had overtaken them
at the hospital, for us because we fully intended to absorb ev-
ery bit of sex and violence. In the downfalling twilight I rested
my brand-new cast on the armrest and admired its pristine
whiteness, the separate aluminum splint that shielded my
thumb, the cute paw-like entrapment of my fingertips show-
ing at the cast's end. Then it was dark. For music there was
a moaningly erotic blare of trumpets whose notes were pro-
longed with a *nyaaaah nyaaaaaah* obnoxiousness well-known
to children. Bond, too, was gloriously obvious: he did what-
ever he wanted. We understood! How beguiled we were to
find ourselves surfing the shock waves of a movie for grown-
ups. We grew bolder, also for some reason indifferent to each
other, staring without whispering. Deep in the movie, in the
silk sheets where Bond had left her the night before, a woman
lay on her side, her hair swerving across a pillow, her back to
us, what my dad called *the cheeks of her ass* exposed, just a little
string running down between them. Bond came in. Bond sat
on the edge of the bed. She was bare bright overpowering

gold, the tilt of shoulder declining to the tuck of waist, the hip the high point of a luminous dune tapering to rigid feet. Had she slept through her own death? Or wakened to feel consciousness beat its wings against suffocating skin? How long did it take? What came next? In his white pajamas, his back upright, Bond extended his fingertips to the glazed throat. No thudding, no pulse, only calm metal *thing*ness like a tin can's, a car fender's. We sat there hushed and oppressed and sorry. My cousins hadn't moved a fraction of an inch, but they had gotten farther away. Maybe to my cousins, maybe to something else, I directed an inarticulate wish along the lines of *Come back, come back.* The wish could do nothing. It was a trammeled, locked-in wish beating against other people's unknownness. It wasn't going to work. Aloneness wasn't going anywhere. While my soul hung waiting for the next part of my life I looked down at my arm, emerging into visibility as the lights came up. Under plaster and gauze was the ghost of the x where I had once bled into somebody and she had bled into me, and it worked, that x, and if it worked once it could work again, or something like it could, the x of one body held to the x of another, and this notion stirred me, though I didn't know enough about bodies to make the desire any more detailed than that, I didn't know this was sex. But I knew it was a way out. *Find Jenny and ask her if she loves you and when she says yes say good because I do too.* And then I did. Love her.

They were *reality.* Like everybody's parents, they were the most real thing there was. It was not possible to blame them,

it would not have occurred to me at ten. The truth is I was sickened by myself for being a child they wanted not to know about. I repudiated myself because I could find no way to matter, it was my failure and I understood that another, more beautiful child could have had a hold on them. Yet it seemed possible that by force of will I could become this other, more beautiful child. Was it a thing a non-beloved child could figure out—could replicate? How long would it take? This was an emergency. I was wrong, in my wrongness I was alienating them, and either I was doing things wrong, or I was imbued with wrongness, irretrievably wrong, a wrong self, and that could not be changed, and it could not be borne. Therefore it must be the case that I was doing things wrong, and if I was doing things wrong, then it was only a matter of beginning to do things right, and I could do that, I would, I had to, it was life or death to me to be loved by them, so I would do things beautifully, beginning now.

If they have both been lost to me by death, gone for years, that hasn't changed things: death, it turns out, can't touch the aura of waiting, the lifelong spell that is the need for them to *see*.

How much honesty is possible about a child if one is no longer that child? Does having once been her make me an authority? Can I understand her better than I can my cat? How radically would what that child would say about her existence differ from what I have said? As I write this I feel the kind of sadness known as *piercing* because it feels like admitting uncertainty

in regard to her experience is to lose her. In contrast, to claim absolute certainty in regard to the child's experience feels like having her. (Not *being* her. Having.) But I know very well that no person whose experience can be narrated with absolute certainty exists, or ever did. The paradox is that to write about her with the utmost honesty I'm capable of feels continually like loss; it's only the loss of her that convinces me I ever was her.

There's nothing here is what we think—the three of us who are children. *See that, kids?* my father says. *That's our address.* In front of the bare dirt lot, on the new cement curb, inside a yellow rectangle, are numbers stenciled in black bars and arcs. Down the exposed length of the curb other addresses promise other houses, invisible as our own; except for our station wagon, the street is lonesome as the last black trace of a settlement lost to fire. From this series of bare-dirt lots everything that was once interesting has been scoured away, uprooted or plowed under by the yellow machines parked randomly in the distance. Our mother and father believe they are *owners*, but to the three of us who are children the development's grid of blocks and corners and cul-de-sacs and real estate agents' signs is owned by wind, by prairie dirt erupting over the curb, clogging storm grates, unrolling gritty streamers down virgin asphalt, by a sky whose clarity is streaked across with matching streamers of cloud. My father wants to get across to us the momentousness of seeing this place for the first time: encouragement emanates from the back of his head as plainly

as if he were whispering *Come on, come on.* He's worried our lack of reaction will bother our mother. If she is dismayed, we can't tell: the back of her scarf is mysterious. Otherwise there is only the trampled dirt of the lot to puzzle over, and we turn toward that. Look at the bareness they bought for us, these two who can change our lives on a whim, who are only so predictable, whose moods are our weather. We wait in the back seat for some sign of what our lives will be like here. My father says we ought to get out and stretch our legs, breathe some fresh air.

We get out shyly, unequal to owning a piece of in-progress earth.

My dad says *Search the whole state, you won't find a prettier lot.*

His voice is reproachful, also adamant, as if we're about to run off to search the state of Illinois.

The house I grew up in could fit inside the living room your mother has in mind.

Has in mind? I study her with greater than usual focus, as if the blueprint might appear in the silk of her scarf. Nothing appears: there is only her profile or, more exactly, the wedge of fine jaw seen from below, the outline of earring under rippling silk, the corner of her eye, the rest hidden by sunglasses, so there's no guessing what she feels. My best chance of finding out lies in staring where she's staring: from the curb the lot ascends to a rise too mild to qualify, despite the prevailing flatness of the development, as a hill. But there it is, this slight steepness necessitating, in the house to come, the two flights of stairs that will be my obsession. Stairs and all, the house in her head is already, that day, complete.

My dad says *No exaggeration: fit inside the living room she's dreamed up.*

On the far side of the rise (and thus unseeable from the curb) the muddy expanse that will be our backyard takes its time descending to a stand of young maples with skittish new leaves, an outpost of the real woods massed farther back, old woods whose owner leaves them alone. Those maples stepping forward at its far end are something my mother will love about the backyard. The three of us have foraged the green world—as much of it as lies within our ken—for what she might find beautiful. Children did that then, scavenged and trespassed with a mother's delight in mind. No wilting handful of Queen Anne's lace, no mason jar wheeling with lightning bug gleams has ever charmed her, but she will praise the doings of the maples as if each is an unsure ballet student. They will be our rivals, these ink-stroke maples issuing leaves greener than her eyes: she will love them without trying. No one knows that yet, not us, not the trees.

My mother points out for my little brother a place in midair. *Right there is your room.*

There's nothing there. Affronted tone of a misled favorite.

No? You don't see that window? Your nice big window.

Gonna get his brain overheating, my father says, laying a hand on my little brother's crew cut.

And the picture window in the living room, see that? And the pair of front doors with brass hardware. That room downstairs, that's yours, you girls.

There's nothing there! My little sister's astonishment is faked, I can tell, but my mother can't, and smiles, first at my

sister, then at the house only she sees. Her rakish discolored eyetooth shows, the one she almost never forgets to hide. The tooth of rare, un-self-surveilling happiness.

Mystified, exasperated, my brother says *I saaaaiiiid. There's nothing there.*

To highlight his cuteness my sister says *Nothing!* and he says grimly *Nothing.*

My turn. *Nothing?*

He shouts *Nothing!*

You kids, my mother says. A rebuke whose usual scornful weariness means we are tormenting her to death turned, now, confident endearment. We want to hear it again. We want more of this voice and of customary rebukes turned inside out. If this place can do that, we will live here instantly. Tomorrow. We will pitch tents and sleep on the ground and excavate the basement with our bare hands. She knots her rippling scarf more tightly at her throat. In the lenses of her sunglasses hang two reflected suns and I want her to hold still, to *be* this and only this, a woman who can see what we can't, who has a whole house in her head, her conviction that it will be ideal sufficiently secure that no failure of ours casts the least shadow on her pleasure.

Under the brim of his hat, behind his sunglasses, my young father studies this elation of my mother's. As far as I know, and I am his obsessed observer and interpreter, he has never minded her involvement in decision-making. The opposite: in the little fables he tells of when they were first married and very poor, her subtlety and canniness repeatedly save them from disaster. Given the times, when men dislike

any appearance of relying on their wives' opinions, this makes
him an unusual husband. But few experiences can touch the
designing of a house for richness of choosing. I recognize at
once that choosing suits her down to the marrow of her bones.
That hers is the deep, set-apart absorption of *making something.*

Making something *perfect.*

My father was indulgent toward the drab Victorian we lived
in while the new house was being built, and touched by his
own indulgence. I especially liked to hear him say, about this
old house, *I've got kind of a soft spot for it.* Rueful, gratified: I
hadn't known you could be both, or that laying claim to an
unjustifiable emotion could be charming. But the dolefulness
of the house wearied my mother, whose taste ran to Scan-
dinavian furniture and Russel Wright china, to cleanliness
and sparseness, order and ease of upkeep. It got her down,
the abiding dusk of the Victorian's high-ceilinged rooms, the
taint of mildew in drawers, the fussy ornateness of chande-
liers with multiple flaring arms, trickily turning stairwells
meant for servants, knobbed and faceted and spindled wood-
work, flocked and floral wallpaper, tattered glamour *cheek by
jowl*, in my dad's phrase, with recent *half-assed* renovation by
the landlord, shag carpeting throughout the upstairs rooms,
fireplaces boarded up against drafts, pea-green paint slapped
onto the kitchen cupboards. My mother's irritation with the
house meant I hid my fondness for it. Secret: I loved our block
of stately old sycamores shading other foundering Victori-
ans, brick sidewalks, and, in the backyards, cisterns sealed by

monumental disks of cement. Secret: I loved that if I drew something—I was going to be a painter—on the wall inside a closet the drawing would never be discovered because there were so many closets none of them got inspected, and anyway it wouldn't matter because the house would be torn down sooner or later due to being *too far gone*. Secret: for its hiding places, its museum-smelling attic and the single-bulb cavern of its basement, ominous with echoes, I loved the house. I pitied it for all it had lost and what it was about to lose. It was going to lose *us*. All the bedrooms were on the second floor, opening off a single long hallway carpeted in crimson shag. Being all on the same floor meant I learned things about our lives. Did my mother and father come up the stairs together, or was there a lag after my mother's ascent, meaning my father was alone downstairs, and if he was what was he thinking and would I ever find out? Who got up first, my mother or my father, and what mood emanated from the awake person? Across the hall from the doorway of the room I shared with my sister, our little brother narrated the movements of the armies of two-inch-high plastic soldiers arrayed on every inch of surface area in his room. Across floor and bed and desk the armies crept with guile and deliberation; their generals were cautious, and confrontations were kept to a minimum. My brother suffered from nightmares and my sister and I could sometimes hear him. Over Cheerios we would tease *You had a bad dream last night* and he would shout *I did not!* because he didn't like his sisters telling him anything about his life.

Every family has its crucial sentences: things it loves saying about itself. For a long while our sentence was *We are*

building a house. It gave you a sweet feeling to say it. Whoever you said it to was going to get it and that was rarely true of sentences. The endeavor of *building a house* meant something to both children and adults. Because it was what all married couples wanted then, adults' response to that sentence was polite awe: *Oh, you* are! Children, even more than adults, recognize the eros of house building; it's hard to get through childhood without having devised hundreds of shelters. My mother and father never seemed more in love than when they bent over the architect's blueprint unrolled on the kitchen table, their exchange low and ardent and important. There was now a third person in their marriage, the architect. The translation of whims into convention was the architect's role, since the house would belong to a street of virtually identical houses, because that was the point of the development, and the architect was left to mediate between suburban inevitability and my mother's *What if*s, notions proffered in a trance of daring, her pencil tap on the blueprint hesitant and her glance sidelong, as if he might find these modest stabs at originality shocking. *What if instead of drapes there are shutters. If the brick of the chimney isn't all that same red but variegated.* Decision by delicately negotiated decision, the difference between our house and the others that were being built narrowed even as she would have told you the opposite was true and the house was becoming more exceptional, more boldly original. Her own father had been a blue-eyed Irish alcoholic who somehow—financial shenanigans were implied—got them evicted from the house they had owned for fifteen years, causing his wife to leave a note under the kitchen-table sugar bowl saying *Gone*

to stay where you will be ashamed to show your face, meaning my
great-grandmother's house two blocks over, and in fact my
mother did not see her father again for a year. Part of her was
always going to be that girl tugged down the street by her
humiliated, vengeful mother. Think how far she'd come from
that. This far: a house was being built because *she wanted it.*
And: *the way* she wanted it. Where her forefinger touched the
blueprint a picture window would materialize in the facade.
Desire had seldom had a more consequential object. Because
it was my mother's desire, my father adored it and oversaw
its limits. What did she have to have, at what points would
he veto longing with *No, sorry, honey, but we can't afford that?*
How many stories, what sort of roof shingles, two fireplaces
or one? *We are building a house* was a sentence whose pleasure
never wore out, but which had to be relinquished because, at
long last, the house was ready.

Because of their ultra-narrow windows our front doors had
had to be custom-made, and when my father said the phrase he
drew it out—*cus . . . tom . . . maayaade*—to convey Tennessee-
boy bewilderment at ending up with a wife so elegant no or-
dinary door could possibly suit her. There was another thrust
to his drawl: he could pay for such whims. He could! Who
had once been barefoot and whipped with briar canes! From
the real and unreal door shone twin rectangles of day, so nar-
row and slittily vertical they seemed to warn *Take the world in
small slices.*

　　If you did go out, there was the lawn. Between you and

nuclear annihilation: the lawn. Every house had one. Chil
dren ran barefoot in grass bred specially for sheen and lush-
ness. Lawn flowed into lawn and only the fathers could tell
where the lawn belonging to one house stopped and the lawn
belonging to another began. When they mowed the fathers
had to intuit the boundaries, and if a father was wrong and
mowed over into another lawn both trespasser and trespassee
were dismayed and would stand on the invisible line shak-
ing their heads. While mowing the fathers inscribed the posi-
tions of dandelions on the lawn map each father kept in his
head, and when he was done mowing the father went back
to mete out dandelion poison from a sprayer with a nozzle.
At the edge of a lawn being mowed children would collect,
wanting to run over it for the prickling fresh-cut thrill. If the
nap of someone's lawn had grown out to the meadowy depth
that would take an imprint of a body, there would be children
lying in it in pairs, scheming, or in groups, cloud-watching
with everybody's heads together and bodies rayed out. We
lay there absorbing the heat from each other's scalps as if we
were one giant daydreaming brain that ran the cosmos. Re-
vulsion struck and we jumped up. Each child in turn would
clasp hands with the child at the center of the lawn, and this
child, *It*, spun in circles anchoring the outer child's wheel-
ing hand-clasped orbit until speed and helplessness fused
and It let go and centrifugal force sent the outer child stag-
gering across the grass, running to keep up with (it felt like)
his own body and then (what made it a game) *freezing* into
a wrenched statue that could be rigidly upright—one-legged
variants were favored—or crouching with arms queered at

temple-dancer angles or bent vertiginously backwards, spine arched, worrying ants might climb into your hair. Frozen, you could see only one or two others from the corner of your eye, but there was the *feeling* of everyone's being frozen near you and for some reason that was a wonderful feeling, looser and sexier and lighter than lying with everyone's heads touching but every bit as telepathically binding. In our stop-time machine nothing moved, in the whole contorted array not a single cocked arm or tensed leg stirred, and there we stayed in our arduous heart-beating immobility while It walked among us. Only It was free to survey the entire lawn, and It took Its time choosing from the museum of wrecked children. Whoever It touched on the shoulder, that was the winner. It was unerring about which pose evoked the worst calamity and in this game alone of all our games we never felt aggrieved or argued otherwise. Older, I would read geographer Jay Appleton's theory that because we evolved on the African savanna a level expanse of grass excites in our brains a sense of belonging and rightness. A lawn, any lawn, was our new world and we rolled back and forth to get it over all our skin.

Below, at the bottom of the lower flight of stairs, there was no real basement, only the cement-floored laundry room and, adjoining that, my sister's and my basement-*feeling* bedroom whose high-up windows were obscured by thorny Russian cedars planted too close to the foundation. These were as menacing as anything with the word *Russian* attached to it would have been, then. At first as succinctly expressive as bonsai, the

cedars had grown lusher and higher than foreseen, merging into a bristling green-black stole draped along the intersection of house and lawn. In thunderstorms they scratched with such avidity at the windows it was hard to believe they were not animals, but plants. Whatever light made it through the cedars was stained in transit, and despite its pristine white octagonal-tile floor, suited to a surgical suite, our bedroom was as faintly, naggingly green as a dirty aquarium. The seeping dreariness of its light was a bad match for the room's basic design: unsparingly linear, it was meant to be a radiant enclosure whose perfect white walls and floor repelled any shady attempt at privacy. It was an anti-adolescence box. An invisible line, electrically alert to infringement, divided the room into my mayhem and my sister's princessdom, orderly down to the ballerina who rose and began pivoting when the lid of the music box was lifted. She slid up from a secret ballerina crevice and it was hard to tell what emerged first as the lid was cracked up, the preliminary *tink* of the waltz or her teensy profile. I hated her, that ballerina, avatar of discipline and prettiness no bigger than a candle flame and with two roles, velvet hiddenness and dainty performance. When my sister was gone I would crank the music-box key as tight as it would go and watch her whiplash through her pirouettes. If she'd snapped off, I would have hidden the body. Sometimes I went as far as imagining myself bravely lying my way through my sister's tears, my mother's accusations: *Don't look at me! I don't know what happened!* The audacity of my imagined lie (not that they would have been fooled) tempted me to twist the key harder, but the manic dancer maintained her

toehold. Matching blankets hospital-cornered on the twin beds on warring sides of the room displayed still more ballerinas, dawdling en pointe or taking their bows: their demureness wicked through furry pink polyester to coat my skin as I slept.

Our room opened onto a hallway where there were closet doors and the foot of a flight of stairs, carpeted in beige, this lower flight ascending to the landing and its mirror image, at the other end of the landing, leading to the upper story—living room, kitchen, the master bedroom belonging to my mother and father at the hallway's end, and opening off the hallway the small bedroom my little brother had to himself. With only the pitch of the roof high above for a ceiling, the landing possessed a proud shaft of vertical space. In this shaft were suspended, at different heights, three sleek cylindrical brass downlights whose use was forbidden since, when bulbs did burn out, replacing them was a ladder-and-swearing project that could ruin a Saturday morning. When, for my parents' infrequent parties, the downlights' master switch was clicked on, guests entered a movie of exalted light. Party radiance transformed my mother into a breathless charmer. Sure, for once, that there would be zero consequences, my brother and sister and I evaded her gaily unmeant warnings to get to bed—secretly we knew she liked the picture we would make for any guest happening to glance up. A row of fresh-bathed Norman Rockwell cuties, *we* had never made our mother weep with fury. No mischief of *ours* ever doomed her to a migraine. In clean flannel pajamas—shooting stars and spaceships and astronauts, a shirt that buttoned and pants with a drawstring for my brother, and for my sister and me

identical ankle-length gowns in an intense pink I associated with throwing up, maybe because I had the flu the first time I wore it—the three of us crouched behind the fancy ironwork guardrail shielding the edge of the upper story from the drop to the landing to spy on the suave hair of strange men coming in from the cold starry night and the lacquered updos of the women with them and the satin linings of the coats they shed for my father to receive and drape over his arm, where they made an overlapping glamorous burden he was in charge of, just as he was in charge of all things that came from outside, and of his children in their pajamas behind the guardrail high above, his manner cunning and magnanimous, superbly male, deeply reassuring to see or be close to, as each lucky stranger was welcomed into our light.

Along with the new house came a new school for my brother and sister and me, a compound of modernist brick buildings set down in neat playing fields, and though my mother mostly preferred our new teachers, from admiration for Mr. Strehlik she drove me back to my old school in the city for violin lessons.

While I liked the violin as an object for its lustrous zebra-striped back and scrolled head with *Sputnik*-y keys and the nervous zingy E string and its parallel comrades tensely ascending the fretted neck, and I liked the inside of the violin case for its ratty scarlet velvet whose curvy vacancy precisely answered the contours of the violin when you tucked it in, with compartments for pitch pipes and rosin and brass latches that closed with reverberant snaps, and I liked the music

room for its atmosphere of devotion and its high arched win-
dows and wood floor gleaming as if made from thousands
of violins melted down and poured out and for the disorder
of music stands and gray folding chairs whose backs were
stamped with the name of the school that wasn't mine any
longer and the hippo laziness of black cello cases lying on
their sides along the wall and the blackboard palimpsest of
older students' tricky passages, hectic flights of eighth notes
disappearing into a cumulus of haphazard erasure, still, I
feared Mr. Strehlik for his impatience and derision and large,
corner-tilted dark eyes that had never missed a mistake and
the horror of his hand redeploying my index and middle and
little fingers on the strings while he chanted in his ominous
accent *Like THIS like THIS like THIS* and his old-smelling
white shirt and the bow tie he acknowledged opened him to
ridicule but refused to exchange for the somber straight dark
tie that would have checked, at least slightly, our abuse, which
commenced as soon as the music-room door closed behind us
and we ran shouting down the stairwell, singing out mocking
variations on this name—*Straw-LICK-y, STRANGE-icky*—for
four flights down to the doors that let us out into the street,
and there went our separate ways, the other two girls in my
class sauntering lopsided in imitation of Mr. Strehlik's tilty
polio gait, me standing bereft on a winter city street corner
with the weight of my violin case as the one real thing I had
hold of, since reality, or what little reality was within my ken,
was banished by the hilarity I owed their performance, and
once reality had gone into retreat it could be slow finding its
way back, or so I was learning, on that corner on the opposite,

old side of the city from our new house and my new school, and while probably another, more confident child could have handled the strangeness of being returned to a previous existence, I submitted to it with terror, bewildered by the steep old buildings with no lights in any of their rows of windows and the onset of darkness and by no one being anywhere around.

When you come out, my mother had told me, *you wait here on this corner, and I'll swing by and pick you up.* Ten minutes, half an hour, eternity. Winter ached under my breastbone. I had been here before—the profound *here* of waiting and needing. This was something my mother did that I never quite believed she did and so when she left me somewhere I failed to foresee that she wasn't coming for me, and this saved me some anxiety but meant that whenever I emerged to find she wasn't there it came as a shock. This first shock was followed by others: because my serious nearsightedness had not yet been diagnosed, I was repeatedly duped into thunderous relief by cars that looked vaguely like ours. I had learned to peer closely. If I thought of trying to get back into the school and find Mr. Strehlik, the memory of having ridiculed him rose up and shamed the impulse out of existence. He would long since have left the school by some other door anyway. I must have known he would have been utterly unwilling to take charge of me, but my long wait on that corner had killed reason, each bitter winter breath an infusion of fairy-tale trustingness, and if he had appeared I would have followed Mr. Strehlik anywhere. My mother, I understood, respected him—at least, her voice in conversation with him was enthralled and deferential. Who was I to despise the person she

trusted to coax beauty from my intractable fingers? For him to do that, to try to do that, cost good money and meant I had to be driven across the city though there was a music teacher at my new school who was good enough for other mothers' children. Not mine. What my mother expected of this man with his large wounded corner-tilted eyes and inscrutable origins was the transformation of my ugliness and awkwardness into talent, which he might be able to do because he was European. At bottom I understood nothing could justify the exposure of mercurial Mozartean sensitivity like his to sawing discords like mine, and I condemned him for submitting to this travesty. No matter how badly he needed money, he shouldn't have tricked my mother into believing there was hope for me. For a fastidious, hypervigilant, disliking mind like hers the onset of hope was as deceptive as infatuation: she just couldn't see what was right before her eyes. And then she did, and what was right before her eyes was me, and not being good at anything, I could not help her. If I had been good at something I could have pleased her: it wasn't impossible. If I had been good at things she would have been as serene as mothers were meant to be in 1963. There had been no warning that a beautiful woman could end up with a child so backwards and ill at ease that it would reflect badly on her mother. As it was I threatened her life and that was more than enough to justify my mother's leaving me standing on the corner forever. Shame was weirdly consoling, since it graced the inexplicable endless wait with a *reason*. A *cause*. The cause was me. Not long ago, when I was only a little smaller, a little more childlike, I had had a chance at perfection. It was possible for

a child to do every single thing right if the child would only *pay attention.* If I had *paid attention* the station wagon would pull up in front of me and I would climb in to the sound of my mother's voice asking *How was your lesson?* and the inside would be warm and the clean smell of our car would set off the scent of her perfume, and as soon as my seat belt was latched my mother would face front with the collar of her coat turned up and after punching a couple of buttons on the radio and finding nothing but ominous male voices calculating the distance from the Russian ship carrying nuclear missiles to the shore of Cuba, which was all there was on the radio lately, she would sigh and punch in the dashboard lighter and fire up a Salem Light for the drive home. There on the winter street corner I vowed from then on I would pay the most exquisite attention the world had ever seen. I would be a creature of infinite attention. Whatever was wanted or needed, it would all be done right, and by me, because I was changing right then and there on that street corner, I was transfigured and how could such transfiguration fail to make the station wagon materialize from the dark? At long intervals a car stopped at the stop sign of my corner, but it was never a station wagon and the driver never turned his head to wonder why a child was standing there—it wasn't an era when you worried about a child on her own or felt compelled to ask the child if she was lost. Dirty snow meant the violin case couldn't be put down without getting ruined, and I kept changing hands, one freezing on the handle of the violin case, one tucked deep into a pocket. Soon it was very dark. It seemed impossible I had ever been anywhere as beautiful as the music room.

Then there was my father's profile—my father about to drive right by! His hat, the set of his jaw, the black frames of his glasses! My father at the wheel of a strange car, my father who had come for me even if he was slow to turn his head and see me. Then he did. He was not smiling, that was all right, he had *things on his mind*, fathers did, I had hold of the door handle and it opened, it swung wide and I was hoisting the violin case into the silence, nudging it over between us with my hip, ducking my head, saying *Daddy* while fitting my cold self in, swinging the door shut, hearing the good click, feeling the car pull away from the corner, looking down at the neat white toes of my saddle shoes, realizing the radio was off when my father always had it on because he needed to know how close the Russian missiles were to Cuba, he needed to keep them from getting there at all costs, hearing the driver say *Little girl, I'm not your father.* Not believing it. Looking once, fast, closely at the face of the man driving, who was not my father. Saying *Oh.*

Knowing I had not paid attention.

Saying *I'm sorry.*

He said *I'm going to have to let you out.* I didn't say anything. He said *I think the best thing is if I drive around the block and let you out right where you were.* He must not have had any children, he had none of the ironical, rebuking style of intimacy fathers then showed to other people's children, as if all children were slightly in the wrong and it was natural for a father, any father, to point that out. Besides which, suburban fathers knew the most private things about all children. A father might say *So I hear you hate your new baby sister*, and that would be seen as

winsome proof he was good with children. This driver who was not my father was not using the droll voice of a charming father. He wasn't ingratiating or comical. But maybe he believed those things would have scared me even more.

I said again that I was sorry.

He didn't answer, he didn't tell me it was all right.

I didn't want to turn my head to really look at him because the quick glances that were all I'd seen so far were dismaying: he was more and more absolutely not my father and that fact was gaining in shockingness. He had not said *Put your seat belt on*. I looked down at the matching scuffed white toes of my saddle shoes since they at least had not changed and I needed something known and stable and if all I could have was the toes of my shoes I would take that. He wasn't saying anything. Very likely he could not think of anything to say that would not worry me. I was aware that the words *It's going to be all right* had not been said and that nothing like them had been said and there had been no reassurance and I was beginning to think of him as a strange person, though that was a dangerous thought to entertain. His spare sentences were only his thinking aloud about what ought to come next: *I'm just going to drive right around the block*. I believed he was angry at having to go around the block and out of his way. I could tell some routine had been broken and the rift threw him off balance, like my mother whenever I wrecked a plan of hers. I understood that for certain adults any measure of uncertainty could generate great, formal-seeming anger. Was he in fact angry, was he unsure? I wasn't going to be able to tell. I couldn't bear to look at him because he was anguishingly himself and not

my father. He didn't want to talk to me. He wanted to drive around the block to let me off right where I was before and that's what he did. As his car pulled in alongside the corner a station wagon nosed up behind it and at the station wagon's wheel was the incredulous face of my mother. I threw the door open, jumped out, slammed the door of the car belonging to the man who wasn't my father, and looked through the window at him. He looked back. He didn't seem bothered or in a hurry now that I was out of the car at last. Neither of us wanted to stop looking because now we *could* look and all the looking we had wanted to do was present between us as we tried to tell each other it was all right. It was all right between us, unlikely though that was, and it was always going to be all right. It was just two people telling each other in one long look that nothing had gone wrong and in its way that was the most essential look I've ever exchanged with anyone. The station wagon rolled forward to urge his car to get a move on, and it did, it turned the corner and was gone, and in its place was the station wagon whose door I opened and my mother saying *What did you just do! Who was that? Where is your violin!*

Because it seems to ground compulsion in an identifiable cause, I sometimes catch myself thinking the instructions arrived that night, as compensation for my losing the violin. Reality, distaining such a legible association of cause and effect, imposed weeks of depressed remorse. My sense was of having lost the thread, of no longer understanding what was wanted of me, or how to live. Only then did the instructions descend.

Ever since we had moved into the house I had gone up and down those stairs without thinking about them, because they were just there, the stairs, a way of getting from one part of the house to another. If the stairs held any meaning it was only the kind of meaning shared by every aspect of the house, which was something like the meaning my own body held for me: like my body, the house was an abiding presence, a given.

Some weeks after the violin night, something woke me. Barely had I gotten out of bed and gone to the foot of the stairs to face upward into the silence of two a.m. when, as if they came softly down from the high shaft of darkness under the roof, the instructions made themselves known. Detailed, sourceless instructions I recognized at once, not because there had ever been instructions about stairs before, but because the conviction they embodied was very, very old and went extremely far back in my life. They were instructions for returning to the rightness of the time before you were a recognizable self, the time when you could not be blamed because you were, as yet, only dark need bound in babyskin. Need, wild need, was going to drive me barefoot up those stairs, across the landing, up the second flight, on whose uppermost stair a ritualized pivot had to be preformed just so, and silently, every breath silent and every footfall silent on the way back down and across the landing where footfalls required tact because the linoleum was tricky and could squeak, then the lower flight, all the way down to the chilly floor of the hallway, where I turned again and again started up, and it was all crucial, every step needing to be done perfectly, but the

most exigent part, the cruel essence, was the ascent, because it required uprightness, chin high, no touching the stair rail, no sound of breathing, the ball of the foot no sooner meeting the nap of the carpet than it took the weight shifting from the poised lower leg, right and left swapping effort back and forth, the ligaments behind the knees emerging, cording, strengthening night by night, metatarsals emerging, too, the long toes monkeyish with seeking and pushing off, the bones of the ankle whittled sharp, the muscle running slantwise down the inside of the thigh refined, and the one thing the instructions didn't say was how long, each night, this was supposed to go on, how many ascents were enough. There wasn't a number. Just as it had generated its own laws, obsession determined its own nightly duration, to which any perfection I could achieve was irrelevant. My proper role was not that of a striver who could succeed in completing a task, but of sustained and, in a sense, impersonal attentiveness to what it wanted. There was a recognition—*enough*—that came and closed it down, and then I could go to bed. Some nights an hour was all that it wanted. Other nights I climbed till almost light. One remarkable absence was uncertainty: below the ongoing annotation of errors ran a steady sense of sureness about what I was doing and what was wanted of me. Another was thought, because the absorption of climbing didn't allow for thinking in the ordinary sense. But it wasn't a vacant state, it was highly alert. Concentration was lucid, intense, confined to details of execution, to the placement of a foot or the tight grace of a pivot. Whether this was going to go on for weeks or months or years, I never wondered. To articulate the question *How*

long will this last? would have struck me as a possibly danger-
ous affront to the source of the instructions.

Plenty of nights I was sick of climbing the stairs and lay listen-
ing for my sister's breathing with hatred because the element
that cast me out cradled her and didn't let her go. I would
lie awake while urgency, crackling and diffuse, collected its
strength. If I concentrated I could hold it off for some time.
My opacity to myself drove me to push back against the ur-
gency, but this pushing wasn't a reasoned attempt to escape
its hold: I never wondered how sane or insane it was to be in
thrall to a set of irrational instructions. In resisting acting on
the obsession I wasn't trying for sanity, I was only trying to
experience its terms with greater bareness of soul. There was
pleasure in making the obsession show its full force before I
had to get out of bed, bare feet meeting cool tile, and go out
the bedroom door and down the dark hall to the foot of the
stairs, which were always there and always themselves and
always indifferent to what I needed to do. How was it possible
that a hundred, two hundred nights' climbing had left them
unchanged? That no one in my family noticed? Could such
odd behavior continue unseen forever? Was the failure to per-
ceive anything wrong a failure of love? Or did my stealth and
deviousness prevent their seeing?

Other nights I felt almost a kind of sympathy for the ob-
session, as if it led an existence apart from me. Those nights I
had some sense of its project—perfection—being immutable,
and of my having happened to be available, and of its needing

to work with what it had. A feeling, certain nights, that I was cut out for this. The rightness of cautiously, silently, without putting a foot wrong, meeting every expectation held by— held by whatever required my submission to this endlessness.

When it came a year or so later the end wasn't distinct enough to engender relief. Once or twice, then several times in a row, I slept through the night, and then, without my realizing I was done climbing, no more instructions came. But by that time they had ceased to be instructions at all, and had become the way I was.

Only when my last analyst, the one I ended up marrying, only when he told me—scolded, really—that I had a good mind and ought to put it to work in support of my therapy, when in his voice a mere forward slash separated the admonition *Read* from the warning *You might try approaching this*—my perfectionism—*as if it could be understood*, did it dawn on me I'd been wasting time: a writer who needs to be told *Read* is a glazed-over idiot, all these years I could have been researching, I could have walked into his consulting room knowing so much more, could have been a more compelling analysand, one who didn't rely for salvation entirely, excruciatingly on *him*, even as I said *I kind of thought it was cheating*—, even as he shook his head, even as I said —*to read on my own, I thought the insights wouldn't connect, would only confuse things, would*—, even as he went on shaking his head, even as I said —*amount to another form of resistance*, even as he went on shaking his head I inwardly criticized him for his casual refusal to be everything

I needed, for his readiness to throw me back on my own self, which could always, *fuck you*, read, but I did not want to be alone with books, I wanted to be with him, wanted him to *want* me to trust his insight and his alone, not books'—wasn't the work in this room supposed to be accomplished through love, which when modified by the adjective *transference* was nonetheless love, hadn't my life held enough books and insufficient love, why was he asking me to do things on my own, but okay, from the cardboard box that had made it through every move since New Mexico I dug out a tattered *Interpretation of Dreams* with its account of the father who dreams his son is crying out from the next room *Father, I'm burning* while his son in the next room is burning to death, the father struggling from the depths of sleep too late to save him, *What good are dreams if they can't help you save your burning child*, I asked my last analyst and he said *The dream did try*, at his suggestion I turned to object-relations theory, Bowlby's *Attachment and Loss* trilogy led to Fairbairn and D. W. Winnicott, *Is this doing any good?* I asked him and he smiled, he could tell from my voice I already believed it was.

Nicholas W. Affrunti and Janet Woodruff-Borden observe in "Perfectionism and Anxiety in Children":

> *Intolerance of uncertainty may link perfectionism with anxiety disorders because the high and rigid standards and perceived negative consequences that occur in perfectionism make uncertainty a fearful prospect. In uncertain situations,*

*perfectionistic children may be unsure if standards have been
met, creating fear and worry about the situation. This in-
creased distress may in turn increase their risk of devel-
oping an anxiety disorder. This may be especially true
for generalized anxiety disorder and OCD. For example,
perfectionistic children who are also intolerant of uncer-
tainty may engage in worry or compulsive behaviors in an
attempt to reduce distress around uncertain situations.*

The existence of a lost tribe of perfectionistic children is news
to me—how many were there? What rituals did they invent?
But "may engage in compulsive behaviors" sounds as if the
behaviors are lying around waiting to be picked up; in "may
engage in" the child is not active, not the deviser; even the
simple word *may* obscures the uncanny instantaneousness
of compulsion, delivered whole into the life of the child, and
while I'm grateful for the passage, it omits the enigmatic in-
ventiveness of compulsion, an inventiveness it puzzles me to
recognize as my distant but unmistakable own. Well below
the threshold of awareness some part of me dreamed up a
weird, strict ritual and wrote it into my consciousness as if it
were holy. Despite the self-hatred that daily dismantled ini-
tiative, that obscure, authoring part of me must have been
solicitous toward the rest, and wanted to save it: what I seemed
to be witnessing retrospectively was the love some unknown
part of my psyche held for me, because look, it had devised
the means for enduring searing uncertainty. The more I con-
sidered those nights from the vantage point of adulthood,

the more stair-climbing struck me as a marvel of anti-self-destructiveness, it was silent, it was neat, involving neither razor blades nor glass and never needing cleaning up after, unlike self-starvation the loss of sleep can remain basically invisible, in the morning the stairs were pristine as ever, my mother and father went up and down unworried, no one else was sucked in, it knew there had to be an end, and it *ended*. From what well of intelligent love did it issue, this strange rescue, and when will the genius behind it size up perfectionist suffering the way it once sized up uncertainty and say *Enough is enough, here's your way out*?

Eighteen, if barely, and away from home, if barely, having gotten into college, barely, and for reasons of its own the surveillance state inside my head narrows its scope of operations. Its remaining rituals, rather than flagging me as crazy, pass as the worthy drudgery of femininity. The diatribe audible under the blow-dryer searing my contrary hair to straw-straight Joni Mitchell hippie-angel lankness runs *Kinks all underneath, maybe they won't show, eeeeww, tendrils, there's that bendy S-wave, put your head under a faucet and start over*, but outwardly I'm only one of countless girls pitting themselves against their hair, their thighs, their bellies: perfectionism has raised a stark tower from the cornfields to house its captives. If you get on an elevator and start in about how you woke up horrendously bloated, your fellow passenger might yawn before telling you *You're crazy*, and she wouldn't mean *crazy* as in menacing or abnormal, she'd mean crazy like *I understand exactly*

and might go as far as pointing at her chin and saying *How disgusting is this*, and when you say *What* she might say *Don't pretend you're not about to throw up* and when you say *What, that tiny tiny pimple?* she might say *Oh right be kind to the leper.* Booklets listing the calorie counts of foodstuffs—*egg (large, scrambled) 102, graham cracker 59*—receive stricken exegesis, *Oh my god, I ate x yesterday, I ate y, I actually ate z!*, while down the cafeteria tables girls' trays are assessed sidelong for further sins of indulgence. Down a hallway, from a half-open door, a voice heckles *Pretty, pretty. Such a pretty, pretty, pretty girl.* Girls strewn everywhere, lounging on basement couches, daubing wrists with sandalwood, emerging from clouds of Aqua Net. Baby-oiled girls sprawl on towels across the roof of the dorm, flicking through *Vogues*, their backs a varnished violin array.

I regard my diminished perfectionism with the cold eye of a firefighter discovering a wildfire's last embers sparkling in tinder-dry grass. I don't know where it will rise up again, but I know it's going to. There are panic afternoons when, instead of taking the elevator, I choose the seven flights of steel stairs to my room, barging up the stairwell whose cinder block walls resound *pang pang pang pang*, but before long my drive slackens, my weak-winded pauses taunt the echoing stairwell to slap me with instructions. The future could be lit by secret rendezvous with perfection, shaped by the need to start over and over from the bottom of the stairs—but for seven *Come and get me* flights, instructions fail to materialize, and when I let myself into room 777 rank and panting, calmed by the

near miss, my roommate says she wishes she had the discipline to work out after classes, too, because look at her behind—she pivots, shirttail twitched aside—*Look!*, denunciation of oneself properly countered, as I counter now: *You're crazy!* I go further: *You're beautiful!* She is, but who, in our world, believes it? *Mouse*, she calls me, a salute to my smallness and tendency to slip down the hidey-hole of a book. Lately this is the paperback *Sisterhood Is Powerful* I've taken to carrying everywhere, its front cover's clenched fist within the Venus symbol gloriously confrontational. *Mouse! Leave the boy-kryptonite here!* my roommate hollers when I'm leaving the room, and we laugh. Her mock consternation celebrates the boldness I'm only raggedly capable of, as well she knows. *Mouse* refers, too, to the fugitive air conferred by damage. Often when someone notices this they will declare *Oh! You're shy* with an air of having nailed down what's been bothering them, but it's not shyness, it's instead the communicativeness of suffering, an inward plight willing itself into visibility. It's my signaling that I should not be esteemed they pick up on, signaling mostly encrypted but occasionally—more and more often—conveyed in a remark too awkward or hurtful to go unnoticed. Strange to be involuntarily *bent* on such signaling, crazy to feel inwardly meticulous, outwardly hapless. To be, willy-nilly, an asshole: my slips of the tongue have a brashness impossible to reconcile with delicate slantwise *me* of my envisioning. My Tennessee cousins had owned a book I coveted, a volume of fairy tales, one featuring rival princesses, and when the sweet one spoke pearls and rose petals floated out, and when the unsweet one parted her lips snakes' heads darted

forth, toads tumbled free, a story I read over and over as if the text might mutate and the unsweet one's mouth produce four-leaf clovers, sapphires, a goldfinch fluttering gladly away. How repellent, the toads that plop from my mouth. How irremediable their alterations of trust. Unlike the person I've just managed to offend, I have no right to incredulity. *You've got a smart mouth on you*—this favored rebuke of my dad's sounded as if an alien mouth had been slapped across my face and my failure lay in failing to scrape it off. At our small college, a fair number of freshmen drop out to return home, a doom I'm often tempted by, but which my parents' foreseeable dismay rules out. Besides, the cloud movie in our seventh-floor room's huge plate glass window is driftingly addictive, swags and boilings-up of shadow and radiance, lightning in nerve-bright internal strikes. I don't want to give up my ticket to that or other visions: Joni Mitchell steeped in blue on a record jacket; the philosophy professor, rumored to be a lesbian, whose Levi'd amble I've more than once trailed across campus; the golden broth in white bowls clonked down on Chinese-restaurant Formica; the fortune cookie slips my roommate tapes to her mirror the next morning. Toward my blurted weirdnesses, she remains fondly detached, even amused, given to crying *You crack me up, Mouse! I just love you!* Such lavish acceptance thrills and disorients me, and when others are its beneficiaries, I decide it's my business to rail against her tolerance. *So naive*, I say. *You're asking to get taken advantage of*, I warn when her sweetness embraces yet another unworthy, *you're being hugely unrealistic*. She teases back *Mouse! So mean!* But that her paradoxical gift for being both unfooled

about someone's idiocy and accepting of them might be humanely *realistic* is a possibility I'm steadfastly ignorant of. Too bad, because as if to compensate for the ebb in self-laceration, my critiques of others have grown more scathing—maybe perfectionism is its own universe in which energy can be neither created nor destroyed, only differently manifested. Other-directed perfectionism had little point in my parents' house, that nest of rival perfectionisms, but now it magnifies acquaintances' offenses, tacks despising footnotes to interactions, shuns further contact. Yet with her, all is well. In our cinder-block-walled cube with its scrolling cloud movie, she and I are rarely more than seven or eight feet apart, the only easygoing proximity to another person I've experienced. Can more such closeness be found, can it be made to last?—it might, if I were capable of learning from her, if the paradox could be absorbed like the lotion I sometimes, in her absence, tip from the bottle belonging to her and rub into my skin. Kind. I want to smell kind. And then one night when an anti-Vietnam protest winds down into dancing in the street, a boy dawns. A boy I've seen around, though he doesn't look like he belongs. *You shoulda heard him just around midnight!* he sings over the shouting, and I hear, I do, I hear the *Who are you?* stretching between us, its tension underwritten by his shit-kickers versus the metatarsals of my ballet-slippered feet, whose readiness to be stomped on worries me, in my head I'm thrillingly injured, fantasizing his remorse, the dismantling of his stoned, genial flirtation, its replacement by a recognizing tenderness. Against the clamor I shout *Watch out!* and when he cups his ear I shout *My feet!* and he shakes his head

and smiles and what does the smile *mean* when he needs to be paying attention and why does a blue-collar-looking local show up at college kids' shambles of an anti-war rally anyway, why turn up in what must be his work clothes, though his shirt has been lost somewhere—did he take part in the protest? The loitering impudence of his dancing argues no way. That it wouldn't be *like* him to chant along. Not a joiner. And if it's a case of missing not classes but work, he wouldn't risk arrest. It's newly dark, the asphalt's tacky warmth littered with discarded posters. Within the thrash we maintain a two-person cove, the opening only we inhabit, barely bigger than our bodies. Another girl might shout at him to fuck off with his shirtlessness and his tar-stained boots and his drifting ever closer. *Watch out!* I shout again, pointing down. He smiles till his eyes almost shut. I'm a little furious. *Who does he think he is!* splutters through my head, and I laugh, and having no clue why, he laughs as well, and since we've gotten this far and might be able to ride out the embarrassment of his catching me staring, I let my gaze dip to the asymmetry that's been nagging for attention, the cyclops gaze of his pectorals, my transit through disbelief-revulsion-pity is quick, almost at once I accept that where his left nipple should be a slant of keloid scar rises instead, damage you can touch but I don't, dancing has accomplished its transformation, our bodies' conspiracy a done deal. Our horizon teems with bobbing heads as if an ocean liner has tipped its hundreds into the sea. Several minutes elbow past, in our cove we are nudged and buffeted, I'm worrying for my feet when his boots' seen-but-not-heard thudding tilts from scary to unerring and trust blinks on, I

have no idea how but without looking down he knows where we—the four-footed *we* of our close fit—are. I hope this is true. The lift of a chin, the torque of a shoulder imply we are still dancing, and it comes to me to step up onto his boots. Lightly. Who do I think I am? He shuffles, teasing. I grab hold of his shoulders—heat. Where is his shirt. His arms close around me. Heartbeat.

He is a student, it turns out, but also a local in the sense that he lives in the attic of his family's gingerbread Victorian on a street of century-old sycamores and oaks. When his parents go to the Virgin Islands for ten days and I spend those nights in his bed on the floor, we wake to birdsong, though *song* scarcely seems to cover this bombardment. *It's crazy*, I tell his barely awake back, and he rolls over, props his chin on his forearm, and answers *What's crazy is you never heard this before.* Downstairs, he scrapes what's left in a can into the bowl belonging to his mother's toy poodle and holds the fork for her to lick, cooing *Sad so sad oh I know ain't no sunshine when she's gone.* To me—in just his shirt, and of that shirt a mere two buttons buttoned, I'm in a movie of my own, it's a French movie, I Brigitte Bardot my way across his mother's kitchen—he says *Not too broke up to eat though, is she.* He gives the bowl a nudge; she growls through the skittery swivel necessary to keep her nose down in the food. *The dawn chorus*, he tells me. *We've got to get you out of that dorm more often.* After the family dairy farm in Minnesota was auctioned off by the bank and *we could have gone anywhere—California, even*, his father had picked Normal, Illinois, on the grounds that a university is always going to need welding. His dad is a welder turned

contractor, two years from becoming a millionaire, at which point they'll pack up and move again, this time to a modernist ranch in the town's second-fanciest suburb, wall-to-ceiling windows his long-legged redheaded mother tends with crumpled newspaper and turquoise Windex, shag carpeting, fieldstone fireplace, basement apartment kept immaculate by its tenant, his older sister; for his parents a chandeliered Vegas suite, king bed lorded over by the toy poodle; and for his father alone, supplementing the big welding shop on the town's industrial outskirts, a converted garage where the snarling of power tools causes no disturbance and neither do the Playmates staple-gunned to the drywall.

He's three years older than me but still some distance from graduation. The problems he's run into in various classes are due to his working essentially full-time on a roofing crew. If he asked, his parents would pay his tuition, but a predilection for working hard runs in his family, and he prefers the exhaustion of the body to that of the mind. He may believe his father esteems him more for holding down a job while finishing the BA in business administration his self-made father doubts the need for—not aloud, because that would be hurtful, and in his family they're not hurtful. In the years between that morning in the kitchen and my early completion of my own undergraduate degree, I spend as much time as possible—more than my boyfriend wants us to—in that old Victorian and the fancier house that comes after. Often I feel like a spy sent to figure out how they manage such nonhurtfulness.

———

Part of his charm turns out to be that he's less reliable than I'd assumed—less interested in *being* reliable, in fact superstitiously inclined to relish whatever harm befalls him as fated. Working as a roofer entails risks to his body, his face, to his beauty, because he possesses a blond, small-scale, straight-browed masculine beauty that leaves him indifferent, worse than indifferent, it's as if he's had to filthy it up: his forearms and knuckles are welted and scarred, his nape bears a permanent redneck burn, his nose broken three times, maybe four, and on the muscled chest so taut-skinned it's almost glossy, the rude keloid welt left when a doctor, without explaining what was about to happen, much less asking the boy's—his— consent, removed, along with the nipple, the ominous black mole impinging on it, whose growth had scared the boy's long-legged, redheaded mother, who for some reason permitted her son to watch as the nipple was excised, forceps depositing the gore in a stainless steel tray the nurse whipped out of sight, not before he thought *That's mine,* and next the boy—he—observed the blotting, the soaking up of blood, the margins bound like lips sewn shut with black thread. *And so?* I ask, and he says, puzzled, *So? So was it cancer?* I ask, and he says *I don't know if they tested it. If my mother ever asked,* and I say *So it could've been for nothing.* He nods. *Could have. Yeah. But that's how they were then. Just went ahead and cut it out of you.* I say *And never a sign since, of anything?* He says *Nah, never any trace, if it was I guess he got it,* and though the complete eradication of cancer, if that's what it was, might serve as partial justification for the peremptoriness shown by the doctor, it's in saying *He got it* that his voice turns hostile. Not far below

his easygoingness lurks a compressed truculence, but predict-
ing its appearances is then and will always be beyond me. Oc-
casionally his old Chevrolet breaks down, and when we are
halted on the road shoulder he gets his tools from the trunk
and tells me to pop the hood so he can prop it open with the
long metal rod and then leans in over the engine and then as
if the problem is bound to defeat him he walks away to smoke
a cigarette. If we are out in the country he doesn't bother with
the road shoulder but saunters down the middle, and even if
there hasn't been another car for hours, even if an approach-
ing vehicle will be visible well before it reaches him where
he stalls, smoking and musing, on the yellow line, this habit
of his unnerves me, he turns stubborn when I try to talk him
out of it and says he's always done it and it's always helped him
think, in the passenger seat I keep twisting to study the road
behind, it's as if I fear some invisible car might come at him,
or a car that for whatever reason causes him to stand mesmer-
ized as it closes in, or maybe it's him I don't trust, it's not hard
to imagine him choosing to stay where he is, facing down an
oncoming car, the lord and owner of the two-lane highway,
fixed in place by the daredeviltry that overtakes him out of
the blue, in the passenger seat I am continually imagining the
wind-suck of some stranger's car furying past, inches to spare.
He comes sauntering back, he fixes whatever's wrong.

When he gets his own place, the second-floor apartment of a
run-down Victorian across town from campus, I seize the
chance to move out of the house I share with five other sopho-

more women. Their membership in a sorority as yet unable to offer them housing unifies them, while I'm a stray. The smallness and undemandingness of our college attract the ambivalent, plenty of whom fail to return for sophomore year, among them my freshman-year roommate, who had written from Cortez, Colorado, saying that her brother got drafted and under the circumstances her parents decided a community college would suit her better than faraway Illinois. I send her my copy of *Sisterhood Is Powerful*, she sends a Polaroid of herself and her brother, two sunburned kids bareback on an Appaloosa, and though it's two or three years before I quit writing, that's the last letter I get back. I never find out if her brother got home, or whether she was able to realize her plan of attending nursing school. Thus I end up among the sorority sisters, whose ritual is to stop whatever they're doing for the *Star Trek* reruns that come on every weekday afternoon at 4:30; they've planned their course schedules so they can sit cross-legged painting their toenails, eating popcorn, speculating about what Spock would be like in bed, they've never said so much as an unkind word to me but I'm crazy to get out of there, and when I pack up and leave, the scandalized landlady writes my mother and father to inform them their daughter has moved in with her boyfriend, and my mother and father drive down to Normal, phoning, first, to arrange to pick me up at the house I've left. To my surprise the other girls had been willing to perpetuate the sham of my still living there. When the sorority sisters—even opening the front door, they do in the plural—greet my parents, the sisters must appear hurtfully poised, other people's obedient daughters, their small

talk prettily effusive in contrast to my hanging-back awk-
wardness. After five minutes' *So nice to meet yous*, they ask if
I want to go for a drive, an invitation that alarms me by *be-
ing* an invitation. Since when have I, their child, needed po-
lite asking? And since when did *we* go for drives? The tens of
thousands of miles we'd traveled in our station wagon were
mapped out in detail; every drive had a point. We didn't just
wander around wasting gas, but the conversation they have
in mind would have been impossible in, say, a restaurant,
where my taste for what they call *overdramatizing* would be
bound to excite strangers' curious looks. Their dread of my
making a scene explains why I am alone, in the back seat. Lis-
tening. What I've done, moving in with my boyfriend—it's
wrong. I am disgracing the name Tallent. I have a choice:
either I move back into the house with the other girls, which
they are after all paying for, or my mother and father want
nothing more to do with me. Through a sear of incredulity
I hear the words coming out of my mouth: *Then maybe it's
time I was on my own.* One of them might glance back, trying
to guess how likely I am to stick to my guns, whether doubt
or remorse figure in my expression, which might imply I can
be persuaded from my resistance back into the fold, not that
it's ever been a fold but one of them might need to turn to
look before the break is declared final, but my father has to
keep both hands on the wheel, which leaves only my mother,
every cell in my body summons that turn of her head, and
when it doesn't materialize, when I'm not looked back at, I
feel a slippage, a rupture. There's a lot of fury in that car, but
it has a floating irrelevance: no one lays claim to it. So is this

how such things happen. My father could have driven us out of town into the country, whose winter-dismal fields and far horizons would not have offended our despair. I regret—I'm guessing we all regret—his having chosen instead the darkening downtown, and then, once the danger of our getting complicatedly lost emerges, picking a random block to drive around, right turn after right turn after right turn. When he slows for one such turn, I half fear he's going to ask me to get out. Maybe I half hope he will, as the theatrical culmination of their—their what, their *disowning* me. What else is *We want no more to do with you?* I could have stood on the wintry corner in my thrift shop overcoat, in bell-bottoms whose hems tent out to hide my ballet slippers, and wept. Tears could have run down my face, I could have licked them from the corners of my mouth and wiped my runny nose on the sleeve of my overcoat, overdramatizing like crazy, and it would have been better, far, than having to sit thus, politely cast out, in their back seat, suffering through this prolongation of their refusal to look back. My wounded disbelief insults them, as yet another failure to take them seriously, to honor their convictions, my simply being *still there* in the back seat forces them to feel my unwillingness to take back a word I've said, this is taking forever, how long can anyone stay lost in such a small town, I call out a turn when I recognize it, but mostly I'm lost, too, and when we discover the street leading to the sorority sisters' place, our shameful destination, we probably think separate versions of *Thank Christ*—theirs would not be profane—but now we're here, look at me, I'm going to have to open the car door and step out and come up with the last

words I'm ever going to say to my mother and father, and how can I do that, what are those words? I get out. Nothing comes. I close the door.

Disgrace—the word caught me off guard. Still, from their perspective, as I even then understood, the betrayal was mine. Suppose I honored them as a daughter is supposed to: I would respect their wishes for my virtue, and other, unvoiced wishes I was only guessing at, wishes that had to do with social respectability, with class, intimations that a roofer boyfriend was not the partner my quasi-promising future required. That he loves me with steady incandescence, that he never tires of me—the saving grace of him, even if I could explain it, which I can't, was bound to appear insignificant when held up against their conviction of having been wronged. *Disgrace*— their relying on the coerciveness of the construct both pisses me off and scares me on their behalf, it shows so little grasp of the way people—the way *I*—work. And if they didn't know that, if they couldn't anticipate the resistance their threat was bound to excite, then what could they be said to understand at all? That might have been our crime: barely knowing each other. But it's not a crime you can convincingly accuse anyone in your family of.

Nineteen: now the only income we have is the money he makes working on roofs. As far as family I'm down to him. Though a lone B+ can prove fatal to the grad-school applica-

tion I've started daydreaming about, my grades falter, in sem-
inars my inattention is chided, certain mornings I fail to get
out of bed. *Let's go for a drive*, he says, and we learn the coun-
tryside for hundreds of prairie miles in every direction from
Normal. I like sitting with my knees bent, the toes of my bal-
let slippers on the dash, his eyes on the road, at peace, the two
of us, absorbed, the two of us, by what we're doing, though
driving doesn't feel like *doing* exactly, more like being *caught
up in*, how sex can feel when you pass a certain point, and
though as the passenger I'm making no effort to do anything
and neither can he as the driver be said to be exerting him-
self, whenever we are driving we have the conviction that the
two of us are *making something*, what binds us is the conviction
not only of *making* but also of some necessary burning away,
of peeling down to who we are at our deepest, his cigarette-
holding hand steadying the wheel, and for me being along-
side him feels like being alive to the exact degree he is, there's
something bold and gainful about simply facing the way he
faces. "It is the space between inner and outer world, which
is also the space between people—the transitional space—
that intimate relationships and creativity occur," writes D. W.
Winnicott.

Twenty: because skipping my last semester of senior year will
save on tuition, because whether he's ready to leave his home-
town or not I'm desperate to get out, I apply early to graduate
school. To several schools, but only one matters. A single pro-
gram controls the territory where I want to work. In the high

desert of the Four Corners, directorship of archaeological digs is assigned exclusively to their graduates—to those exalted beings with PhDs from the University of New Mexico.

The evening after I mail off the application, I ask him whether he will come with me if I do get in, and when he doesn't immediately answer I say *So you'd break up with me?* He says *It'll be you who packs and leaves.* I say *You've got your degree, too, what's keeping you here?*—completely unfair, since I know very well how hurtful it would be for him to tear himself away. He says we're going to need to talk more. To my disbelief he seems to regard graduate school as another, longer archaeological dig I'm going on, during which he would continue working as a roofer, writing letters, driving crosscountry to see me. I want him to regard separation as a calamity. I want possessiveness from him, jealousy too intense to risk my being out of sight. His good-son trip is less charming, now that it threatens to lock him in Normal. His needing time, his wanting to talk trouble me. *You have to tell me now*, I say evilly, and he says *Let's go for a drive, want to?*

You have to tell me.

Why, when it's going to be weeks before you hear?

Because I can't sleep, not knowing how this's going to go.

You slept fine last night, he points out.

I would spend more time scared of losing him, but I mostly don't believe this slim hope of grad school has the least chance of coming true.

But it does, and amazement at my having gotten in—been *accepted*—erases the ambivalence that haunted the process of applying. My undergrad adviser was a revered Texas

archaeologist known for his pranks and bestowal of nick-names, and when he first casually called me Clementine, my thought was not *Why Clementine?* but *Coulda been worse.* Clementine was lost and gone forever, exactly what I wanted to be in relation to everyone in the Midwest. According to my adviser the University of New Mexico's archaeology program was harder to get into than Harvard Law, and I ought to hallelujah myself hoarse, the more so since my grades could kindly be called lackluster. He had saved my bacon with the most righteous letter of recommendation in the history of letters of recommendation.

My boyfriend's proposal is *For me to come with you to New Mexico, we have to get married first.*

My desire to be an archaeologist is an ambition people puzzle over, asking questions I'm startled to find I have answers for: the response to *Grad school! You must really be smart then* is an apologetic claim to freakish good luck, while the aggrieved challenge *Well you're not likely to make much money doing that* calls for rueful concurrence. *So,* someone will say. *So—you like bones?* For once I know how to disarm the Midwestern readiness to feel injured by another's strangeness. I seem to have assembled the ingredients for adulthood. Marriage helps my credibility, as does my husband's having a bachelor's in business administration; his level-headed degree weights the pan of the scales opposite far-fetched archaeology.

———

My mother-in-law lit a cigarette and towed the pine tree through the snow, dragging one-handed while her little dog barked after her from the garage. Instead of shoving the tree up over the curb's steep snowbank into the street, she stopped. I'd believed her incapable of leaving a task half done and when she dropped the tree I was a little offended by this last-minute deviation from who I understood her to be: What was she doing, confusing things now, and would there be worse to come? She stood out there smoking while her dog ratcheted up its barking, ruining the street's five a.m. *O little town* stillness and the perfect getaway I was trying for. My nonchalance in climbing out of the car failed—the dog skidded away to face me rigid-legged, its barking turned personal, harsh claps of denunciation raked from the bottom of its lungs, jolting it backwards. *Carrying on like this,* I told the dog, then thought how Midwestern that was, gerund as rebuke, fragment as accusation. My husband and I were not simply leaving town. We were going as far away as we could get: New Mexico. My mother-in-law's back was to me, but I could tell her left hand had characteristic hold of her right elbow, a hip-slung, outlaw pose, her right hand moving the cigarette toward its Revlon-red kiss—the morning following the heart surgery awaiting her five years down the line, the surgeon would enter the waiting room to report *She's conscious and asking for lipstick* and then stand waiting for the laugh he'd anticipated as her daughters began scrabbling through their purses, comparing their uncapped shades, saying *Ugh, no* and *She won't think that's red enough* and *In the ballpark?* Theirs was the only family other than my own I'd ever seen the inside of, and I should

have learned more from them, but instead of amazement at my mother-in-law's honesty or gratitude for her acceptance, I nursed a viper of condescension under my black thrift shop sweater and copied her most foolish and naive remarks down in the spiral-ring notebook I'd been carrying around ever since the directors at the Texas archaeological dig required an hour of note-writing a day. My mother-in-law had been seventeen when the son of neighboring farmers returned from the navy as a lieutenant and proposed. In her dealings with her husband and grown children I never saw her hold anything back. Love as plain as that ought to have made her wonderful in my eyes, this redheaded mother out there at the curb with the Christmas tree, exhaling wraiths of smoke, this person deeply, disobligingly herself. Whoever she was, out there in the dark, I was married to the repercussions and echoes of her uncensored largeness of heart. The whole time she stood out there smoking, her dog maintained its shattering performance. Finally my mother-in-law came tramping back into the garage and cradled the little dog against her chest, saying *What's got you so upset,* flicking ash from its topknot, watching dry-eyed while my husband finished giving the Chevrolet engine a final going-over. His Saturdays since the wedding had been spent leaning in under the propped-up hood to make sure the engine was good for the twelve hundred miles to New Mexico, where I was due to start school in five days. As long as we didn't get held up by storms in the plains we could make it; without yet having driven a single mile, we shared the pleasing riskiness of cutting it close. As a couple we disliked responsibility and often relied on an emergency flare of

desperation to get things done at the last minute. The inside of the car was a shambles, jammed to its vinyl roof with my blaze-orange Samsonite graduation-gift luggage, boxes of books and dishes, clothes bundled straight from the dryer into garbage bags. The trunk held our newspaper-wrapped pots and pans and our army-surplus parkas laid over a rabble of sneakers and high heels and the tar-stained boots of our first night, with, for bedrock, a wrestling trophy and carpenter's tools wedged in around the spare tire. The black toy poodle in my mother-in-law's arms kept tipping its head back to lick her chin. Whenever it did she would say *It's okay, Peekie*, and the dog would lick her chin while she held her cigarette off to the side so as not to bother its bugged-out eyes. I had been around long enough to have witnessed her grief when the previous Peekie, let out the back door for the two a.m. pee necessitated by its advanced age, had failed to return. After hours of flashlight searching it was concluded that a raccoon had gotten the little dog. Within a month my father-in-law brought home the downy black handful of purebred puppy who grew into the current Peekie. My husband slammed the Chevrolet's trunk—the fishhook bottom of the first *J*, the only letter visible in a chink between piled boxes, was the last trace of JUST MARRIED left on the rear window—and reached around the dog to hug his mother's shoulders; she held her cigarette aloft so as not to burn his hair. When he got in behind the wheel we grinned at each other. The whole ravishing drive lay before us, the hard plains states we would drive through, nights whose stars would come out for us, motel beds we would set creaking. We could have rested like that for a while, on the

brink, but my mother-in-law would have wondered what was wrong, and it fell over us, the mood of finally really needing to say good-bye, and she came to the driver's side and handed in some money. My husband said *Hey this is five hundred dollars, Ma.*

When she bent closer her dog licked his nose. *Don't stop at just any motel, you look for a nice one.*

You can't give us five hundred dollars, Ma.

For just in case.

Mom, hey, Ma, we'll be—

My bingo money is mine to do what I want with.

We didn't feel bad, we just didn't feel as good as we had a minute ago. We were reminded of all we were going to need to pay for.

You kids be safe.

It was like something was taken from us, our having to say we would be safe, something we wanted back, which might be regained if we set off after it in a hurry, but we only got to the end of the block before he stopped the car, gazing over his shoulder as it fishtailed in reverse back to his parents' house, where it came to a halt, and he left the car running as he got out and climbed over the curb's jumbled embankment, crouching to the tree, dragging it up and over till it rolled down into the street, getting back in behind the wheel, dusting needles from his hands.

Down through Illinois, into the snowed-silent corner of Missouri. Even if all went well—unlikely, given the car's propensity

for breakdowns—we were barely going to make it to New Mexico in time for me to show up for the first day of the new semester. When I got there I would be sitting down at the seminar table with others who would already have each other figured out—alliances, rivalries established; my arrival would make me the last addition to a cohort midway through its first year. I could get as far as picturing my intimidated self coming through the door of the seminar room—taking a seat, opening my notebook—but where we would have slept the night before, what kind of job he would have a chance at, how we would manage to pay for first and last month's rent plus deposit, those were unknowns. Perfectionist interiors, perfectionist planning are not supposed to have a lot of loose ends. The messes she makes can fool those around the perfectionist into believing she's no such thing, but a paradox of perfectionism is its nurturance of haphazardness, disarray, and negligence. In perfectionism a task can be done two ways: flawlessly, or not at all. The charm of *not at all* lies in yielding to the guilt-infused sensuousness of procrastination. Letting things slide is an erotics of dread. If you haven't even made a start on some task facing you, there's zero chance of your having done it badly—according to perfectionist (il)logic, you're blameless, and since blamelessness is your preferred psychic state, you don't mind generating a fair amount of chaos to sustain it. Thus, rather than being neatly packed, the interior of the old car was a shambles in which it was impossible to find a toothbrush or clean pair of Levi's; thus, rather than having planned to arrive in Albuquerque with plenty of time to settle in, we—mostly *I*, my fault—left it to the last minute.

But I *loved* his blitheness regarding last minutes in general: it freed us to take chances. He never minded having to compensate through quick-wittedness for preparations left till almost too late, the same needless little crisis that would have driven a more orderly person crazy with vexation turned him blithe, as if it was a particular pleasure to be called on for some ingenious fix, and also as if only then, when we ourselves had invited chaos, could his quickness and deftness emerge as unambiguous grace. Then it showed: the incisiveness of his least movement, his way of judging exertion precisely, the trim execution, the eloquence his body would always have shown, if allowed. He was not usually willing to let it show, and it interested me how gracefulness so extreme could be dissembled, but it was, it mostly was—for the sake of masculinity, was my assumption, as a defense against ridicule, but also possibly due to the Midwestern dislike of standing out.

The summer after I'd moved into his place, when my depression at having been cast out by my family was darkest, I had left for two months on an archaeological survey in Chaco Canyon, New Mexico, no digging, only endless walking and setting up the theodolite and making careful notebook entries, and while in the testing company of the male prof and grad students on the survey I was fine, tirelessly willing to prove myself ballsy, when I returned to his second-floor apartment all I wanted was to fall apart. This I accomplished in slow motion, by means of reading. *Within a Budding Grove* and *The Centaur* and *Far from the Madding Crowd*. *The Professor's House* and

Ethan Frome and *Great Expectations*. In the funky thrift-store 1930s armchair by the bay window, curtains drawn against the Illinois August, a rotating fan aimed at my bare feet lolling over the chair's arm, I sank deeper into motherless, fatherless depression. One afternoon he startled the apartment by letting himself in early, and when he crossed the room something was wrong—that his *body* was unharmed, I could tell, once he'd shucked his boots off, from his walk, his usual slightly pugnacious, shoulder-driven walk, though he was broadcasting as much riled-up disturbance as if he'd been in a fight and his sullenness cautioned against my asking *Baby, what*—? Usually it took him half an hour to wash the tang of chemical smoke from his hair, to scrub the grime from his knuckles and the flecks of ash from the cartilage of his ears, but this afternoon the shower ran and ran, when I stepped over the Carhartts in the hallway and rested my forehead against the bathroom door the same radiation forbade my opening it. I fumbled through the rest of the evening attempting not to transgress against the privacy he required, when we got into bed I understood the potential offensiveness of reaching to touch him, though to have to remain ignorant of the cause of his disturbance confused me. In a dream I heard a dog barking outside our front door, snarl-clotted barks; unsure whether to open the door, I woke; he was crying, and the dread suffusing my dream was relieved, tears must mean he was done holding in whatever it was. Possibly for the first time ever I longed for us to be restored to a previous version of ourselves, for the first time I grasped what it might mean to fall from grace as lovers, and pointless, selfish fear overcame

me, though he couldn't have known I was failing to honor his tears with the empathetic pity he would have shown if it had been me blurting out sobs. Trembling. If it had been me trembling, his arms would have gone around me instantly. *Oh no,* I said, *oh no, baby, what is it? What is it?* Because it seemed wrong to try to touch the face he had hidden in his forearms, I instead touched the stain on his pillow, to make his tears more real—it was as if, though he was inches away with wet-ness streaming down his face, I still somehow did not quite believe him capable of crying—and he started talking at last. He told me they'd been working on a downtown building twelve stories high, at 102 degrees that roof is Venus, from below a steady scorch rising through the soles of their boots, overhead a hazed-over lens of shrunken sun. In the white glare depth tended to vanish, you had to set your boots down precisely in the sweltering two-dimensional world you found yourself treading, had to blink sweat from your eyes as hal-lucinatory hard-hatted figures passed back and forth through caustic drifts of tar smoke—and this guy, this one guy just kept walking, walked right off the roof, barely time to think *He's gone* before, my husband said, insides of his wrists pressed against eyelids, *before his friend, his friend who's like a few feet away goes after him, goes after him over the edge. Walks right off it.*

No. That word is mine.

We go to the edge, we stand there, someone's saying their names, I didn't even know their names.

After a while: *Thinks he can help him.*

After another while: *Thinks he can help him.*

He stops there, and I'm sorry. I don't know what's stopped

him when this, it seems, is the utterance he needs to rehearse over and over in the monotone of shock, to get a look at the intolerable event briefly pinned to reality by the plainest of words. I try to hide how unreal those two deaths are to me. No, not unreal. It's just I can't make them matter. I'm scared at not being able to make them matter. Scared, too, that he'll be able to tell I'm not *with* him. But those deaths might as well have taken place on another planet. The only death that's real to me in that bed is the one he's imagining for himself, walking off that edge because he, too, inclines to thoughtless rushing-after, because he's always known he needs to help.

Oklahoma seems to have been ironed flat for the winter sun to perform its cold slow dwindling across, a theater of darkening fields whose furrows arrow toward the horizon, the grisaille of distant woods holding the last embers, and when, after an interval, the woods vanish, taking the horizon with them, that's all there is to this day—beginning to end, it has been driven through. This falling-snow night chooses *us*. No one in any of the other vehicles materializing as distant headlights either far ahead of us or far behind is as lucky as we are, tearing ourselves out of an old life. When I glance over, he's got the aloofness of truly gifted drivers, apartness with a core attunement, tracking incremental shifts, weighing incidents—the alighting, say, of my hand, cupping the nape of his neck, hair that feels blond, the occipital bulge and below that the declivity where the C1 vertebra (*So—you like bones*) seats itself, enabling the species to stand upright and gaze at

the horizon, I like cupping him below the base of his skull because it's like holding the stem of him, the foramen the essential stuff flows through. *Feels like Oklahoma,* one of us says in answer to a question several snowy miles back.

No sign or did I miss it.

A back road like this, whoever uses it knows where they are.

He's driving like he always drives, scarily fast, full of grace, but the wheels now and then lose traction and sluice across ice and a point far in the future blinks into being, the first instant when I will look at him and feel only anger gleams warningly across decades I don't yet trust to materialize, I am a *wife* keeping her doubts to herself, a *wife* in the passenger seat of a vehicle skimming the surface of a winter planet. *Just married*—he's *my* person now and he has some idea what he's in for and emanates sexy goodwill and steadiness, the times I've asked *Do you still love me?* readily answered *Yeah I love you,* that amused *Yeah* the somehow just-right note, my monstrous neediness blotted up by this willingness of his simply to answer, his appearing to find nothing crazy or alienating in compulsive repetition, but more than that, really, it's as if his interest in me embraces even my worst monotonies, as if it is very simple, whatever I am up to he will help me with, as if, however light my voice when I ask, I'm up to something, the bothersomeness, the plaintive, senseless appetite for *I love you* is treated by him as my right, as, almost, a kind of work I am intent on while he does the outward work of getting us across the country, the two of us talking sometimes, enough to keep him awake, not that he needs it, he seems plenty awake, fine with talking or not talking, fine with my not saying anything,

fine with my asking *Do you still love me?*, me permitting him a clear view of the insatiability it feels dangerous to let show, which appears to amuse instead of aggravate him, his patience isn't *tried*, metal and glass enclose us, the space within the car turned holy by the endlessness of the drive, the endlessness of my needing to feel loved, by some miracle we have gotten this far without a single breakdown, by another miracle I delight him, I *know* this is delight, but will his next answer be *You're wearing me out*, will he mutter *This is a waste of breath*, proving his love finite is the calamity I'm after, each time I revise my question for the next state I'm gambling with that calamity, *Do you love me in Missouri* answered *I love you, Do you love me in Oklahoma* answered *I love you*, being loved all the way across the country in the dark, loved so plainly even I believe it, his breath isn't wasted, his love both variation on and continuation of the love shown by the mother smoking in the half-light of the freezing garage half a continent ago, love by its steadiness opening a space risk can inhabit, his *I love you*s from those nights in that car had much farther to travel, casting forward a decade and a half to the afternoon when I find myself lying on the kitchen floor of our adobe house in La Puebla—saltillo tiles we were scarcely able to afford, so cool and lovely beneath bare feet, so every-penny-*worth-it*. I will be lying on my side in a C-curve with our baby, who is only eight or nine months, in the middle, sitting on his diapered bottom, fooling around with something, some toy, wrapped around by my regard, engagement and forgetfulness gleaming back and forth between us, just *there* with each other, when something passes over him like a cloud or a tremor and

he collects himself—I can see this happen—and *he stands up* without the least hesitation, simply stands right straight up from being seated on his bottom with nothing to hold on to or steady himself, though he has never stood up before and has shown no sign of being ready to do so and will not repeat this daring one-off for an oddly long interval, till after his first birthday, stands up or *unfurls* as if he has done so a thousand times, and then stands steadily on braced-apart legs and his feat of standing there sturdily and with great gravity and beauty is Baryshnikov to me, and he looks around all lordly at his world and lifts his chin at the realm beyond my C-shaped silently adoring body, and he will let things hang in this balanced radiance for a long, long ravishing moment before plunking back down on his bottom.

By Texas we've driven far enough to feel orphaned—good orphaned, hero-of-your-own-story orphaned. In the keening, buffeting two a.m. dark, halted on the side of a two-lane highway running west through a Texas stripped of every sign of life by subzero wind, we try an upright lap-dance sort of sex. The car was often devilishly hard to start, and if we could have spared the gas we would have left it running. With the engine off, the wind careens louder. He goes out into it to pee, turning on the headlights first, to find his way, and from the passenger seat I see the headlights' corridor crossed by a grizzled, bounding herd, laggards tossed aloft, the scrum abruptly recognizable as *tumbleweeds*, dozens more scurrying across the frozen road in Chevrolet radiance. When he got back behind

the wheel I told him I was ashamed to have been scared wit-less by tumbleweeds. *There's worse*, he said. *Look*—he pointed and there it was, the apparition of prison lights starred along a fortress-steep wall, a windswept quarter mile between that wall and the high wire fence, and what came over us—both of us, I think—was revulsion at having fucked within its sight, the force field of the sleeping prison, its emanation of stifled and furious life carrying through the dark to us, blithe us, tainted now. Despite the wind, despite the prison, I got out and crouched to pee in the frozen fawn dirt between clutches of bunchgrass, and though rationally I knew that the Chevrolet looming above, screening me from the wind, also hid my lily-white bare ass from the slits of prison window, still I felt ashamed, and steam from my urine sailed past jittering seed heads. When I got back in he said *I'm not going to look for a roofing crew, I'm going to find some other work*, and started the car. What else was out there that we were unaware of, what worse thing? We drove through the wind-rocked hours until the horizon behind roused itself in a miles-long fire and the desert ahead came up mutely into the dawn, cutouts of yucca, islands of chamisa with their shadows unrolled, even the dashboard of the old car as glorious with glints and detail as a Vermeer, the needle steady on ninety, the east-west highway running on and on till it dead-ends in a T-intersection, two choices indicated by the black opposite-pointing arrows of the big bold highway signage, south to Albuquerque, where classes begin on Monday, north to Santa Fe, city neither of us has ever seen, where a Saturday-and-Sunday's hooky-playing will cost money we can't spare, an unjustifiable whim, a diver-

sion from grown-up responsibilities, finding an apartment in Albuquerque, unpacking our shit, getting our bearings, but our rapport with each other was always intensest on the verge of transgression, what was plain as we climbed out of the car to stand on the road shoulder studying those yellow signs with their black arrows aimed south, aimed north, was how badly we wanted to stay in running-away mode. The morning's brilliance gusted toward us across tawny vacancy and the thing between us of standing there on the road shoulder was crazy-sweet and entirely dependent on our not knowing what was going to happen. We stood there waiting for one of us to say *This way* or *That way*. After a while of our saying nothing he said *Let's toss a coin* and fished a quarter from his tight jeans pocket and showed it to me to prove this quarter in fact has a head, that it has a tail, and when he tosses the quarter it spins upward and chases through its arc, his hand clapping over it, the girl I was saying *Tails* and the coin resting in the blond hair of his forearm and there it is, tails, and he says *Want to go for two out of three?* and tosses and it comes down and shines from blond forearm hair. Quarter—you I should have saved, drilled a hole in, worn around my neck, never let go. And a third toss because we like pushing our luck.

Santa Fe.

Santa Fe.

Santa Fe.

Skip ahead a year, and you'll find no graduate-school me at the seminar table. Whichever professor would have impressed

me as most brilliant goes about his business unadored, at least by me. Even in dreams, I've stopped digging up bones. That imagined seminar table excites the same worried dread as those prison lights in the distance, and I never write to explain why I'm missing, not to anyone at the university, not to my mother and father. The rapprochement we stitched together before I left Illinois depends on my making something of myself academically, is my fear, and to write or call to tell them we'd come to Santa Fe because of a coin toss and never left is to risk hearing *Want nothing more to do with you again.* As if a second rift is inevitable, I inflict the severance myself, by means of a silence that feels necessary to me, and at the same time dangerous. Meanwhile my young husband, the non-fugitive in our marriage, has figured out more about our new existence than I have. He's working and I'm not, an asymmetry we can't afford. The Chevrolet's been replaced by a pickup truck, each month's payment a cliff-hanger, as is the rent check for our low-ceilinged converted stable on Upper Canyon Road, and he keeps taking things in trade, a buffalo pelt for bathroom cabinets, a wine-stained Two Grey Hills rug for restoring the shutters on our landlords' Territorial adobe, *next door* in the old Santa Fe fashion of being virtually on top of our place, meaning we sometimes hear them making love, and surely, sometimes, vice versa. *The new bookstore*, the competition that has opened two blocks down from stodgy old Lawson's on the Plaza, I answer, *that's where I want to work.* It's a question he's asked after having held off as long as he can. He says *That's it? Out of the whole town? Do you think you've maybe narrowed it down too much?* He's right. I let

him be right. He says *So go there on your lunch hour if you work someplace else.*

He says *There are people I don't want to work for that I work for.*

He says *Jobs I don't want that I take.*

He says *I get that you're having kind of a rough time.*

Says *Okay so it has to be this bookstore. Have you asked them if they need someone?*

Yes, I lie.

Okay, he says. *Okay, that's a start.*

No openings yet.

Which I know not because I've done anything as direct as asking but because my hanging around and eavesdropping would've yielded mention of a new clerk's being sought, if one was.

We can get by a while longer, he says.

We can't. Lately a great day for me is one when I make it out of bed. When I do, it's only ever for one ritual, the long downhill walk from Upper Canyon Road toward the Plaza, past old houses whose doors and window sashes have been painted evil-repelling Virgin's-cloak blue. To follow the narrow verge past these dream-sunk irregular old adobes is to be wounded by the fecklessness of rentership and whiteness and recent arrival. Apart from images snatched in passing—windowsill geraniums with parched leaves, a bald forehead gleaming from a brown portrait—I understanding nothing about these houses except their—to me, enormous—desirability, nothing about the mother ditch they front or the time they were built or which family had hung on to them until forced to sell by some calamity, taxes or cancer or

quarrels, nothing about who was likely to have acquired the house then, though I was aware the acquirers were likely to be what was called in Santa Fe *Anglo*, and rich, and I was Anglo without being rich, the condition of rootlessness, of failing to belong, and when house-covetousness wears me out I sour-grapes it, because isn't there, in those crouching adobe warrens with their period details, some feeling of the most meaningful part being over, of aftermath or echo? Isn't the desire to own such a house a wish to insert oneself into— but whatever insight I'm pursuing peters out and I walk along under rustling cottonwoods whose leaves broadcast a dry vanilla scent, through the Plaza with its vendors and mimes and homeless, down the traffic-jammed street to the bookstore, whose door opens with the chiming of antique sleigh bells on a leather strap fastened to its inside handle. I don't conceive of what I want from the bookstore as a job, because I don't believe the transformation I'm after is anything a person can or ought to be paid for. In a poem I read for the first time in a corner of that store, the archaic torso of Apollo tells Rilke: *You must change your life.* What is a bookstore but a *gaze, now turned to low,* emanating from thousands of books longing to break from the borders of themselves? I've overheard the owner explaining to the sullenest of the clerks, a plaid-shirted boy whose pony forelock flops over his glasses, that some people will not come back to a place where they haven't been smiled at when making a purchase. Because I hardly ever have money for books I contribute to the atmosphere of the store by radiating quiet ardor. Nobody notices, but I have a good pre-employment feeling of doing my part. More virtuous, still

out of reach, is the clarity working here will bestow, the hon-
orableness of *bookstore clerk* mitigating the taint of *grad student
who failed to appear.* The clerks I want to be one of are ruth-
lessly tribal, given to puns and rankings of the ten greatest
novels in English, to jokes that wither into disuse only to be
resuscitated, some moment when laughter will be awkward,
in the form of an insinuatingly murmured first phrase—I
would fall for that! Would laugh and look stricken. Would
love them. All three. Sometimes my heart runs after one,
sometimes another. Fairly often when some dispute comes to
a boil—whether the dog's point of view in *Anna Karenina* is
sentimental; if a pedophile can read *Lolita* unscathed—a clerk
will say *Let David be the judge* and they will laugh, reunited by
dread of having to go and knock on David's, the owner's, of-
fice door. He is a former professor, mild and sardonic with his
employees. Behind the closed door he is working on a novel
narrated by Lord Byron's valet Fletcher. The clerks make a
game of conversing for an entire November afternoon in
Byron quotations. *I am so changeable, being everything by turns
and nothing long—such a strange mélange of good and evil.* They
only seem to be improvising, I soothe myself, they must have
boned up on the *Collected*—which I'm going to need if I want
to ingratiate myself with the owner, but which can't actually
be bought, since to slide that volume across the counter to
one or another of the clerks will be too frank an admission
of the eavesdropping they are of course aware of, and gen-
teelly ignore. Occasionally I have seen the owner out in the
open, rousted from his warren to meet with publishers' reps.
I've imagined telling him *But this is the most beautiful bookstore*

in the world. Wouldn't his response be *What's the second most beautiful?* and how would I know, having never been to Paris, surely that will rule me out, never having been to Paris, how am I going to get to Paris and back in time to be able to answer *There's a bookstore in Paris that comes close.* At, probably, thirty-six or -seven, the owner seems much, much older than us, the imaginary *us* of the clerks and me. His corduroy jacket has buttons of dark leather conspicuous as dachshund noses; he wears suede shoes, aviator glasses, the topiary sideburns of a Civil War cleric. He is the first person I have seen who is *writing a novel.* The clerks run things, insofar as they need running, so his door can stay closed.

The alphabetically first volume in paperback fiction shows, on its black-and-white cover, an egg-shaped visage whose closed eyelids are blind to the threat of the dune looming over her, and though I know this book is too cool for me, likely to punish my beginner's solemnity with avant-garde duplicities, whenever I come into the store I drift toward it. I leaf through it, head bowed. I slip it back into its slot. For anyone else to buy it would derail my covert progress toward becoming its worthy reader. To walk away, as I do repeatedly, is to toss a quarter into the air, heads *You're smart enough*, tails *Not smart enough yet.* The morning I finally feel ready, the boy with the hanging forelock waits behind the register. I come forward in apologetic ballet slippers, emerging—so it feels—from the grove of lurkers and browsers into the clearing where taste declares itself, but it takes barely a minute, an unimpressed minute, for him to bag the little book, slip in the receipt, and dispatch me with *Come again soon*, precisely as if this is the ten

thousandth copy he's sold — wait, wait, can we do that over, can you look at me? Am I really going to be alone with this book? Over and over during my long uphill trudge to Upper Canyon Road the pony-forelock clerk taps two fingers on *The Woman in the Dunes* and says:

It will change your life.

Taps two fingers on the book and says:

Tell me what you think. When you've finished it.

Taps the book, says:

You should obviously work here.

Days when there was little chance of my getting out of bed, I lived for the downshifting of my husband's truck turning into the dirt driveway. This was tucked between our house and the landlord's. Upper Canyon Road was winding and narrow and he drove it fast enough the driveway always came as a surprise. He would bring in the newspaper so I could sit up, my back braced against the headboard, and go through the want ads with a pencil, crossing out *waitress, caretaker, receptionist, bartender, nurse*. One night I came across a description infuriatingly close to the ad I was hoping for. I read it out loud.

From the kitchen where he was pouring a beer he called back, *Part-time is maybe more realistic than full-time*.

More realistic given my depression.

The fridge door kissed shut. *Not a lot for supper*. Fridge door opened, in case fridge emptiness had spontaneously corrected itself.

My *It's the wrong store* was loud enough for him to hear.

Even more plaintive was my quoting the ad's concluding line: *Call for an interview.*

You're good at interviews.

Often when he got home I would feel hungry for the first time all day. *Make me some toast.*

You make a good first impression. Unwrapping. Thunk of the toaster lever depressed. *I mean: reach out your left hand.* He could tell I wasn't. *Really. Reach out your left hand.* He could tell I was. *Lower it.* He could tell. *K, now say what's under your hand.*

It's The Magic Mountain.

Ideal answer for a bookstore clerk.

This ad is for Lawson's.

The old bookstore on the Plaza? He waited. *Is that the end of the world?*

It's depressing. It's for tourists. Going in there makes me want to kill myself.

So you work there till the other store needs someone, you gain experience, you'll be more desirable. Is how it works, and before I could come back at him resistance evaporated, leaving, in its stead, a scared readiness to see how this would turn out, and I heard myself say *All right.*

We both listened to see if I would take it back, that slender *All right.*

He came into the bedroom carrying his beer and my toast. *What else've you eaten today*, he said, extending the plate. I watched him register the despair bomb that had gone off in the room, clothes lying where I shucked them off three days ago after my last foray into the world, his thrift-store birthday cowboy boots shoved under the bed with the tar-stained work

boots he hadn't worn since Illinois. On the crate nightstand, saucers with crusts and smears, burned-down candles, condom wrappers. The filigree Victorian birdcage he'd accepted from the broke client whose back stairs he'd repaired, which we kept meaning to strip of rust, repaint, and get birds for. Stacks of books, cups balanced on top, a sin that ought to have disqualified me from clerkdom for good. With a forefinger I printed my first initial on his cheek. *Your face is all sawdust*, I said. He must have wondered, since I was going on thirty-six hours' immobility, what the chances were of my making it into work on time every morning. *Don't worry*, I said. *I'm going to get up.* He said *Are you going to get up?* I said *I'm going to get up. I'm going to clean this room, then the whole house.* He said *You don't have to clean the house but it would be good if you could get up. It would be good if you could make that phone call. I don't know how long this job's going to last and I don't have anything lined up after. Winter's always harder, people stop wanting things done, they don't want dirty boots tracking in and out.* He sat on the edge of the bed and watched me eat toast.

Lawson's never made you feel what you hope to feel, walking into a bookstore. Morning after morning brought the same revelation: the absence of a distinct threshold means a place will forever feel *unmeant*. Lawson's leased half of the ground floor of a grand 1930s faux-adobe building right on the Plaza, but it got the back, light-deprived half, and to reach it you first had to pass through the territory of a dealer in Native American art, display counters livid as saltwater aquaria with

lapis lazuli, malachite, ivory, turquoise, coral, mother-of-pearl, and jet, silver in rings and cuffs and concha belts unbuckled long ago from some velvet waist and pawned, rugs, too, eye dazzlers and pictorials and chief's blankets whose geranium-red wool had been hard to come by in the 1800s, magical slit-eyeholed masks of pale doeskin tattered from use and never meant to be in the possession of a white person.

Lawson's belonged to Leo as bookstores have always be-longed to their most obsessive clerks. If you took Leo's ap-pearance apart the pieces refused to add up to his actual attractiveness: hyperthyroid eyes of extreme paleness, glossy plump clean-shaven skin, hair razored into a bristling white-blond nap, flawless shirts. Leo preferred days devoid of cus-tomers. He preferred the owner, when present, to stay in his office at the back of the store with the door closed. So that was a thing. I had done a brave forty-five minutes' self-invention in that slovenly hideaway while the owner frowned and rum-bled in deaf interrogation from behind a desk strewn with apples and biographies. *Help yourself,* he said, waving at the motionless onslaught of apples. Was he serious, did I look like I could bear to eat an apple in front of him—was it a test? *No, thank you.* They had a tree. *Old tree, neglected. Never did any-thing for it. Never watered. Never fertilized.* He sounded proud. *But then, every summer. As you see. What does one do?* In my head I echoed, in my own voice, *What does one do?* Not mockingly. Because I found it irresistible. Ha! I was alive in there, inside the nervousness—that was me, doting on *What does one do?* while the owner went on. Biographies were the highest form of literature. The timbre of his voice, its cavern resonance,

was too grand for the quailing tactfulness of his interview style. *Your favorite biography?* The fat biographies cluttering the desk were mostly of Republican presidents. Had I ever read a biography? Never. Not a single one. Lincoln was there. I felt encouraged by Lincoln's gaunt and riven homeliness.

More loudly: *Your favorite biography?*

Anaïs Nin—a diary, but he seemed unlikely to know that.

Speak up.

Anaïs Nin.

Speak up, can't you.

Anaïs Nin!

He bowed his head in what I took for a self-communing moment of decision and kept it bowed a disconcertingly long while before clearing his throat and saying *Yes, well.* The two of us waited there under the spell cast by mutual unintelligibility till he recollected the paperwork I was supposed to fill out. He pushed the pages toward me. My turn to bow my head. I was relieved to read such sensible questions.

He appeared satisfied with my paperwork; he stood and said genially *Now, one—*

At last we were out of that room.

Mr. Lawson ambled toward the front counter with me approximately in tow. The old-fashioned register reigned over a long waist-high counter where books could await the clerk's attention. To the left, wedged tight against the higher counter, was an old oak schoolteacher's desk, and on this desk, surrounded by binder-clipped sheaves of invoices, was a *typewriter*, olive green and black and chrome. When Leo glanced up from the register drawer where he'd been counting coins,

Mr. Lawson clasped me by the neck, the contact astounding as a good-sized steak slapped against my skin. Plainly he hadn't told Leo another clerk was going to be hired. Mr. Lawson said *Well*, followed by a pause whose awkwardness neither Leo nor I made the least attempt to relieve, then again *Well*, followed by another beseeching pause, and I was beginning to get the hang of the pauses, this was a man used to presenting others with opportunities to rescue him socially, and as soon as I knew that I knew Leo knew I knew it, and it was ever so subtly two against one, and I thought what a pleasure that could be, being in the two of the two-against-one, based on this evidence that Leo and I could communicate wordlessly I trusted him to get to like me, and as I stood there humiliated by his heavy hand on my nape Mr. Lawson changed into *the boss*, who said: *Well, you two will take it from here.*

From our separate vantage points, Leo's behind the cash register, mine on the customer side of the counter, we studied Mr. Lawson's lumbering retreat in the first of many bouts of joint mystification. The hitch in his gait roused a shiftless pity. A jacket of marvelous gray-green and tawny tweed strained and flexed across his back, and as sometimes happened to me with words, the word *bespoke*, whose definition I wasn't sure of, attached itself to that jacket. His office door closed. For the rest of the day Leo carried on with business while I wandered around shelving books. Leo's system abolished the friendly amplitude of categories like fiction and nonfiction for fussy distinctions—Eastern Mysticism, Noir, Local, Women—and when he had a free moment, Leo fetched my misshelved volumes and fitted them into their rightful homes.

The next morning he showed me how to work the reg
with its be-numeraled ivory keys, drawer of bill-sized slots
and *ding* of closure, and watched as I counted out change for
the first customer. He was a good teacher, droll, patient, his
corrections discreet enough to spare me embarrassment in
front of customers. I had gotten it wrong, I had believed my
apprenticeship would be to the three brilliant clerks down
the street, not to dogged, cranky, perfectionist Leo. It didn't
matter that he didn't much want to mentor, or that I couldn't
have said how exactly I wanted to be *like* him: there was just,
between us, the steady inexplicable sweetness of my learning
from him, even if what I was learning was just how to show
up and keep showing up.

In the early nightfall skiers who'd spent the day on the
slopes were walking to restaurants under the portal that ran
along the storefronts in a sheltering roof, beyond which snow
was coming down, with lights from the other side of the plaza
blinking through it. *Texans!*, Leo named a duded-up pack go-
ing past, and when two of them turned back, Leo cast me
a glance of comic incredulity meaning *They heard me?* and I
laughed as the skiers came through the door, pausing to stamp
their expensive boots, and as Leo gave them his reserved wel-
come I went to the back for the broom and swept the snow
from the runneled rubber mat that was there *for* snow, but
the wide old fir planks of the floor were irreplaceable and I
was married to a carpenter and besides Leo liked my showing
initiative. When things went the way Leo wanted them to he
could be very charming, and when he was at his most charm-
ing he told stories. As a mimic he was sprightly, transformed

into the despised customer who had just left or into the mail-
man flirting with me or into Leo's boyfriend, Nate, talking
Leo into buying a pink shirt. Next to Leo I felt unfocused,
undriven, humbly heterosexual, but free of the despair that
had oppressed me before Lawson's.

After moseying through the aisles the skiers approached
the counter with two paperback thrillers and *The Milagro
Beanfield War*. Leo hated *The Milagro Beanfield War* with venge-
ful intensity; it was our best seller. He rang the books up, nod-
ding his big platinum-blond head when the skiers asked if it
was always this beautiful here in winter and did he know
what they meant when they said they could hardly stand to
leave tomorrow but they had to get back to the real world?
And after the door closed behind them he said *Hopeless*.

What is?

Hopeless, what we do. The despair of his tone was a bad sign;
once that was in play it tended to ramp up. *Look why don't you
take off*, I said. *Nobody else is coming in tonight.* When he didn't
immediately decline I said *You should get home. To Nate.* When
things threatened to go awry with Leo, Nate's was the calm-
ing name to invoke. Leo had admitted to attending art school
a couple of years before, where he'd been confronted, he'd
said, with his own lack of talent. *Not good enough*, he'd said. He
had begun confiding a little about himself, and always he was
touchy afterward, quick to denounce any trace of what looked
like attachment in me, as if confession was not talk, but sex,
and we shouldn't have done it. He and Nate owned a house
Leo had shown me pictures of but never yet, I couldn't help
minding, invited me to: a little dovecote of a fawn-colored,

flat-roofed early-1800s house with the usual mongrel outbuildings. Weekends were lavished on the quest for the spoons they should have, or for the right chair. That charming primitive chair the dusky blue of old milk paint—it had to be searched for, estate sale after estate sale. Nate got bored with the quest, but the chair bobbed with raffish Chagall allure across the starry sky of Leo's perfectionism. The interior of his house was bound to end up exquisite, as the bookstore would have been, too, if he could have exercised complete control. To work under Leo's gaze was to be found wanting, and it was as if his exasperation with me sufficed and my own could slack off, the ministry of inhibitions headquartered in his skull, now, the surveillance occurring in his pale eyes.

And I could watch him. I could watch how he was living with our malady.

Some time ago I had found, in a drawer of the schoolteacher's desk, a spiral-ringed artist's sketchbook on whose first page was a drawing of Nate yanking his T-shirt off over his head, navel and lower rib cage bared, the tip of his nose, the jut of an elbow poking the white cocoon, on whose second page Nate was yanking his T-shirt over his head, whose third and fourth and—I counted—nineteenth pages held the same drawing. The twentieth page was blank. However many times after that I took the sketchbook from the drawer, the twentieth page remained blank. The sketchbook was too charged with Leo's frustration to be left in the drawer of the desk while I was writing. My habit was to carry it to Christianity's tiny ghetto and wedge it on top of *The Sickness unto Death*, where it could wait safely till I was done for the night.

Leo's not saying no to my offer to stay at the store alone
meant he could have been reflecting, as I was, on the likeli-
ness of the streets' getting more dangerous as the snow kept
coming. *Go,* I said, testing his tolerance for assertiveness from
me; and to my surprise he left.

Snow was steadily deepening in the street; across the
plaza, the last lights glimmered through its descent. The Na-
tive American art store had closed as usual at five, but Mr.
Lawson wanted the bookstore to stay open till eight p.m.
these last weeks before Christmas. The storm guaranteed my
being left alone, so at the oak schoolteacher's desk I began my
ritual, situating Leo's sketchbook, turning off lights. I fed a
sheet into the platen of that typewriter with its keys poised
in QWERTYUIOP readiness and fell into a canyon where it
was also winter, in which I was a sheepherder, a boy in charge
of a starving flock, ribs looming beneath their matted wool.
When they teetered up on their hind legs to gnaw at twigs
of juniper I pitied their draggled behinds' being clotted with
shit, and when, leaning over the typewriter as if it were a
flame warming my cold sheepherder hands, I typed *The entire
world was bare as high as a sheep could reach,* god, it made me so
happy all I wanted to do forever was write more sentences. It
would be midnight before I stopped and called my husband
to come get me, and twenty minutes later the pickup truck
would roll down the white street to the bookstore's front door
as I locked it behind me, shouldering my backpack with new
pages in it, and in the truck the heater would be on full blast,
my husband's sleeves would be rolled up his forearms. When
I leaned to kiss him the chambray of his shirt would smell of

sawdust, though he would have already been to bed he would
have gotten up to come get me, on the slow winding drive to
Upper Canyon Road he would tell me he'd done some dove-
tails he was proud of though the client was unlikely to notice
and would ask how my writing had gone, but how could it
be explained that the enormous thing that had befallen me
was a sentence about the bare world, a sentence that sounded
like—that must be what *I* sounded like.

In spring when the snowmelt river whose name is Santa Fe
riots down the canyon, we like to lie awake listening. The
roar obliterates my hours behind the bookstore cash register,
his fielding the questions rich people direct at the carpenter
redoing their kitchen cabinets. *I'm sorry* is the utterance I keep
to myself, since to say it aloud would invite *For what?* A light-
hearted *For what?* anticipating an apology for some funny,
forgivable slip would worsen the tension between his trust-
ingness and my guiltiness, a somber *For what?* would wreck
me. Out of love, he's willing to be slow to catch on, and I go to
some trouble, tightly wrapping the unsayable against radioac-
tive leaks, digging a hole to stash it in. Certain nights it's all
I can do not to tell him what I have done and beg, as I would
have to, *Don't leave me, don't leave me, it was a mistake*, why that
seems to have a chance of moving him to forgiveness, my
saying *It was a mistake*, I don't know, I'm not sure, but I lie
awake imagining saying *It was a mistake* over and over, and if
push comes to shove I know I *will* say it, each time I imagine
saying it I feel it gain something, but what? Something like

charisma, if an utterance, an imagined one, can be thought of as possessing that quality, as I lay awake saying it to myself with him beside me *It was a mistake* was translated from its original role of abject confession into the only seemingly antagonistic mode of assertion of innocence, since somehow guilt inhabited deeply enough *is* innocence. He's been working steadily for a month now, putting in long hours. They're subtle beyond replication, the colors of the painted wood he's scavenged from a source he declines to reveal, but which I know, from the old Saturdays when I rode shotgun, come from an abandoned stable two winding hours north, whose thrifty long-dead owner, his guess was, had happened by a paint store the day they were disposing of dozens of nearly empty cans, the dulled red of cayenne, paled yellows, wan pinks, and ghost blues of fifty winters' exposure deemed *So unexpected* by the wife of the rich couple whose kitchen is taking forever, who had said *No one else will have this, isn't that right* and waited for him to assent before adding *It's got that delightful folk art playfulness, doesn't it*, gazing at him before concluding *Highly desirable, don't you think*, which, repeated, causes us to lie on our backs in our bed, laughing at the ceiling.

I say *At least you know she thinks you have made something beautiful.*

He says *The trouble with people like that is they can just as easily wake up one morning and decide "I'm sick of playfulness. Let's tear it all out and start over."*

———

I had been fucking a poet who lent me *The Collected Poems of Frank O'Hara* and took me to the zendo where I sat cross-legged in the row of meditators behind him, staring at a hole in his black sock. The aloneness possible on the zafu comforted me, an aloneness in the midst of other straight-backed silent alonenesses. What if in every head around me was a vision of being held in the right pair of arms, if desire was general in that array of heads facing forward toward the cushion where Roshi sat in black-robed silence, then within each head it was called by its name—*desire*—and let go, if it came again it was again called by its name—*desire*—while far back in my mind a hand lifted and waved bye-bye to desire other forms of dukkha arose and were called by their names and dismissed, *jealousy, boredom, panic, fantasy of mending the hole in his sock, fantasy of his saying he can't live without me, fantasy of the next story's being beautiful, of its being published, of a book of stories, of Leo's shelving my book of stories*, and when that got boring I began writing in my head, when I caught myself at that I named it *writing*, gratified to find that on my cushion I had gotten the hole in the poet's sock into the first line of a story, ha, *vanity, thy name is woman*, the foxed mirror with its fleur-de-lis held my reflection, and all of that was five minutes on the cushion, or maybe only two, with no way of telling how much time was left before the bell I closed my eyes and named the next thing that came into my mind and the thing after that and then it got quiet and nothing needed naming and I thought *So this is what meditation is like when it's working, it's fantastic how peaceful the inside of my head can get, I'm good at this, I will be the student whose enlightenment*

amazes Roshi. Delusion, what an asshole I was, *self-hatred,* how
needy, insatiable, faithless, touchy, a sucking waste of others'
time, of others' love, of their lives if they let me, destroyer
for instance of my parents' peace of mind, *perfectionism,* sit
tight sit there don't move there's more, what is going on in
the heads around me, facing forward so seemingly calmly, is
it anything like this shitstorm, breathe in, breathe out, *pity,*
amend that, *self-pity,* what exactly is wrong with pitying the
self, it's in trouble, the self, bone weary, is that the phrase,
bone weary can't be true, ten thousand years after its soul bled
away the antelope skull was tirelessly *beautiful,* lately I had
begun picturing the bones that would be all that was left of
me; they were bound to be beautiful because the bones of a
small female human are of exquisite design, torque of femur,
knurl of vertebra, it was as if perfectionism had turned its
gaze to the whole of me and found only my bones accept-
able, an escalation, a leap in the disorder's evolution, death
esteemed as the alternative to being mired in sickening flaws;
there was an undertow; was _____; perfectionism
believed it was immortal, why shouldn't it believe that, it
had been immortal so far; it was used to killing things off,
grown brutal from the fare. Possibly there was no *one* to self
in my case but the doubleness of perfectionism's superior-
ity and its abject object; *I want no more to do with you; fear.* I
opened my eyes, was there fear in any other head around me,
fear, it was so quiet here among the hundreds of heads, any of
whom would have saved me if they could, *love* was the word
for that, *love,* they would if they could, if they knew what was
happening, if it showed.

Sometimes I get so tired, I had been surprised to hear myself tell the poet, *of needing to get everything just exactly exquisitely right and never never being able to, I'm sorry, I never talk like this, sometimes I'm just so tired I don't think I can do another day of it, I'm sorry, I know how this sounds, I know we don't really know each other*, and he had said *I know what you should do*. That had been our first conversation, and what he'd thought I should do was Zen. Sitting. He hadn't meant what I should do was get involved with him. He'd been writing something inside a matchbook at the table next to mine in the French Pastry Shop on a corner across from the Plaza. He'd pivoted the matchbook so I could read what he'd printed: *ETERNIT.* He'd closed the matchbook. *You're just going to leave it?* He'd said he was doing a series, matchbook poems. The point was to leave them where anyone could find them. *But I want it.* He'd slid it across, past the sugar bowl on my table, till it nudged the saucer of my cup. The act of never-ending reading concealed in the matchbook was mine. Sometimes he would bring up that first conversation. *You said you didn't think you can do another day of it. You can't act like you never said that. You've got work to do.*

I'm better now. Things are better now.

You're not the most convincing.

I wrote a new story. About skaters in a travelling Ice Capades. One of them wears a bear suit.

He would tilt his head first to one shoulder, then the other, a stretch he performed after sitting. *Can you come over Tuesday?*

I'd taken the poet along to the birthday party my therapist

had thrown for herself in her house in the suburbs; he had liked her intensity and her platinum hair short as a boy's— *but don't be fooled into thinking you can talk your way out of your shit*, the poet warned, what was needed were the changes that could only come from sitting, and I could learn from, for example, the late seventeenth-century Zen Master Hakuin, who had been living in the monastery for a decade, only his attentive disciples for company, when a young neighbor woman turned up at the door carrying a baby. The child was illegitimate; unless she gave it away her family would cast her out. She had assured them the baby's father would accept the child, shelter and educate him. When she told the Master, "He is yours," the Master said "Is that so?" and took the baby from her arms, and loved the child for ten years, watching over him, patiently schooling him, and then one night the woman returned, married now to a wealthy man impatient with their childlessness, who had decided her already existing boy was better than no son at all, and when the boy was presented she seized his wrist, telling the Master, "He was never yours," and the Master said, "Is that so?" and the boy disappeared down the road, lagging behind his mother, gazing back over his shoulder as long as he could—*And the mother slapped him*, I finished, *and the Master said "Fuck this" and ran after the boy and grabbed him back*, and the poet said *You're missing the point.*

My favorite thing about sleeping with the poet was finding out more about Ceres, the woman he lived with. I loved when she came into the bookstore. Why she chose Lawson's over the other bookstore was unclear—or maybe she frequented it as well; I wouldn't have known, my employment at Lawson's

banished me from that store and its conversations. Ceres fa-
vored the same thin-soled cloth Chinese-peasant shoes the
poet did, so they walked alike, flat-footedly, but hers were
worn with lace-trimmed ankle socks, from one ear hung a
silk Victorian curtain tassel, from the other a silver kokopelli,
and over her thrift shop floral dresses she wore old-man car-
digans, just one or two buttons buttoned, never the correct
button in the correct buttonhole, and worn thus the droopy
beige or camel vapidity of the sweaters took on an air of witty
dereliction, and below the buttoned button her belly jutted,
five months along, and for me it was a surprise, the detailed
impudence of her improvisation, since when the poet wrote
about her she was ethereal, a soul in its last incarnation, and
the thought crossed my mind, *If he got that wrong what else did
he get wrong?*

Leo and I watched her forage in World Religions. *Who is
that?* he asked. He could tell I knew her. I said her name. *It
is not*, he said. *It is. Ceres. What is she?* he asked. I said *A per-
formance artist. She is not*, Leo said. *She is, she did an MFA, her
thesis was living in a glass enclosure in the art building for a month,
completely on display, eating, sleeping, zero privacy in everything.*

And for that you get an MFA, Leo wondered, and I looked
at him to see if he was exaggerating his old-fogyism, but he
wasn't. I said *Ordinary life as art, you know?*—because when
he got riled up, Leo could be unpredictable, and I didn't want
Ceres returning to the poet with some tale of how that weird
girl in the bookstore had egged her fellow clerk into accosting
her, demanding to know whether she was going to buy one
of those books she was pawing through. Leo did his silent

scrutinizing damnedest to make her uncomfortable, but did she care? Nope. Genuinely, insouciantly: nope. Merely by coming and going without minding what Leo thought, she instilled in me the longing to be, not her exactly, but a woman capable of failing to notice male disapproval.

She carried Leo's sketchbook to the counter. *This was in Christianity*, she said, *but someone's going to want it back, the drawings are beautiful.*

Leo's *Thank you—they're mine* conveyed, under its gentleman-bookseller politeness, delinquent charm. His gunslinger mustache curved in a smile answering the white teeth of her admiration.

She had everyone.

Upright in lotus, the Roshi visiting from Japan hadn't seemed dangerous, he hadn't seemed predatory, though I had no trouble imagining the calm set of his mouth turning impatient, I can visualize the shift to scorn in virtually any face and did so compulsively about his while I sat cross-legged before him bothered by feeling that he was sexy, or being in his ambit was sexy, when the more complicated response, which I was also having, was that being in his presence was moving, as was his casually profound absorption in the ceremonious matter at hand, the process of settling on the koan that would be right for me, to do so called on Roshi to decipher, from the answers I was giving to his translator's series of questions, what kind of trouble I was in, and the searchingness of his superb focus on me pierced me by being what I always longed for, which—it dawned on me as I exerted myself to maintain

my weak-ass semi-lotus with a straighter spine—could only last another minute or so, because these interviews had formal parameters strictly observed, out of reckless mourning for the immanent loss of his attention I met the last question from Roshi's translator with the plainest truth I was capable of, *Needing to be perfect is killing me*, words barely uttered before being translated into the language the translator was leaning close to speak into Roshi's ear. My therapist was in love with the translator. Sometimes Santa Fe could seem like a very small town.

The road kept leading into the moon-shadows cast by shaggy old cottonwoods and out again and it was all I could do to make myself walk into another swath of darkness. Between the rich people's place where the sesshin had been held and my house on the canyon's opposite side, the road was laid out in a long inverted V, with, at the point of the V, a bridge across the river, the only safe way to cross when it was, as tonight, high with snowmelt. To stick to the road was going to mean five exhausted, flashlight-less miles, though I could look across at our small semi-neighborhood of companionable old adobes, flat roofs stair-stepping down every habitable bit of steepness. Little lights shone there.

One of them could be my husband's—in our bed, under our patchwork quilt, reading.

The river ran between.

I waded in.

The opposite bank wasn't far, maybe four or five yards,

but the river was freezing, its bottom a mosaic of cobbles sunk in angora algae. The soles of my ballet slippers curved around stone after stone in a grippy, monkey-footed version of wading. A stone rocked and before I could regain my balance I was tipped into a pothole, drenched to the waist. The sodden drag of my jeans rendered even pleasanter the fluttering of my shirt in the breeze that was the close counterpart of the river's rush, staying low, mirroring its roil, whisking off the foam tossed from its whorls and the geysers repeatedly slapped up between stones large enough to jut from the surface, behind stones lodged in twosomes or threesomes twiggy debris was trapped, rough half-sunk nests orbiting pell-mell, an occasional rock-anchored branch looming haughty as an antler. From the bank the river had looked as simple as a night lawn, as neighborly, as easily crossed. With the next slip I was knocked onto my ass, scared by the hurtling pressure against my chest and the close smell of snow and the impersonal possessiveness of the river's wanting to roll me over, twirl and drag and bang its animal toy against rock. I shoved up, hoping my footing would hold, wishing I was stronger, wishing I hadn't gotten into this, but I felt stubborn as well, and close to ecstatic. Drops came slinking from my ears and ran down my jaw to tremble at the point of my chin. I shook my head to fling them off. I wasn't turning around. Above, where the woods thinned, a pair of headlights eked along the rutted dirt of Upper Canyon Road, and those lights had to be my husband out looking for me, and I shouted his name against the roar, and kept shouting, because with each shout the chances of his hearing me, whether he was driving that car or at home

reading under our quilt, seemed to increase, each shout more urgent than the last, each instance of his name's being flung out more desperate, likelier to be heard or sensed, because I believed in everything now, telepathy, the emergency intuitiveness of the soul, the lengths I knew he would go to to save me if he had the least inkling of my being in trouble were fantastic lengths, and equally fantastic was my own valuableness, my consciousness too great for the river to blot out. The headlights went slowpoking down the road and in their dust-infused radiance the silhouettes of chamisa and rabbit-ear sage seemed to billow outward, then contract with the lights' passing, and I followed those lights until their disappearance drove home the loneliness of no one's knowing where I was. Who was going to think to look in the river? Would he? Half-way across loomed a boulder big enough to climb onto and I floundered forward, freezing nerves of river running under my shirt. I slung my arms across the boulder, pasting my rib cage against coarse-grained granite, flecked and pitted, yet with a baby-powder-delicate film over it. Within a month my therapist was to leave the translator for the poet; in midsummer Ceres would give birth at home, in the bed the poet and I occasionally slept in when she was out of town, and because I had never seen a newborn and one had just appeared in a story I was writing, I would knock on their door when I was sure the poet was elsewhere, and she would let me in and give me the baby to hold—buttocks sleek as hard-boiled eggs, his umbilicus jutting like a withered jerky stick. A thousand nights' bookstore typing wouldn't have stuck that umbilicus to the belly of my fictional baby; how wrong had I gotten all

the shit I went ahead and made up? Ceres squatted to soak her episiotomy stitches in a basin of warm water infused with yerba buena, glancing over her shoulder toward the bed where the baby sprawled across my thighs to say *Don't you think you and*—she named the poet—*have come to the end of your karma*, and when I agreed we had, she said—over her shoulder—*Do you know where he is?* I was beginning to understand how callous I had been, the openness of their relationship an assumption it had been convenient for me to leave unquestioned, at the guilt my expression must have conveyed Ceres said, over her shoulder, *Please just stop moaning to him about not being able to live another day*, and I said *That was a mistake*, then, *All of this was a mistake, I'm sorry I came*, and she said *It's good you came, this was necessary*, and I said—insanely— *Thank you* and waited along with her in weird harmoniousness for the timer to ring, at which point the stitches would have been soaked long enough and I could hand over the baby, but before it rang, while her back was turned to us on the messy bed where I had done things I hated to think of, I touched my nose to the baby's scalp and breathed in so I could get the smell right in my story, almost caught in the act when Ceres stood up from the basin and turned and said nakedly *Try to love this incarnation*, and only then, like a joke confirmation of wisdom, did the timer chime, and for whatever reason I was to hear her voice saying *Try to love this incarnation* at various moments of fucking up far into the future. I lay there with the boulder sending cold vibes of steadfastness through my chest, pelted by drops flung off by the river, and I thought of how I had sat down in front of Roshi, the dignity and re-

pleteness of his person allied with the formality of the black robe whose spill lapped around him like the sand-waves encircling a Ryoanji boulder, what was affecting about meeting him was that he was immediately real, down to the fuzzed facets of his imperfectly shaven elderly skull he was real, down to his pared nails, to the blackness of his pupils, how hard and how long did you have to work in this life to come across as so immediately, vastly, eminently real to a random other, he was saying something, his Japanese translated by the translator my therapist was in love with, this person, the translator, the reason she'd asked me to accompany her to sesshin, to play wingman to her obsession with the translator, she'd needed a witness to her being in love and if it was a weird use for a therapist to make of a patient, okay, I was willing to sit there on the cushion beside her as an observer, a person acquainted with her impulsivity, who wasn't therefore too surprised when at the conclusion of this evening's session the translator ambled through the dispersing students toward us, only there was no *us*, there was only his smile at my therapist and her smile in return and his asking whether she'd like to go somewhere and her saying yes and not asking, not needing to ask, where, but she had been my ride to the sesshin, in her nice car she'd picked me up at the front door of the adobe where I lived with my husband—he'd called after me *Get enlightened*—and as I climbed into the front passenger seat and shut the door I felt honored to be enclosed in her *real* life, relieved of the distance maintained in her office, to be in her car was flattering, a vindication of the hard work I was doing to come across as sane, a person she could call her friend, and

if I was her friend that must mean I had gotten free at last, as she had been rooting for me to do, of perfectionism. I would be her rock in the rushing vulnerability of being in love, I who had never been anyone's rock. Once silent zazen was over, the interpreter asked who would like to meet one-on-one with Roshi. Anybody who wanted one would be given, in this private encounter, a koan. My hand went up. Alone with Roshi and the interpreter in an otherwise empty room, I waited for the riddle. The interpreter asked a series of questions meant to help the Roshi ascertain the right koan for me. As the interpreter asked and I answered and he translated into Japanese, Roshi presided in soundless, signless *presence*. He was in fact fathomlessly present. So it was true!—there was such a thing as enlightenment. His was a mercurial aliveness, like that of a fox or some other irremediably wild thing, which gives you pleasure just to be near, but also you start wanting wildness for yourself, you find yourself thinking *Why am I this and not a fox*. He spoke at last, gazing right at me. The translator translated: *How does the river run?* My therapist had said she sometimes found Roshi too austere, too commanding; when I'd asked *Commanding about what?* she'd said *He's used to getting whatever he wants, try finding a famous man who's not*, at my frown she said *The people who're capable of changing your life, they're not necessarily angels*, and though koans were supposed to be kept secret I wanted to confide mine to her, but she had gone and I was inchworming down the boulder, shoving off, ripped through by shudders of cold, thinking *How does it run? How does it run?* and as I was asking *How does it run?* there came a sort of floating self-notification, a light, bearable omi-

nousness, warning that I was halfway across with no idea
how to even begin to answer.

The romance of perfectionism worries me, the attractiveness
of its claim to superior susceptibility. For a birthday card, my
sister once sent me Arthur Rackham's illustration of "The
Princess and the Pea," its tower of saffron, pale green, and
rose patchwork mattresses crowned with a princess in pretty
distress. Princesses in other fairy tales have wolves to con-
tend with: she has a fucking *pea*. Try telling a new acquain-
tance *I'm obsessed with details* and they're likely to wince in
recognition, even to offer rival examples of detail addiction,
especially if the new acquaintance is literary and discerns in
obsessed with details the echo of Henry James's admonition
Try to be one of the people on whom nothing is lost! Perfection-
ism assigns you to Henry's tribe, the Nothinglostonus, zero
trying involved. Researchers can argue back and forth about
whether or not an adaptive form of perfectionism exists,
but colloquially, how bad off are you if your disorder can be
preeningly confessed? A leper can't say *I'm* such *a leper.* When
other afflictions overwrite reality with fantasy—alcoholism,
or addictions to gambling or sex—their self-destructiveness
is bleakly acknowledged, but perfectionism's rep as ambition
on steroids remains glossy: it can present not as delusion, but
as an advantageous form of sanity. The advantage lies in per-
fectionism's command of the sufferer's energies, its power
to intensify, focus, motivate. Its exalted goals are likewise
treated as plusses. A supposedly surefire means of pleasing

a job interviewer is to answer *What is your biggest flaw?* with *I'm a perfectionist.*

Moreover, the trouble a perfectionist gets into can be hidden. The materials necessary for her to damage herself are readily available between her own ears; she will never need to trek barefoot through a snowstorm to the 7-Eleven for a bottle of vodka. Perfectionism offers self-sufficiency *within* affliction.

How dangerous can that be?

Often, when I was dithering over a problem, perfectionism would intervene, dangling before me flawless elizabeths who would transcend limitations lightly, with every hair in place. Of course mistakes originating in the overestimation of one's abilities are appealing to perfectionists and nonperfectionists alike, with a dew of miscalculations precipitating all along the spectrum of wishful thinking. What sets perfectionism apart may not be the fact of wishfulness, but the degree of its tyranny.

For me, fantasies of exceeding competence again and again proved irresistible. No image of myself enchanted me more than that of sleek-haired, slender invulnerability, and while my first decision (if it can be called that, heedless as it was) one early-winter morning thirty-two years ago emerges now as an unthinking invitation to harm, at the time just the opposite felt true. *In dreams begins responsibility,* the compulsive mockingbird perched on a brain-branch had taken to reciting, the body of the Yeats poem didn't interest the mockingbird but with that particle it was downright obsessed, it whaled away, a frittering repetitiveness the rest of my mind was going

to have to submit to till the mockingbird tired out. It was anti-dreamy, responsibility, carnal as bone marrow; language for responsibility recognizes its origins in trapped or pressured bodies, responsibilities are *inescapable, arduous, urgent, weighty, burdensome, crushing,* there is *bearing responsibility for* and *carrying the responsibility* and *having to shoulder* and *needing to live up to* and *being overwhelmed by,* and I was drafted into solicitude, given something to carry—me, who tended toward haphazardness even about things that mattered to me most. Impulsivity suited me down to my nerve endings. Patience, I experienced as a numbing imposition. My father's favorite rebuke for perceived ingratitude from a child—nearly always me—had been *I keep a roof over your head,* said often enough and in a tone so complicatedly composed of righteousness and cajolery that even now writing this down brings his almost-lost voice back: the way it felt to be near him, to be pinned in place by blame, to love him in silence. He had kept the roof over my head, but it was his unpredictability that prospered in me, it was as if negligence was my first language, the one I felt most like myself in, most genuine and spontaneous, while in speaking other languages—responsibility, diligence—continuous parsing and management were required, the stiltedness of translation became oppressive and I would begin craving the sabotage that would return me to the known, it was as if my true work was to extend the charged atmosphere of my childhood into the entire rest of my life, as if when a fuckup was followed by incandescent blame, even if all this was done by me to myself, I was inalienably at home, I *belonged* and nothing had ever been lost.

All of that was going to have to change now, at the very time
I felt hormonally downgraded from brilliance, shoddily reli-
ant on my husband for the management of practical matters,
not a way he wanted to live, he began discreetly communicat-
ing his resistance, then not so discreetly, staying out late at the
locals' bar on the windswept red-dirt corner where our miles-
long dirt road debouched onto the highway, a bar notorious
for fights, whose sign flickered first through the word *Saints*
and second through *Sinners*, a tilted white-neon halo over the
S of *Saints*, a red pitchfork clasped by the *S* of *Sinners*, and
when my loneliness bit worst I would drive our dirt road at
midnight and park close enough to keep an eye on his pickup
in the shard-glittering desolation that served as the bar's park-
ing lot, lowriders whose chrome glimmered with mobile radi-
ance from headlights passing on the highway, each lowrider
given a wide margin, set apart in an isolation the other vehi-
cles honored, in collective homage to the glamour of the
candy-colored paint jobs and because a single drunken scratch
while backing out would mean hell to pay, apart from the spa-
ciousness conceded to the lowriders the scene was more or
less chaos, old trucks parked higgledy-piggledy, displaying ev-
ery variation of disrepair, one night I parked next to an an-
cient Dodge whose windshield was missing, but the most I
ever did in the parking lot was to cry for a while before back-
ing up ultra-cautiously and driving home, and hungover or
not he was sweet to me in the mornings. If confrontation
could be avoided, I could hoard my psychic supplies. As I saw

it I was now far more responsible than ever before, and I didn't
know what difference it was making, however effortful the
generation of responsibility was, it left no vapor trail, it was
just gone, the purity of its disappearance intimating the flu-
ency and constancy of the tenderness I was going to have to
manufacture in the near future and how tracelessly that ten-
derness would be absorbed. For ongoing grown-up obliga-
tions to be required of me when I was desperate *to figure out
how to do this* was unjust and worse than unjust, alienating,
but my husband wasn't the only one who asked, my life as a
writer came with commitments, some of them sprung as sur-
prises, as honors, and not only was I bad at saying no in gen-
eral, I feared there would be some cost in entirely breaking
with that world, disappearing from it for the duration, so
when appearances were asked for, I went, and was on the way
to the Albuquerque airport for my flight to one such commit-
ment just after dawn when I had to get off the bus, and
because my bag was stored in the luggage compartment the
driver, too, had to descend the stairs and come around the
side of the bus to unlock the compartment packed with duf-
fels and hard-shelled suitcases like my ridiculous orange one,
and when I pointed he hoisted it out, and the embarrassment
of imposing on him, of having stalled him and everyone on
the bus in their transit to wherever they needed to get to was
keen enough to obscure the dangerousness of the decision I
was committing to, standing beside the idling, rumbling
bus, whose windows overlooked us, and our consciousness
of being observed allied us in five minutes' stilted perfor-
mance, the Greyhound bus driver and me, his performance of

thwarted protectiveness, mine of—well, I wanted to look as if I knew what I was doing, consciously and I'm sure unconsciously I was radiating resistance to further questions precisely because I did not know what I was doing, of the two of us only he could grasp how vulnerable I was about to be and the somber obligingness of his body language in setting the blaze-orange suitcase down beside me would have been enough to enlighten another, more *present* person about the craziness of what she was doing, but not me, and however worried he was, he was efficient, when I said I wanted to get off he had said, startled, *I can't let you off*, and when he saw he would have to he said *We can wait*, and I said *Don't wait*, he must have felt he had carried intervention as far as he appropriately could, and in resisting his attempt to talk me out of doing the very thing I was doing I was a problem not easily dealt with, which he had no more time for and was going to have to drive away from, but the detachment required for the act of driving the bus away and leaving me there wasn't coming easily, his brusqueness had an insulted quality—the insult being this: what was being asked of him diminished him. At the time I didn't have the wherewithal to grasp any of this, though I was trying to keep my dissent from his advice courteous, out of fear, the fear I always felt of male retaliation for perceived slights, and this, too, the tincture of fear in my share of our minimal dealings, may have been visible to him, exasperating, since what he wanted was to rescue me. Bluish stoles of exhaust slung themselves around the rear of the bus as a cat's tail wraps its haunches when it sits. It came crawling past our knees. I wondered what kept the smoke close to the

ground—did the cold prevent its diffusing?—and how I could get away from the smell, in short how I could convince the driver to go, and just then he turned and mounted the steps and took over the bus again, and everyone at the back was watching as I lifted my suitcase and walked off to give a small wave to the driver, leaning forward over his wheel, not yet willing to relinquish eye contact in case the last-minuteness of this scenario should induce me to change my mind, and he was right, I could have, I almost did, and the kindness of his patiently wanting me to be all right, his gaze's solicitation back to safety, his seeing what I could not and the one-to-one human valuing implicit in this remarkable, unremarkable departure from business-as-usual were lost on me, the need to vomit was mounting even as I returned his gaze, and when the doors accordioned shut and for better or worse my choice was made, I was glad and gladder still when a roar relaunched the Greyhound. At first it rolled slowly. For those observing from the rear window—people had been sympathetic; someone had called out *Don't get off, there's nothing out there*—I must have had the idiot staunchness of a scarecrow, my black coat flapping. For some reason it struck me as crucial to appear poised in the wake of my conceivably disastrous decision, maintaining an air of bright composure. But the work of maintaining it turned acridly lonely, all of a sudden. When finally the bus seemed far enough away I shuddered and hid my face inside the gloves whose costly new-leather smell had helped keep the nausea at bay while I was on the bus. I was very capable of imbuing objects with intense significance, I'd done so all my life, or—not *done so* willingly, but since

childhood often had the experience of instantaneous convic-
tion about an object, its valence, whether it was charged like
a battery with potent grace or had the dead meaninglessness
of manufacture, and out in that blazing-cold desert I felt justi-
fied in having invested the gloves at first sight with something
like transitional-object magic because look what they'd done,
they'd saved me, and it was as if the desire that hit when I
noticed them on their shelf in the expensive store had been
foreknowledge of their worth now that I was out in the mid-
dle of nowhere *needing* them against my face, needing this
snug ostrich reprieve from whatever was going to happen
next, and it wasn't the first time I'd needed them, getting
dressed in the dark that morning I had admired the gloves as
if they belonged to some other, perfect woman, talismans of
the sophistication I did not in the least possess, originality,
too, signified by their being bright red, and I was like that,
given one perfect thing to work outward from I could man-
age to assemble my persona for the trip and the reading sched-
uled for that night. And I worried about them, as I did about
all perfect things, worried I would ruin them, these gloves
whose new-leather scent I took steadying breaths of, trying to
placate the nausea just then turning from a promise into ac-
tual movement, acidic upward gushes I swallowed down un-
til I had to give in and vomit, hunkered over my knees with
my hands flat on the ground, rocking forward when the next
spasm rolled through, trying not to splatter on the flapped-
forward tails of my coat or in my hair or on the gloves, ran-
sacked till I was dry and bright-minded and relieved, able
to stand up alone on a long-shadowed planet, chamois and

rabbitbrush yanked at by wind, rolled over by cloud shadow.
No help in sight, which for some reason amazed me. The cold
felt sharp enough to put an edge on the visible world but the
land resisted it with soft hues and folds, the ruched rims of
old arroyos, distant mountains ranged in layered translu-
cence. I spat repeatedly. Wow, my high-heeled boots were stu-
pid, worse even than my suitcase, which was going to be
tough to lug across the six lanes between me and the small gas
station over there, my only chance of a telephone. No neon
showed in the station's windows and its parking lot was empty
and what made it appear even emptier was the skinny dog
trotting across. If I hadn't been on the other side of the high-
way from it I would have called to the dog because to be
glanced at by the dog would have made me feel I had a little
more hold on life which was threatening to get away from
me. Clouds in the east looked as if they had been swept from
the earth upward like reversed cascades of snow, sheer blue-
tinted launches of snow whose radiant-dust edges were an-
gled as if being towed along gently, and miles overhead these
swathes culminated in prodigious glowing mother-of-pearl
brains. Before long my plane would fly through them. I
wouldn't usually have taken a bus, but my husband had to go
into the office that morning and I needed to get to the airport
for my flight to Washington, DC, for that night's reading at
the Library of Congress, an event I was overjoyed to think
might impress my parents, who were very pleased by the tick-
ets I'd sent, their tickets to my perfect restoration of our rela-
tionship. In order to carry our reconciliation off, every detail
of my clothing and appearance and manner needed to be just

so. Washington was their hometown, and if I chose a story with no sex in it and no blame of any mother or father, then this, their first attendance at a reading of mine, might go okay, and afterward I was going to tell them I was going to have a baby. In these early weeks I was experiencing the most opulent sleep. The more I had of it, the more I wanted. I slept and slept; then the need to vomit woke me and I knelt before the toilet and bile thrashed upward. Some days, the vomiting tore through every couple of hours, and why I had thought I could get away with a bus ride followed by a cross-country flight and an intimidating public performance on whose success the future of my relationship with my parents rested was obscure, on that gusty road shoulder I had no idea what I had been thinking. Except of course I did: perfectionism was my reality-neutralizing opiate, promising my inadequate nausea-prone self could be easily discarded and replaced by a creature of red-gloved stylishness and health and readiness to take on the world. Perhaps it was only ever my mother and father, whose vanishing it had once failed to fend off, who mobilized perfectionism to its most violent incitements: it was thrilled at this chance at minor but, in my parents' eyes (I imagined), redemptive fame. After that crazy U-turn away from graduate school, look how far I had gotten: books were out with my name on them, handsome volumes with borzois on their spines the same as John Updike's had. The absence of traffic meant I was going to make it safely across the highway, and I did, hastening, strands of hair lashing, eyes tearing up from self-pity and the wind, and once across I could tell that the gas station was a ghost of itself with no sign of being about to

open any time soon, but there at the edge of its parking lot loomed the most merciful phone booth in human history and its accordion-hinged door closed almost all the way, leaving the wind only two inches to whine in through, and the glass of the booth was hazed with etched, scratched inscriptions, initials and hearts and *fucks* and *sucks* and *pendejos*, and being shut up inside so much raunchy communicativeness induced the need to vomit again, the need that had made me pull the emergency-stop loop on the bus made it impossible to respond to the bus driver's *Not here, sweetheart, there's nothing out there*, except by saying *Let me out, please, just let me out*, other passengers murmuring their pity, the shame of being about to go down on my knees and make disgusting sounds in front of these kind others and the cloying vitriol smell bound to make them nauseous in turn and how embarrassed for me they would be but also resentful, wondering why they should be held up by such grossness when they had planes to catch, none of it was bearable, not to me then—unbearable to vomit into the red gloves that declared my desire to be a famous writer. That had been the absurd truth. I hadn't yet tried the phone. I was afraid to find out it wouldn't work—often this kind of Edward Hopper bleakness in a gas station meant the receiver would have been left dangling by its metal umbilicus— and worried about intruding on my husband's morning. The meeting he had gone to was an important one; he had a reputation for bohemian unreliability as it was, without his bosses witnessing the dramatic interruption this call would be. My awareness of the jeopardy my call would put him in made me lonelier and my teeth were chattering from the cold. He was

working as an insurance salesman. He was intensely affable without being in the least convincing. He had never said so, but I sometimes thought he had begun to believe I was getting to be ashamed of him, and when I imagined I saw in him various insecurities and a devious new tendency to undermine me, it was as if I no longer knew him; but I wasn't sure whether these perceptions were true or some kind of hormonally induced paranoia; I could barely *think*, and when I found quarters and picked up the phone the dial tone lullabied and I was happy until the receptionist at the insurance office flat-out refused to interrupt the meeting. By the way she said *Is it an emergency?*, I understood I should be ashamed of needing my husband then, and as I was about to say *Pretty much*, a truck rolled past and pulled up in front of the gas station and sat there idling out plumes of exhaust whose taint the wind carried to the phone booth and I told the receiver I would call back later and hung up. The driver of the boxy white truck was looking my way, smoking in a manner suggesting, somehow, helpfulness. On the side of the truck was painted a brown loaf of bread with slices fanning from one end. After a minute or two I stepped shyly out of the phone booth. He waved. Listing to one side because of my suitcase, my hair whipping, I crouched-ran toward his truck and he leaned to lever the door open, and when I paused he said *Come on in where it's warm*, and I climbed in, hoisting my suitcase after, and once I was in that truck and close enough to feel what he was like all stupid needfulness drained from me and left alertness in its wake because something, I didn't know what, was wrong about him, it just was, it didn't matter that he was

nonthreatening in appearance, clean-shaven and wearing the
company uniform, and he levered the doors closed, shutting
us in with the bread, and I wondered if the doors locked or if
I could get down the stairs and throw myself against them
and break through, and he saw the thought and gave his head
the slightest of shakes and as if accepting that the head shake
needed accounting for, before worse meanings could coalesce,
he said *Hey, come on, just get warmed up*, he was looking out for
me, was all, and hadn't I consented to being looked after by
entering the truck, wasn't he just a good guy answering the
second-guessing remorse I was trying to keep hidden from
him, advising me not to act crazy but to take advantage of the
warmth I had believed I needed or I wouldn't have come into
the truck in the first place, couldn't he reasonably have won-
dered what was wrong with me, *How far off was my intuition?*
was a question asked only by the most superficial, most
wistful-for-normal water-strider mote of consciousness rid-
ing the flood-skin of intuition, the steady pour of terror more
urgent in its hiddenness, in the advantageous ruse, as I saw it,
of keeping terror out of the social equation as long as possible,
whatever impulses toward restraint (in hesitations, in dips of
tone it existed: his restraint) or actual rather than manipula-
tive courtesy he felt needed a social field to assert themselves
in, if the social field was stripped away those impulses would
be cast into outer irrelevance, the continuousness of his ac-
count of himself, to himself, as a good man would have been
damaged, and *by me*, my perception of him as dangerous,
should it show, a weapon immediately turned against me, my
fault for bringing it into the open, dangerousness, when he'd

been doing what he could, when he had no intention of, when
he'd only meant to, but look what she thought of me, *she* went
there first, it was possible he did not know what he was capa-
ble of, had not yet decided, and there seemed to me an advan-
tage in no one's having decided, in maintaining the plausibility
of this encounter's basic innocence, closely bound up as it was
with *my* innocence, innocence of thought, of perception, in-
nocence in my stance there in front of the closed doors, inno-
cence of my shivering, innocence in my gaze seemed like it
might count on my side somehow, I had little idea how to
carry the deception off, my face, small-boned and made for
subtlety, probably wasn't helping, I was told throughout child-
hood that whatever I felt could be read in my face, to me it
seemed we were both engrossed in performance, in choosing
what was to be signaled, divining the consequences that
would spin out from there, him at the wheel of the idling
truck, me five feet from him at its door, immobility seemed
like the most innocent way to occupy space, the gestures I'd
made toward getting warmer had been exaggerated, when he
studied me clasping my gloved hands to my cheeks I felt
weirdly ashamed, phoniness could offend people, men, in
even ordinary situations, how much could you guess about
what a person was likely to find offensive, was the spic-and-
span interior of the truck company policy or his preference,
though it wasn't in terms of square footage very big the front
of the truck felt like a boxy vacancy focused on the steering
wheel where he sat in the vehicle's only, and very simple, seat,
apart from the tiers of bread the whole truck was unusually
empty, the floor mats of trucks in New Mexico were never

this clean, if he abandoned the truck there would be no sign of his ever having been there, his uniform similarly imper- sonal, if his name was embroidered over a pocket his jacket hid it, he was one of those men for whom the saying *nothing, not a hair out of place* was true but at some cost, though it wanted to curl forward his hair had been groomed back from his forehead with some sort of pomade (pomade?), because he was sitting I wasn't sure of his height, only that he was taller than my husband, stockier and more inward, yet with an air of readiness, it strikes me only now that one of the things you know instantly about those you encounter, how good-looking you privately deem them to be, that quick, gratifying estima- tion was absent, I had no awareness of his looks as *looks*, only and intensely in relation to his essence did his appearance of- fer itself, he seemed confident, he had all the time in the world, I was wondering about the door, how hard it would be to get out, maybe his unfussy quietness was proof he had nothing in mind and while he went on studying me I kept still, immersed in desperate interpretation of subtext, inten- tions that slid across his mind slid across his eyes in the form of briefly intensified opacity, nictitating membranes of fan- tasy gone in a blink, and it was cold terror to be in the pres- ence of such fantasizing, a gesture as inconsequential as his little finger's lifting from the wheel to point at me to under- score the words *just stay there* lit my nerve endings, what did it mean to be pointed at, was it meaningless or a first, subtle vio- lation of the aura around my person, the realm that, though it was only air, was necessary psychic clothing, and I be- lieved it to be crucial, the zone of inviolability he and I were

enormously aware of and pretending did not exist, and point-
ing is interesting because even if the gesture begins small-
scale, done with a little finger whose nail is too long, the
gesture's energies extend outward from the point, that's what
pointing is, the gesture's object is identified, singled out, pos-
sibly accused, the menace implicit in pointing was why the
Dineh relied on juts of the chin to indicate what was being
referred to, in the bread truck it came back to me how delight-
edly savvy I had felt at nineteen on the dig in Chaco Canyon,
jutting my chin at the raven alighting on a fence post to await
a feast of crumbs, how embarrassed when the Navajo boy
sharing the table had laughed in a startled whoop before re-
gaining composure, the boy I liked, and as so often my body
was quicker than my mind was to get the hang of the situa-
tion, my laugh a sweet reflex, we were in it together, white
girls should go ahead and point at ravens, *Just stay here where
it's warm*, the bread-truck guy had said a second time, why a
second time, what was that about, my sense of him was that
he was not impulsive and the steadiness of his studying me
seemed to bear the conjecture out, a second time could seem
like a warning, what would the warning be, not to misbe-
have, if that emerged, if a warning for me not to try to get
away emerged and hung itself flagrant as a banner between us
there would be no going back, and it was as if reality had all
along been a substance, an encompassing transparent mem-
brane visible now as it warped sideways, and I could see his
thinking as he had seen mine, and I said with a sort of pure
authority I didn't know I had in me *I'm pregnant*, and his ex-
pression told me that meant nothing and I said *I'm going to be*

sick, and in the boxed-in, purringly warm, spic-and-span interior that did mean something, vomit would be horrible for the bread, and I said *I'm going to be sick* and could feel it turn true, burning its way up my throat, and I said helplessly *Right now!* and he levered the doors open and I banged my orange suitcase down the steps, out into the buffeting wind, walking fast to the phone booth, feeling his gaze on my back, feeling him thinking *She was lying*, and only once I had the receiver in my hand did I look back at the truck. I held a long pretend conversation while that truck idled. He didn't get out. He didn't get out. He didn't get out. But I was not far enough away to be sure it was over, every detail of what I did could be seen through the glass, and it dawned on me that in my performance I'd missed a step, I hadn't rummaged in my bag for change, I could do that now, could feed coins to the machine till black vacancy yielded the aural drizzle of the dial tone, I felt I needed to keep an eye on him and needed not to let it show that I was keeping an eye, only that was the kind of thing I had just definitively proved I was bad at, in the bread truck, not letting things show, I'd known it before but had somehow nursed the daydream that if ever I ended up in real trouble, if my life depended on it I would effortlessly shed my usual inadequacies and a fine new elizabeth, courageous and quick-witted, would emerge to deal with threat. There wasn't anybody in the truck stop to accept a delivery of bread. He didn't like what I had done, getting out of the truck. The rudeness of it, the insolence of my being involved in a phone call clearly fake. Fakery was stupid, not as stupid as my having gotten into the truck in the first place, but still, stupid, if

something happened to me wouldn't that be one of the questions asked about my disappearance, passengers on the bus would remember where I'd been let off, the bus driver would say *But she insisted,* the person who'd said *There's nothing out there* would say *I told her, I said there's nothing out there,* and it was likely the driver would have a fairly accurate sense of where he'd stopped the bus and could describe how far it was from Santa Fe, thinking to add *There is a truck stop, other side of the highway, too early for it to be open but she might have gone there,* it wasn't far-fetched for him to recollect the truck stop if he drove the Albuquerque to Santa Fe route as well as the southbound route from Santa Fe, the interior of the shop was well stocked, the placards in its window unfaded, its windswept lot empty of the old car tires that spelled abandonment in New Mexico, after all in real time the sun was just barely up. The bread-truck driver sat there, why. The one and only thing for him to look at: me in my glass box, performing calm connection. He didn't take his eyes off me. I hung up from that pretend call, I rummaged, I found what was needed, noticing meanwhile I had lost the gloves though I had no remembrance of taking them off, *When was the last time you saw them?* was what people asked of the lost thing, *Are they somewhere?* is what I wonder now, and while the phone rang each ring was an increment of safety, the world's proffer of concern, ringing with the protectiveness I deserved, only it was not true, when I turned and caught the eye of the man in the bread truck and felt again the profound slippage into some other, ongoing story of what I was good for, a story being written, if it was, in

a mind whose acquaintance I had foolishly made, that I was precious to myself was in fact a matter of indifference to the arroyo, however distant, where I would have been found, the skull of the Pleistocene antelope had held as much aliveness as my head did now and I remembered what I could not afford to be conscious of in the truck, in the ultra-visibility of my freaked-out exposure I closed my eyes, time doling out its seconds slowly, fourth ring, infinity, fifth ring, infinity, sixth ring before the secretary could answer with the name of the company and *How may I direct your call*, a recitation that held me for some reason spellbound in its surreality until she said again *How may I direct*—and I said my husband's name, aware she was probably steeling herself for another refusal and preempting that refusal by saying *This is an emergency*, and when the silence suggested she didn't believe me, *You need to get my husband now, I'm stranded in the middle of nowhere and he has to come get me*, just barely keeping myself from saying *fucking*, get him *right fucking now*, that grenade not nearly as common then, viewed then not as proof of scorched sincerity but craziness, and I could hardly risk that, and who knows why she got it, heard the ferocity of despairing need which I was both sorry to have had to show her, because it was fucking private, and proud to have been able to summon on my own behalf, except it wasn't mine alone, and when she said she would go find him I said *Listen please write down this number because I'm not sure when this call will run out or how many quarters I have left and he might need the number to call me back, I'm not at home, without this number he'll never find me*, proud, very proud to

have foreseen that contingency, I had managed that at least, thought of that, it didn't counterbalance the sickening mistake of having gotten into the bread truck, nothing could, ever, that was always going to have happened, I was always going to have shown such fantastic stupidity, to have risked not only my own life, but at least I struck myself as thinking clearly now, now that I had entered into a new relation with the world, beautiful, terrible, beautiful I had known, terrible confided to me in of all places a bread truck, I was in possession, happened to be in possession of so terribly much to lose, *not very* was the answer to *how far along are you*, the socket of my pelvic bone, if a finger had been run around the rim of its central oval in the far-distant, infinitely detached future, wouldn't be sufficiently altered to confide the truth of what I was responsible for, more than responsible, already in love with, in love since the blue + floated into visibility, the universe plus one, as rushed and emphatic as tears, the float into visibility of the little sign made me wet, bodily receptivity as sparklingly instantaneous as tears arising from who knows where, they never feel like they come from right behind the eyes, more like from darkness, how glad I had been of my cunt's *yes*, how even proud of my arousal because if it began with love how could it ever go wrong, surely after that *yes* responsibility would glide into place, in dreams begin, I had only to enlarge my soul, but wasn't that a lot, an endeavor that reflected well on me not because I'd carried it off but simply because I'd thought of it, virtuousness laid the groundwork for the project of enlargement, of transcending an inheritance of damage, no one had done it for me, the unseeingness that

had diminished them they'd passed on, when she left the phone to go find my husband I pitied myself because with no inheritance of caretaking I was going to have to invent its gestures and intonations from scratch—the whole mother-child cosmos, from scratch, invented by a woman who had willingly gotten into the white truck. And I could see how badly it was possible to fail and let harm in. Without meaning to. Without ever meaning to.

Part III

Because it was three-quarters of an hour when I could *think*, and thinking was as close as I had come to writing since being hired to direct Stanford's creative-writing program, I loved the commute home from day care with my son in the back seat, and if my head hadn't been full of my own concerns, he might have entrusted more news to me about what being alive was like for him, at six.

A part of mothering that gave me trouble was the power of frustrations that should have been minor, easily dealt with, to evoke the dicey fractions of an instant when my mother's long-ago anger emerged. Often the evocation was visual—her flat-open hand swung out of black space. It didn't connect: the image lunged toward me and paused. This liminal teetering, pre-violence, offered a double vantage point, mother's and child's, which a completed blow would have dispelled, locking consciousness into one or the other, assailant or assailed, and within this double vantage point her anger was a taste

I could taste, an exhilarated bitterness, even as the emotion that had actually been my own swept in, shock, and within shock, readiness for the worst she was capable of—that's what's strangest, that mischief glee of mine at havoc's being about to materialize. The gladness with which some aspect of my psyche greets eruptions of violence, seeming almost to experience them as a resumption of the real life running along below lesser, disguising existence, confuses me, and my every attempt to wish it away has failed: it exists, for me—in me. My trouble was with these tiny scenes' sense-flooding vividness, their attempted saturation of consciousness. For instance if my son did something that would have earned a harsh word from my mother, I not only heard that word but experienced the haywire animation that was the character of her anger. Was that *being* her? By the odd means of rushes of anger I regained the young mother I had loved—I was sunk in her, made to recognize that whatever harm she had been capable of, I was capable of as well. Again a sort of duality pertained, because I was both inhabited by her emotion (so it felt) and pitted against the behaviors it had inspired. The margin of my self that was *pitted against*, I nursed, I guarded, I spoon-fed with self-help and object-relations theory, communing with the mother I carried around inside my head, proving over and over *See, this is how to love a child*, and—this phenomenon yields a multiplicity of doubling—I found that through resisting the repetition of various violences I seemed to reach the child I had been, and even to comfort her. After seeking for so long, with the help of my series of therapists, to restore this child-self to wholeness, I found her accessibility now astonishing.

Unfair, too—suppose I hadn't become a mother, would she have gone on sulking in the unreachable depths? Strange to encounter in day-to-day mothering the original occasions for long-ago wounds, to feel *something* set right. But of this covert, reparative involvement with my child-self—who kept pace as my son grew, her age corresponding to his—I was a little bit ashamed, as of some secret greedy practice like hiding the *good* chocolate from my six-year-old. Patience and consolation should be between him and me, not bestowed on some forlorn little ghost of myself. But there she was. Whenever some hurt of my son's invoked a far-distant hurt of my own, I had the chance to hold not only my son but the child-me: gestures of care she had pined for materialized simultaneously in the present and in the past. The template for each gesture was the shape of her longing, the tone of voice that would have soothed her tears was the one I spoke in, to my own boy. These gestures, that tone went against the grain of vivid inheritance. I made them up. They partook of the happiness of *making* in general. "For the perfectionist," Adam Phillips writes, "to be 'good enough' is no good. For the perfectionist, for example, there could be no such thing as a good-enough mother," but ordinary though my good-enough care-gestures plainly were, nothing to write home about, my being able to make them aroused the possessive incredulity I would have felt at suddenly being able to write sonnets or perform heart surgery.

At my worst I felt jealous of my son, steadily loved as he was.

I had the luck of finding him tremendously interesting, a

luck originating for me, as it had failed to do for my mother, in his newborn gaze; and for me, made as I am, interest proved to be the best possible antivenom for perfectionism—perfectionism is in a sense the failure to be interested in things as they are, or people as they are, the mortal loneliness of perfectionism originates in its blindness to what is right before one's eyes, to sentences as they are, a newborn's gaze just as it is; the perfectionist's interest is reserved for a fixed destination, the perfect version of the page or child, toward which the actual sentence or child can be forced to move, and because the preternatural attunement of a child craving love divines that destination, the parent's perfectionism can imperil the child's ownership of herself and warp her into an ally in the pursuit of the unreal, a deformation of the soul object-relations theory calls *compliance*, of which the creation of the false self, the self designed to fit parental specs, is an extreme form. According to what writers call the logic of the story, meaning the expectations a narrative generates as it goes, which the narrative needs to be conscious of as it unfolds (even if it ultimately chooses to dodge those expectations, or upend them), my first sight of him ought to have been a gamble, I ought to have searched him head to toe for the flaws that would alienate me, but I didn't, I didn't even properly fear the risk of being blindsided by revulsion for him as my mother had been for me, I just, when it came down to it, couldn't work up any dread about how things were going to go for the two of us, for the odd reason that I trusted him. While I was pregnant it didn't matter to me that my conviction that the baby was rooting for me to be able to love deeply was a faculty

I dreamed up and attributed to him, and it doesn't matter to me now, if in reality—"in reality"—his contribution was not telepathic but merely—"merely"—hormonal, physiological, the him-and-me pairing of pregnancy created a love I knew myself to be incapable of, and I mean that with the most vehement literalness: *incapable*. In one third-trimester dream he did cartwheels across the lawn of my childhood, in another, he and I had a long talk. Ultrasounds had revealed his snub-nosed, bulge-eye-lidded face, in there, sucking his thumb. One session we watched as his lips parted and the thumb escaped and he roused himself, bowing his head toward the hand adrift nearby, nuzzling after it. He had a *will*. His quest for the companionship of his own thumb, there in the solitariness the ultrasound waves flexed through, moved me to tears. And then he was held up naked in white operating-room light, and when his father shouted *My boy!* his blood-streaked head swiveled toward the familiar voice, and if my wrists hadn't been fastened down with restraints for the cesarean, I would have reached for him.

From early on he had a sturdy sense of his rights, a funnily intense apartness I worried originated in his fear that as a single mother I might require shows of affection or a precocity flattering to my mothering; though given an audience he was transformed and became boldly entertaining, when he and I were alone, especially in the car, we could pass through intervals of musing silence; because he'd sometimes shown weird flashes of eloquence it was always worth waiting for him to speak. This chance could be ruined by my inadvertently broadcasting distress. Because look at me behind the

wheel in my heels and pencil skirt, distracted by the may-
hem of the about-to-be divorced, run ragged by my new job
directing a famous writing program whose faculty is riven
by feuds. As far as the job of director went, my ambition to
be a wise conservator of the extraordinary creative-writing
program smashed headlong into my deficiencies. Among my
shortcomings was a tendency to the intense dislikes charac-
teristic of other-perfectionism, which judges others with per-
fectionist righteousness and finds them wanting, and they
of course naturally dislike the disliker. Right alongside my
growing sense of doom as director ran my distress at my slip-
shod mothering. I burned toast, lost keys, forgot stuff right
and left—Band-Aids, ingredients necessary for dinner, the
times of playdates, and, once, a class field trip to the Monterey
Bay Aquarium, which he missed due to my getting us to his
school just as the bus full of his classmates turned the corner
and disappeared; and if at the last blink of those taillights I
did not rest my forehead against the steering wheel and weep,
it was purely from the awareness that tears would mean
my kid's trying to console me and I wanted him to have the
right to anger and dismay and blame, a right he was likely
to exercise only if I gave every sign of being able to handle
them, from him—such, anyway, was my thinking, but he had
known how wretched I was, anyway. He could tell.

The loss may have taken place long ago, it may already have
been survived, but these realities fail to be communicated to

the perfectionism devised to defend against it. At bottom perfectionism is petrified panic.

Anxiety makes me a strictly eyes-on-the-road driver, but that evening I was scanning the road shoulder for teasels, whose prickly dried heads my son's Waldorf teacher had instructed parents to collect for a crafts project the kids were going to do, and when?—tomorrow!, meaning the teasels had to be found tonight—in fact, since teasels are weeds and the campus where we lived was groomed to horticultural perfection, finding his teasels was a now-or-never proposition. News spun from the radio, traffic competing in the Silicon Valley style of signal-less alpha-male lane changes. The prospect of my son's arriving at school tomorrow without teasels filled me with a shade of desperation peculiar to my years as a Waldorf parent. The aim of Waldorf pedagogy was to offer the lyrical, trailing-clouds-of-glory childhood available in 1843 in Somerset or somewhere, and hewing to this vision took incredible effort in Silicon Valley circa 1994, but the other parents were not kidding around, they really *were* constructing near-ideal childhoods for their offspring, or at least it looked that way, while I was managing no such feat. I hadn't yet told the analyst I made the eight-hour round trip to Mendocino to see about my mothering fuckups, despite the tolerance of his therapeutic manner I was convinced this new twist on incompetence would cause him to think less of me, or make me seem like more work than I already was, or both. Meaning no

disparagement, he had once casually declared my life *tumultuous*, and here was one more panic to add to the sweepings. Some lines of Plath's occurred to me often—except *occurred to me* suggests a wafty felicity, whereas these lines issued from some underground workshop where my at-risk sanity was actively cherished. Unmoored as I was, I seized on their orientation: the child. Two weeks before her suicide, Plath had written the poem "Child" about her boy Nick. "Your clear eye is the one absolutely beautiful thing. / I want to fill it with color and ducks, / The zoo of the new." That was as far as it got, in my head, but—color and ducks, I could do that, couldn't I? I could do that or its equivalent. I could do that though I couldn't sleep.

In this evening traffic I doubted whether, if a patch of teasels showed up amid the scruffy grass, it would be safe to pull over, but I was fixated on the road shoulder when my son said, "Mom."

I turned the radio down. "Unh-hunh, what?"

"What you need is more self-trust."

More tawny California slid by before I managed to say, "What?"

"What you need is more self-trust."

Out of the blue.

Also: wildly precise.

He'd made up the word, his first *interpretation* of me, ever—its accuracy was piercing, and I would have said *What?* again, meaning *Where did that come from?*, but he mostly resisted repeating himself. Based on scant dealings with other people's children, I had trusted motherhood to be a charming,

monotonous fugue of *why why why*, and my professor streak meant I had looked forward to countless chances to explain the cosmos to a short, easily impressed interlocutor, but with him, questions came *once*, lucidly, as if much thought had already gone into them. As if he had gone as far as he could on his own toward an answer, and only then posed his question aloud. At times, though I kept it to myself, his deliberating manner struck me as sort of hilarious. He could not *mean* it. Could not *really* be so different from impulsive, scattershot me. But he was. With me, at least, that seemed to be how he believed crucial things should be proffered: uniquely. I could rise to the occasion, or not. I did as much rising as I was capable of, for love; I did a lot of hoping it was enough. On our drives home he sucked his thumb, a pastime he reserved for non-school hours; he had taken his thumb out to say his sentence and his gaze in the rearview had a diagnostic directness. He wasn't condemning, he was merely, from the brimming sufficiency of his awareness of who I was, handing me an observation I could use, or not, as I chose.

"Okay," I said. "I'll work on it."

The traffic hustled us past a couple of road-shoulder brush patches showing the tall, spiky seed heads.

Long afterward I would come across a sentence of Plath's: "The worst enemy to creativity is self-doubt."

Whose opposite is *self-trust*.

On those commutes home from day care in the evenings, I wasn't overjoyed to find an icon of suicide in my mind, where some verifiably sane form of consolation ought to have emerged instead, to support the worrisomely expensive work I was doing with the Mendocino analyst. Plath's voice, even in bearable fragments, wasn't one I wanted to keep hearing. Whenever the thesis that perfectionism is linked to suicide is advanced, Plath gets name-checked, the genius sufferer who understood it from within: "Perfection is terrible, it cannot have children."

Of the twelve lines of "Child," the final three spell out what she wishes the child's eye had *not* been filled with: "Not this troublous / Wringing of hands, this dark / Ceiling without a star." For the longest time I thought it was strange for a poem that begins by exulting in the newness available to be given by the mother to the receptive child—the two of them brightly alive and desirous in stanza one—to trail off into the fourth stanza's dim clichés of abandonment. The impetuous joyousness of "I want to fill it" fixes the mother's living, breathing presence—nothing makes a person as real as giving something beautiful away—and the child's receptivity is figured by the first three words: "Your clear eye." Subtly, it's *eye*, singular, because the child is in profile—rather than anxiously watching the mother, he's sufficiently secure to gaze away from her, at the world, which it is the work of a child to get his fill of. The confidence evident in his gazing away, so necessary if the child is to go about the business of becoming, is a collaborative achievement, proof of her good-enough mothering, and for this treasurable bondedness to

vanish from the poem, for the pronoun *I* and the pronoun *you* to slip away, leaving in their wake the disembodied "wringing of hands" and the cliché-y dark ceiling the presumed but not named child-eye stares up at seemed not emotionally deliberate, but weak, like the poem just got tired of the joy it started with. I didn't think it was good. I didn't think it was strongly executed. That was a forlorn disavowal of an ending, it seemed to me.

I would read it differently now. In their cadenced brevity those last lines manifest wounded responsibility: the speaker trusts the reader to *see* what seeing is, and what enables or cripples it. Given her presence, her steady nearbyness, the child can gaze out at the world. The stakes, though obliquely conveyed, are high: he needs to take in enough world to become a full self. It's as if the essence of mothering is enabling clear, delighted *seeing*. She has, till now, companioned his gaze, desired *more* for it. With her imminent disappearance, such seeing will cease to be possible. He can't do it alone. His chance at realness and beauty and variousness: that's what's at risk, and the poem's most fugitive question is *What world will he be able to make for himself if I disappear?*

The deceptiveness of perfectionism may partly account for its being famously difficult to eradicate. Its aura of emergency seems endlessly renewable, and strikes the sufferer afresh each time, making it hard to identify perfectionism's futility *as* futility: its urgency cloaks its pointlessness. Often when I am in its grip I feel sensationally lucid, supremely ambitious. If

a detached observer objected *What you are doing is actually incredibly stylized and repetitive, the opposite of creative*, their reasonableness would be steamrollered by perfectionist heedlessness in pursuit of some fantasy or other.

By shepherding energy to predetermined destinations, perfectionism allows no margin for those serendipities of noticing that make the world real to us. "Child" is about fucking up the "one absolutely beautiful thing," about the awful erroneousness of having transmitted damage instead of the variousness, beauty, exuberance the world offers for the taking—the particular kind of taking that is clear seeing. The child's clear eye isn't the only locus of absorbed gazing in the poem. When the poem begins, the mother sees the child clearly. Conceivably the one absolutely beautiful thing in any individual's possession is her own life, possibly the poem secretly mourns the closing of her own clear eyes.

He, this analyst—he's my last try.

Last try at solving perfectionism.

Because he was my last try I kept my rented loft in a renovated barn in blink-and-you'll-miss-it Little River while teaching at naggingly complicated Stanford, and whenever my son was with his father I made the drive to Mendocino in order to come to this room again—except that sounds simple, and as if I knew what I was doing, when my decisions were made messily, often at the last minute, and ceaseless second-guessing was my style

Over the couch hangs a painting of three harlequins whose

gondola is passing facades of rose pink, amber, and turquoise, colors that seem unlikely, but how would I know; I've never seen Venice.

Of such a carefully contrived space you can find yourself saying, as I did in my first session, *Wow, the light is beautiful*—light being more innocently praiseworthy than the actual room, if the person responsible for its order is a straight male, liable by virtue of his gender and orientation to detect an insinuation of effeminacy in praise of the room's effect, whereas admiration for light leaves maleness unclouded, something was wrong with the way I was warning myself against fractal offenses against maleness, whatever was wrong about that was wrong with me not only in relation to the analyst but all the time, it was as if maleness were an incredibly frail construct requiring kid-glove handling, and after saying *The light's beautiful in here*, I stopped, and twisted around to gaze at the painting.

That perfection obsesses him as well, this intensely curated room has already informed me.

When I turn back, he's older. Even sitting, his bearing emanates sturdy authority. His beard is close-cut enough to seem like a kind of white glaze around his mouth, his sclerae are keenly white and, backlit as he is, the last unruly white filaments flare from his bald crown. He's maybe the least harlequin-looking person in the world.

The charm of the harlequins lies in their louche self-approval, the tallest of the three using his pole to prod their gondola along, and the most frequent thought prompted by the painting is one I might have about an enviable writer, the

thought *I need something like that*, like boldness, or authority, or joy, qualities inoculating the writer against the erasure with which I instantly oblige internal criticism. Between appointments I lust for this bad painting with the debauched longing a Gauguin might deserve. The door of the room has a window of opaque white glass. If it were valuable or even likely to be mistaken for valuable the painting would never have been left in a room whose door is inset with glass, because valuableness would be an invitation to breaking and entering. Does this mean everyone involved, analyst and clients alike, tacitly recognizes its shoddy whimsy, and for its nonvaluableness to be plain to one and all, doesn't a painting have to be more than mildly bad, doesn't it need to be flagrantly so, and if it is, what is wrong with me that I'm obsessed with it? It's hung high enough to be safely above the head of a patient much taller than I am, but unless they want to sit directly under the painting, clients must choose either the right or the left sides of the couch—probably right-handed clients prefer the right side, as I do, but in my mind the spot belongs to me alone. Beyond his armchair looms a ficus tree, really three individual trees whose slim taupe trunks had been braided together when they were supple twigs. Their plastic pot has been fitted inside a basket whose chunky coils are patterned with chevrons mesmerizing as a rattlesnake's; it must have been brought back from the travels he had as yet only hinted at—Vietnam, Kenya. Clots of fake moss have been positioned inside the pot to hide the soil, a detail I puzzle over. Who is bothered by naked soil? If the ficus has been recently watered, petrichor is added to the room's other scents. Possibly

the ficus is not rotated often enough, one side is lush, the side toward the wall twiggy and bereft. On its lush side, almost hidden within glossy leaves, hangs a single Christmas ornament. Forgotten. Or a joke. The unassertive gray-green velvet of the couch is silk, not synthetic, showing the rub of use, it's slowly wearing out, and for two years, then going on three, I'm in the habit of running both palms across that velvet as soon as I sit down, again whenever I can't think what to say, if a shrink was going to mind the poor transparent seductiveness of a client's stroking the couch he shouldn't have gotten velvet in the first place, I can't be the only one, I'm not trying to be original and I'm not trying, not seriously trying, to *get to* him—for me the stroking is more private than that, like telling the couch over and over softly *I'm here, it's me*, as when in a trance of private repetitiveness my son rubs his nose with the index finger of the hand whose thumb he's sucking, a gesture my father can't witness without saying *Take your thumb out of your mouth* because eight is, to his mind, well past the age when thumb-sucking ought to have been abandoned, when I argue that thumb-sucking counts as self-soothing and for a person, even a person only eight years old, to find in his own body a harmless, continuously available source of reassurance and pleasure encourages not the infantilization my father dreads but self-reliance, at eight years old that is what practicing resourcefulness and self-sufficiency looks like, moreover his devotion to his thumb is his right, I'm going to want him to understand his dominion over his body as only and absolutely his own, an understanding that begins with my regarding his pleasure in thumb-sucking as natural

and actually wise, if his need for oral gratification is satisfied
by thumb-sucking he's less likely to smoke or drink later, I
professorize to my father, meanwhile wondering if his irrita-
tion at his grandson's thumb-sucking reflects his having been
made to give up his own thumb-sucking long ago, my father's
irritation has a mean kick to it, bespeaking deprivation, when
I can I prevent his speaking to my son in that peculiar injured,
repudiating tone attesting to his own long-ago hurt because I
think that's how fucked-upness leaps from generation to gen-
eration, in that tone exactly, and for once, explaining the new
thinking about thumb-sucking, I'm indifferent to the sullen-
ness of my father's withdrawal, a sullenness I can scarcely
bear, otherwise, the sullenness I do whatever is within my
power to placate, otherwise; not this time; it's *informative* to
stand up to my father without cravenness; so this is what it
takes, the supreme love I have for my son. That's how I tell it
to the analyst whose room this is, who when the worst stories
are being recounted takes on an air of having been bruised
or mauled, himself, but most times emanates a large, unaf-
filiated empathy, only a little ragged around the edges from
fatigue, I'm not good at telling people's ages but he has to be
sixty-something, spruce, eager, fastidious, the precision of his
arrangements dear to him, and apart from my velvet strok-
ing, which fails to bother him, his reliance on order is rather
easily jostled, he's got a particular wince of a frown for the
instant of noticing something slightly awry, it's delicate, his
investment in the proper arrangement of objects and issues,
it's vulnerable, it's like me, I'm in love. *So this is what it takes.*
I say *Now I know.* I say *The problem is I'm never sure what I know*

will translate to other areas of my life, areas desperately in need of my knowing that thing, and he says *What thing?* and I say *That I can be uncompromising, and not get killed for it.* The delicacy I attribute to the analyst, his body contradicts. He might be hardly taller than I am, but his is a much denser presence, despite the gentlemanliness his clothes vouch for he's bandy-legged and barrel-chested, above the gold-rimmed Chekhov spectacles his forehead is a balded-back scoop confrontational as rhinoceros horn, and maybe fittingly for someone who makes his living listening he has cunning ears, small, ornate, tucked close to the skull. His living is also made by talking, the teeth showing now and then within the close-cut beard are fine, the voice accentless though he is from Kentucky, not that I know that then, but cadence can be harder to eliminate than inflection and to my mind a trace of evangelical call-and-response informs his analytic style, whose beckoning pauses I condemn as overly directive. On both sides, from early on, there's irritation. The distractedness I'm prone to irks him— mildly, he will ask why I am wasting our time. Two incompatible versions of him take turns dominating my attention. The first is flawless. Unerring in empathy, appropriately opaque. Chaste. Imperturbable. Wise. The second is a lonely, joshing con artist as mercurial as I am, as fallible. Vain. Also: mortal. His brute bald head casts his body into puniness, could his short-statured bandy-leggedness be the consequence of polio—given his age, it's possible, and I fear polio's threat to him as if it lay in the future instead of decades behind, I dread any incapacity that would deprive me of his presence (of his alternating presences, whose every shade and variation

I'm indiscriminately in love with), when I say so he neutrally points out my seductiveness. But its being pointed out doesn't mean it's not working, is what I think. I come to this room for the love he's bound to let show, the arms he might yet hold out to me.

We have our set pieces. *It's deadening my writing,* I will complain of perfectionism. *Suppose it was no problem,* he will answer, *suppose you wake up tomorrow and your perfectionism is*—snap of his fingers; another instance of his being too theatrical for my taste—*gone, nothing's stopping you, you can write anything you want, what do you write?*

About—I named the painter I was having an on-again, off-again thing with. The analyst said neutrally *About,* and I said *About waiting for him. Neediness, how I keep letting it show even though it repels him. The other women. His contempt. How he says "I hate people like you" and I don't care, the only part of his saying he hates "people like you" that bothers me is his thinking there are people like me, to him I'm a kind of person, there's a professor pigeonhole I belong in, in with the other abject failures at leading what he sees as real life, which because he was born here and has never gone anywhere he insists is possible only within Mendocino County, he hates it that I have money—not a lot but a lot compared to him: one night my son and I ate supper at his house, he didn't seem sure he wanted us to stay and I was afraid maybe another woman was going to turn up but he got out this huge wheel of cheese from the food bank and sawed down through it with a guitar string and it was as if he wanted the ingeniousness of his using a guitar string admired, so I admired it, which turned out to be a mistake, he heard condescension, he said if my son and I wanted to stay we couldn't*

*eat any cheese, he threw a fork at the cat. He threw the fork, he said,
"You bitch." But the cat was ahead of him, it did this dodge thing
and crouched back down right where it was, and, no, I told it wrong,
that's when he said, "You bitch," not when he threw the fork, but
when the cat crouched back down, just, you know, melted back into
place and stayed there. Staring. Which of course is me. And I don't
want any of this in my kid's head, and sitting here telling you this
I'm incredibly ashamed that I can't stay away from him, I'm afraid
of losing you, like you're sitting there thinking, Get the fuck out of
my room, like you'd throw a fork when I know you'd never, it's you
who matters, you I'm in love with, you who are good for me, because
I don't know how this ends, any of it—*

Tomorrow I was going to have to drive back down to
Stanford, I wasn't going to get back to Mendocino for two
weeks, the analyst and I were going to miss a session. Maybe
that's why I'd told so much all at once, why I'd said, as if it
were only another item carried along in the torrent, *I love you.*

Bachelor pathos of his argyle sweater vests.

Bachelor at, what, sixty-something.

No wedding ring.

He waited.

Was I done?

I seemed to be done.

He said *This is good.*

Pleated khakis, neatly shod feet embarrassingly resting on
the embroidery of the bedouin saddle serving as a stool.

What it would be like to shelter under such wise solicitude,
not merely for an hour at a time, but down through one's life.

How is it good?

What would it be like to get one's fill?

He said *This is a case of your beginning to see things clearly. However painful it is. And it is.*

After two weeks I came back to find his door closed—often, he let sessions run over, and I would spend twenty minutes or so in the waiting room's Victorian brocade settee, opening *Jude the Obscure* to the page bookmarked by a Polaroid of two sunburned kids bareback on an Appaloosa, but this afternoon was different, his light was off, the white noise machine absent from its customary station just outside his door. After as much silence as I could handle, I closed *Jude*, braced my notebook against the mahogany armrest, and turned to a clean page. My handwriting sloped and slewed, it wasn't pretty, but experience had taught me how *sticky* perfectionism is: to tear up that first try would dictate the tearing up of every subsequent attempt, I'd be left with nothing to slip under his closed door. The note that had started out honest devolved into compensatory feminine apology, had I made a mistake, gotten the time wrong? I had waited for him—my watch confirmed— three-quarters of an hour, the darkness of his office, the silence of the old building began to scare me, as I was writing *I hope nothing is wrong*, the outside door at the bottom of the narrow old stairwell slammed and the century-old risers cried out like the notes of scales plinked key after key, the concussions of his ascent slowing near the top, where, for him, there must have been a Schrödinger's-cat instant I was both there and already gone, the landing was reached, he turned

the corner. I'd barely ever seen him outside his office, but here he came, breathless, baseball cap and old jeans and muddied wellington boots, halting just short of the settee with an air of distraught recklessness. *You're still here*, he said, *my god I'm glad you're still here*, his *my god* rang handsomely, part of his vitality lay in liking to wrench good lines from the mess of utterance. *I was gardening*, he said, *and I lost track of time*. Not a car wreck, not a heart attack, a garden. Another habitat of his own making, quite elsewhere. Thriving green order, of course he'd be into that, the office ficus could have told me as much, his having a garden needn't have come as a surprise and, at this bad moment for heightened attraction to him, a fresh allurement, but it did, I was on the brink of being the person who could say *Let's go there now*, but as he had come to a halt a second ago, so did I, internally, wanting to prolong the sanctimonious eros of having the upper hand, the exclusive property of injured parties, not that he was particularly conceding I was one. He gestured toward the door we could now go through, him first, me hanging back to witness gestures and movements, when we were apart I was given to imagining the details of his sessions with other clients, his manner of unlocking the door, how he turned the lights on were revealed—I'd spent hundreds of hours in that room without the least clue where its light switches were—his habit, it must be, of correcting the angle of his chair before sitting, and I sat, and without taking off his baseball cap he nodded, he said *Well*, and I thought *Really—it's up to me?* and started talking, now that we were in *the room* he was not going to continue to apologize—a decision calculatedly therapeutic, it could be, since more soulful

apologizing might come across as defensive, possibly what
was being granted to me was the freedom to accuse him of
having done harm, to find my vehemence absorbed without
retaliation was the experience offered by his benign reticence,
but as so often freedom was wasted on me, I busied myself
with unrealities, chief among them the determined presen-
tation of empathy: under his sheltering cap-bill he was *real*,
therefore *bound to make mistakes*, in D. W. Winnicott's *Hold-
ing and Interpretation: Fragment of an Analysis* Winnicott quotes
himself telling a self-absorbed analysand, "It seems a funny
thing to say, but I think at this moment you are forgetting
that in fact I am alive," a remark that charged me with the
responsibility for cherishing the aliveness of my own, oddly
baseball-capped analyst. For twenty minutes I talked without
saying *You can't do this to me*, talked with dodgy formality, it's
how I stupidly compensate for awkwardness, I'm never more
awkward than when ruled by outrage—he had injured me,
he whose role was good-object *steadiness*, wasn't it blindingly
clear I needed all the help I could get, and not another straw's
weight of harm? Finally I said, with a sort of controlled child-
ishness, *I thought you forgot about me*, and he answered gravely
Oh no—the opposite.

A little more than a year later, in a clapboard shanty whose
hand-carved wooden sign reads *Mendocino Vintage*, above
a strewn and cluttered maze of display cases, on a hanger
hooked over a low rafter, the uniform of a drum majorette
awaits the return of 1959, its bodice of closely sewn sequins,

whenever the door opens, flaring from the dark like the breast of a penguin in an arctic dawn, the door closing, the uniform drained of hope, whoever's come in must reach up to tug its kick-pleated hem and say *Where did you get this*, it's a law the shop's interior instantly communicates to customers, it gives the owner the chance to look up from whatever she's doing and say *From a dead drum majorette*, a joke she'll work variations on throughout the store's successive reconstitution in bigger, handsomer, better-lit spaces until one winter afternoon she finds herself answering a customer who's asked *Where did you get this* about the Edwardian ring the customer has skivered over her knuckle, *Took it from the finger of a dead woman*, and the customer can't get the ring off fast enough, is almost in tears trying to wrench it back over her knuckle, and ends up getting a sizable discount when she decides she has to have it after all, but more often the dealer's boyishness alchemizes her taunts, intended primarily to amuse herself, into a sharp and original charm lost on exactly no one, and why butch nonchalance gets to carry off this trick of mischief's seeming cool remains a mystery, she's got a business partner and I time my appearances for days when I'm likely to find her alone, tinkering, repairing, polishing, so busy it feels like an honor when she looks up, a lick of blond hair in one bandit eye, and asks, "Didn't find the dress?," waiting amused for my answer, my explanation, which has entertained us both before, of how the right wedding dress eludes me, and I would like to get into it with her, I could use a dose of her amusement, except my son comes to the counter and asks politely about a knife whose handle is the antler of a spike buck,

he can barely see over the counter, nine and as obsessed with knives as I am with wedding dresses, and she says, "Sure," laying it on the rectangular pad whose black velvet is meant to set off glimmering bracelets and winking jewels—against that velvet, the knife has a homemade brutality—and I'm interested in the discretion of her nudging toward him not the knife itself, but the velvet pad, and then I understand her doing so affords him the pleasure of picking it up, all this accomplished without her needing to glance at me, the mother, as most adults would when the child is about to pick up a knife, already secure in the conviction that if I don't like something I will let her know, with casual regard for the independence so dear to him, somehow simply—it will turn out to be one of her great gifts—knowing the right thing to say, she says, "Tell me you'll be careful," he takes promises seriously and says, "I will"—as aware of her not having checked with me as I am; he feels honored, I can tell. Surprised, too. And so am I. Her getting him exactly, effortlessly right is sexy; also cute; done with such nonchalance, as if she caters to knife-crazed nine-year-olds every day and has it down. Lightly, her attention is on him. She can tell he *is* careful. The blade has a honed nakedness, small but serious, what my son calls a real knife. (My response: "If it can cut you, it is real.") Enough color and ducks: he wants knives. For carrying around, this one's useless. Its purpose has always been to be admired. Above the relative narrowness of its shank, its honed edge mimics the bulge of a swallow's breast; the niceness of the contour is the same, the same graceful receding to the long tail. The impression of intelligent balancing that swallows give, and

objects almost never. Plainly the knife has had a fortunate history of ownership. My son's carefulness shows his comprehension of the care others before him have taken. Lustered by its hundred years' cohabitation with the oils and unguents of skin, the antler has been saved from the aridity of dead bone. It's never been underground.

"How much?"

She tells him.

He's gazing downward, but we both catch his frown.

Now she checks with me—a glance—before saying to him, "Some things, you can just tell belong to a person."

He's hopeful. And hides it.

"I guess you have to have it?"

"I don't have enough money for it."

"Oh," she says, "I think we can work that out. You're coming back, right—next time you're in Mendocino?"

He turns to me. "In two weeks," I tell him. "We're back in two weeks."

To him she says, "Here's the deal. Five bucks down holds the knife for you. Second payment next time you're in Mendocino."

To me she says, "Don't worry. It'll find you"—the dress.

The opposite, the analyst said. *I'm in love with you.*

He wrote down the name of an acquaintance in Palo Alto, a colleague whose approach should be compatible with his own. By the stiltedness of his phrasing he deserted me, the notion of someone sharing his *approach* to me left me

incredulous, was that what he'd had, *an approach*, was that
who I was, a person he had an approach to, from which *I'm
in love with you* was an unfortunate deviation, a glitch to be
compensated for by this display of professionalism I found
transfixing, surreal; since *I'm in love with you* he had not ad-
dressed a word to me *as me*, possibly I had already heard the
last genuine words he was ever going to speak to me, in my
stead he was addressing an imaginary creature capable of en-
during the loss of him, he talked to her as if she existed, in
effect summoning her into existence, this person it was my
responsibility to become, who was going to be able to stand
up and walk out of this room for good, who was capable of
recognizing the slips and imperfections of an overall useful
and rewarding analysis, as he hoped ours had been; even as
I tried to take in what he was saying I was aware of another
conversation streaming along below our surface rectitude, in
this underground conversation I was raging *No, no, this can't
happen, I can't lose you*, aboveground he was commending this
colleague held in high regard within the community, oh as
if, the under-rant continued, as if the lonesome, floundering
man before me had any use for community—how long had he
had this referral up his sleeve? At what point had he guessed
he was going to blow it? The acquaintance might be willing
to take me on as a patient on an emergency basis—the tone
of *willing to take you on* was, to my ear, delicately competi-
tive, as if this replacement for him was also, immediately, a
rival. But also: *emergency basis*. Yes, okay: *emergency*. Was he
already wondering what I was going to say about him to this
other analyst? As long as I related it accurately—that I wasn't

always accurate, he was all too aware, but if I recounted this conversation accurately his confession would come across as the raw, spontaneous revelation of emotion—it *happened*—he would be understood as honorably seeking to devise, for me, the best, most therapeutic of aftermaths. He needed to be plain. We could not go on as before, it would be an injustice to me to continue and could jeopardize the work we'd done so far. On a winter street corner, violin case weighing down my gloved hand, I froze. It rushed back, the incredulity of abandonment. Outward paralysis, internal questing, as if since bodily movement was unwise, *the awaited* had to be whirled after, inwardly. The Scottish psychoanalyst John Bowlby had gone as far as postulating the ancient origin of immobilizing depression lay in the lost child's having a better chance of survival if she crouched and stayed put. Down through the millennia as, lost child by lost child, those who kept moving disappeared for good, the species's DNA was recast to favor paralysis, the sinking wretchedness of *being left* valuable because it drained the initiative to move, pinning the child to the last place she had been seen, thus giving the searchers a chance of backtracking and finding her. But anguish flung through my mind, with cries flying from it. Images, too, a sort of *movie* of myself sliding from the couch to my knees, of walking to him on my knees. None of which he was privy to, since I was sitting there in my usual place, saying sanely *I can't believe this is the last time I'll be in this room.* Saying *I'm going to remember this room as—you're going to think I'm exaggerating, but—as heaven.*

Heaven was my last-minute try at thanking him for the

room's impeccable curation, its museum aloofness, the cau-
tious situating of every object in its trance of light, with the
fastidiousness I knew to be his, so that to love the room was
to love him as he wished to be seen. The three harlequins in
their poled-along gondola moped for the last time over my
head. I was going to mourn for the power of the room's listen-
ing silence to amplify the least disturbance of its perfection,
like my habit of stroking the couch's velvet, into meaning-
fulness, was going to miss his calmly absorbing my stories,
who would they matter to now, would he open my file and
leaf through my dreams, should I ask for them back? Briefly,
because I wanted to hurt him for costing me himself, I con-
sidered demanding every page he'd ever scribbled about me.
He'd sat in his chair recording my erasures, deletions, obliter-
ations, inhibitions, in the pages he'd written lay the most elo-
quent account I could give of the despair I was in, and I would
like to read it, myself, if I could no longer read its reality in his
eyes, to read of perfectionism's pursuit of the next numinous
object of desire, of how my desertion of work-in-progress left
a trail of stories crouched tightly down into themselves, hid-
ing in the last place they'd been seen, his notes a map of their
whereabouts, tucked in a folder to be filed in a drawer with
other folders belonging to other sufferers, once he'd filed the
folder away those crouched stories would be forever beyond
finding, as in some sense would I, the prospect of telling
my story over again to any other listener approximately as
disgusting as if he'd suggested my giving a blow job to the
person whose name he'd written on the slip of paper, a repu-
diation of the depth of my attachment—of what was, to me,

holy. And hard-won: I was amazed to have gotten so far. I had
believed there could be, not exactly an *end* to perfectionism,
but a slackening of its hold.

That new pages could be written and allowed to exist.

If he was there.

If he was listening.

Committing to separation was more black-and-white, then,
before the technological facilitation of stalking, which I'm
fairly sure would have sucked us both in. As it was a year went
by without our being in contact—no letters, no phone calls.
During that year either of us could have fallen in love with
someone else and embarked on—I was about to say *embarked
on a less complicated relationship*, but how can that be known?

The enchantment of transference love easily survived the
year's separation.

Only once I moved into his house did our happiness in
each other begin to wear off, little by little, the degrees of its
fading perceptible in sex. Our first fucks were illicit mutual
congratulation, a matter of bodies catching up to souls al-
ready as-if transparent to each other. We burned through that
co-conspiratorial grace in weeks, deflated by the realization
that our being together offended no one. I was superstitious
about his age, and considered his libido touchier than it was.
But I was straightforwardly into his pot-bellied bandy-legged
nakedness, whorls of soft white hair enclosing sepia nipples,

big crude rib cage, the fat-veined loll of his penis, his whole
testy, distracted, mischievous, ruefully age-tainted maleness,
hidden for years in shrink garb. In short he was a revela-
tion, this contradictory, shambling, bald-headed, touching—
Da!—man, waiting on the leather-and-chrome Corbusier
couch meant for the male companions of women who'd dis-
appeared into dressing rooms where they were trying on
wedding dresses. As I was—for him, to be married to him!
Tucked in a softly illumined boîte, behind curtains that had
the power to shush reality itself, I had been mesmerized by a
garment composed of shambolic layers of voile, the ravages
of deconstruction contested by the prim faux-Victorian ascent
of mother-of-pearl buttons up its bodice to the high neck. By
contrast with this uptightness, the insincerity of my small-
boned face was recast as limpid provocation. The artful inflic-
tion of ruin holds perverse appeal for perfectionists, or maybe
I should speak only for myself: by its wit, by its excesses, de-
construction ejects my monotonous perfectionist dread of er-
ror and seats playfulness in its place; surely if your seams are
exposed, your ruching disheveled, your every edge fraying,
the self within has flown perfectionism's cage. This dress as
good as shouted *The witch is dead, the wicked witch is dead!*, and
when, through the silencing velvet, the salesclerk's arm thrust
a lesser garment, I said *Hey*, and he made eye contact with my
reflection and I said *What do you think*— and he studied us, me
and the dress, whose gloriousness drained away as he gazed.
To apologize for his inability to say what I'd hoped he would
say (*It's you*) I offered *Punk Miss Havisham?* and he laughed a
confused laugh that made it impossible for me to wander out

to the semipublic cove where dresses were displayed to fiancés. That changeling in skinny leather britches, that Barneys Ariel spirited away the exalted dress before it could suffer my crude attempts at fitting it back onto its hanger. The analyst never even saw it.

A new dress would have been a mistake anyway, I tell myself, newness wouldn't jibe with so passionately complicated a union—and $1100, did I want to be paying that off forever? But my declining to show myself to the analyst in the ravaged beauty of the dress is only the first entry in an increasingly long list of things I want to hide from him—surely a dire sign for our looming marriage, and I keep returning to Mendocino Vintage, paging through its racks for the garment magical enough to substitute for the one that had been whisked away. When the price on a dress's tiny white cardboard tag is accompanied by the warning *As Is*, I know to conduct due diligence, checking for split seams and underarm stains. When the flaw eludes me I carry the dress to the counter, where the antiques dealer lifts the shade from an alabaster lamp and angles the fabric close to its bulb, whose light sprints through a half dozen moth holes. "But those are tiny! Do you always remember what the 'As Is' is, after you've written it on the tag?" I ask, and she shrugs. It's the shrug of a blonde androgynous boy in a vintage rodeo shirt. "Sometimes there's actually nothing specific, just an 'As-Izzy' feeling," she says, and to my surprise, maybe hers, I end up telling her about the lost Comme des Garçons dress. If I were prepared to believe what I'm feeling,

which I'm not, I would understand I want to tell her all my stories. That I want to go home with *her*. Back in the dressing room tattered beauty after tattered beauty slides down my uplifted arms, I twist to see my beaded or brocade backside in the mirror of the renovated garden shed that serves as Mendocino Vintage's dressing room, a length of jet-beaded black twenties silk skims like cool black oil coating my nakedness. I buy not only that dress but, in the coming weeks, four others, each more far-fetched, more thrillingly unsuitable, than the last. When I bring them home, the analyst tries to hide his disapproval, he holds his tongue, but where was the perfectionist he'd believed he was getting, whose aversion to frayed hems and AWOL buttons, to shabbiness and stains and unraveling could have been taken for granted? If I want to test how frowningly far I am from ideal, all I have to do is put on one of those five dresses and pad barefoot into the living room where he is reading. All that's necessary to elicit his dismay is give a shy spin, saying *What do you think—this one*? Why I keep up the pretense of not knowing how much these dresses bother him, I have no idea. I can't help understanding that my tattered-dress obsession is going sinisterly wrong, and if what I want is his happiness, I should cut it out. *He* hasn't changed, he is orderly and meticulous as ever, and within the bounds of the household whose bachelor rigor my son and I upset, he's companionable, he is reasonable, he's looking forward to getting married as if the *Yes* after *Do you take this man* will return his reverent analysand to him. Uncharacteristically, since he is the supreme homebody, he coaxes me to try other department stores—what about a trip to the city? The date's coming

The argot spoken by antiques dealers names—nicknames—
the kinds of damage different categories of objects are heir to.
By its specificity, dealers are advised to look closely, to hold
the unearthed whiskey flask up into the light, to run a fin-
gertip around the teapot's spout. It is an undespising honesty,
conceding to the world, and time, their power to mar, count-
ing the ways. In addition to its colloquial genius, can slang be
thought of as possessing a tone? Antiques dealers' does, rue-
fully proposing discrimination without exclusion. Clouded
glass is *sick*, glass that has been minutely chipped shows *a
little aggravation*. Porcelain has *fleabites* or *hairlines*. Books are
foxed. A language for imperfection that refuses to cast out the
imperfect, a whole language for that.

*If you are really alive, you end up spilling plenty of milk, I say, and
you, you're going to be the alivest, you're going to make mistakes
and think fearlessly about the mistakes and go from there to the next
thing that interests you, and lots of things will. And I'm going to love
seeing what does,* and his expression might be the expression of
being told more than you need to know at the time, but if it is,
he'll choose what's valuable and let the rest slide, the spilled
milk of overexplanation easily mopped up. I'm surprised to
think *I think that was good enough.*

For most of my life the police state inside my head has gone
about its business invisibly. Indefensible though this wish is,
I confess to having longed sometimes to trade my affliction

for the flare of alcoholic self-destruction so there would be a chance of someone's being moved to intervene, to sit me down and say *You need help* or *Work these twelve steps*. I didn't want the now-you-see-it, now-you-don't illegitimacy of a malady *all in my head*, I wanted to be handed a map of recovery. To be told *Make amends to everyone you have hurt*.

From: Elizabeth
Subject: Re: bracelet closures
Date: November 13, 2018 at 1:41:52 PM PST

On Nov 13, 2018, at 1:24 PM, Elizabeth Tallent wrote:

Okay my beautiful *source*. I need names for kinds of closures on Victorian bracelets, what I want specifically is the kind that would have been on the bracelet you fastened around my wrist. Barrel closure? I'm thinking it had one of those long narrow wedge-shapes that compresses when you slide into the matching housing—what's that called? Are there technical names for the closure's separate parts?— *specific* words—help!

On Nov 13, 2018, at 1:34 PM, Gloria wrote:

Bracelet closures . . . not a barrel clasp on a Victorian bracelet. More likely it was either a box clasp, which I like to call tongue-in-box clasp; a V-shaped "tongue" is inserted in a hole in the box and clicks into place.

Another style would have been a fold-over clasp—
the hinged side is inserted into a slot on the other
side and then folded closed. Kinda like a lot of watch
straps these days.

To: Gloria

Seriously—*tongue in box*? How, how, how am I
gonna get away with that in the scene of how we
meet?

Cancer, though—cancer is imperfection with a mind of its
own, a blister-like squamous cell carcinoma under my lower
lip appearing barely a month after my son and I moved in
with the antiques dealer. I tried for a long while to believe
it was a cold sore whose persistence was owed to the stress
of my divorce from the analyst. After the diagnosis, in the
months of waiting for surgery at Stanford, the blister doubled
in size, aggressive but not invasive, they said; it grew as big
as a ladybug or fattened tick, and as its legs fringe a tick's
outline, miniature blood vessels emanated from the cancer.
At five or six, unable to tell left from right, I had learned the
oval callus on the middle finger of one hand, if rubbed by my
thumb, would unerringly embody *right*. The cancer was oval
like that callus, and the same size, and indicated a direction as
surely as had the callus. I wept for the loss of my looks. Would
the antiques dealer fall out of love, and if she did, who could
blame her for leaving a girlfriend with cancer on her lower

lip? Meanwhile, I was involved in various magic transactions
with the cancer. Primitively, I construed it as punishment.
That I had *brought it on myself* by uncensored blurting, by my
smart-ass offensiveness—*How will you ever get anywhere*, my
father had said, *with a mouth on you like that?* They said the
cancer might grow fast but wouldn't travel elsewhere in my
body, it was not a mortal threat, but I kept dreaming it had
turned up in my armpit, in my labia, in my blood. This wasn't
an emergency, or was an emergency only to me, and the kind
of surgery known as Mohs, in which tissue samples were
analyzed during the surgery, which continued until a slide
showed zero cancer cells, meaning the margins of the incision
were clean, proved difficult to schedule. Thus the wait, dur-
ing which our three lives, my son's, the antiques dealer's, and
mine, became more closely intertwined, not only because we
were living together, but because she was on her way to be-
coming a mother, and we alternated nights of reading to him,
Where the Wild Things Are, The Golden Compass, Oliver Twist, a
series he loved in which the Wars of the Roses were fought
by armored and helmeted hedgehogs and foxes and mice, and
one night he said softly, "What do I call her," and I said, "Call
who," and he said, "If you are Mom, then what do I call her,
Other Mom?" and I said—so, so pleased with this stroke of
genius—"What about like in *The Cat in the Hat*, you know,
where to tell the cats apart there's Little Cat A, then Little Cat
B—what about I'm Mom A, she's Mom B, does that work?"
Because I wanted the A slot, I wanted to be the first, tallest-
top-hatted cat, and her lovableness was kind of threatening in
that regard, and her honesty and unpretentiousness, and her

being very funny, and her always doing what she'd said she was going to do, and her being the mother without cancer. I wanted my kid not to have to witness the cancer's visible progression, or my fear, or my tears, but he proved optimistic and sensitive and calm, as did the antiques dealer, her steadiness an improbability I was hardly better equipped to believe in than I was to believe in cancer. Both struck me as mysterious. One seemed deserved. The other was love.

There's a sentence, only four words long, I've always been a little in awe of. It appears in certain books at the end of the Acknowledgments. Longer, funnier, or more charming variants occur, but in its irreducible form the sentence is: "Errors are all mine." "All mine," in other contexts, lays claim to something desirable, and can ring with a possessiveness exasperated or sensual, but, either way, alert to impingement. Consorting with what's often repudiated, error, "all mine" registers as a minor tonal departure in this sentence whose essence is straightforwardness. Probably, in many works in which it appears, it's the plainest sentence in the book, the least vulnerable to misinterpretation, and the last thing it wants to do is to startle its reader the way it startles me, disclosing, as it does, a relation between writer and error free of shame, or one in which, at the very least, shame has been sufficiently managed for the necessary honesty to make it into print. It's not meant to leave you wondering what it feels like to write it.

———

Strangers were working on me. I followed their small talk, listening for the sound of something going wrong. As surgeons whose patient was awake, their conversation was necessarily upbeat and trivial. At the same time, their voices were entirely conscious of each other, as if, like me, they could know each other *only* through their voices. I was lying on my back, eyes slitted against the radiance eighteen inches above, a whiteness of such depthless intensity it did not seem like light at all. I lay there figuring them out, liking one voice for its confidence, disliking another because it was flirting with the first and flirting counted as a distraction, loathing the third, which was too bad, because the third was going to work on me as well: asked by the first if she was ready, the third voice said, "I love to cut." There was a fourth and a fifth who hadn't done more than make low sounds of agreement. Possibly some people left, while others came quietly into the room, because once there seemed to be a sixth voice, even a seventh, while four and five were either altogether silent, or had departed for more interesting surgeries. It was a teaching hospital and observation was an essential step in instruction. Theoretically I was *for* that, but how many hands were actually going to cut into my lip, and how inexperienced would they be? The hands I'd seen (or half seen, my eyes narrowed against the light) so far belonged to the main voices, one, two, and three. Right now, *I love to cut* was wielding the scalpel I could not feel. Her saying *I love to cut* was, in part, flirtatious, the kind of flirtation that consists of a woman's asserting her indifference to blood or filth or anything usually regarded as repellent, but her tone had been too emphatic, the definiteness with which

she proclaimed boldness only made her insecurity clear—in short, she terrified me. The doctor cluster extended an array of arms into my field of vision. Somebody's forearm rested on my right shoulder as if it were the edge of a bookcase, another arm angled in from the left, a third from directly over the crown of my head. Local anesthetic had been needled in and my head fastened into some kind of bracket whose cradling viselike rigor I welcomed because at least my head couldn't do the wrong thing. The rest of my body was on its own and that was a cause of worry to me. Before my long-ago cesarean, I was racked by powerful shudders, which struck without my even having been aware I was afraid, and though my anaesthetized lower half of course remained immobile, my wrists had had to be buckled into restraints. Now I didn't know what to do with my hands and tried to figure out what placement would appear most calm. My ridiculous striving for politeness was the only support I could offer their concentration. From what I could sense from their movements, the surgeons needed more space, they shuffled and reconfigured at whim, or what seemed like whim, and when people are sliding past each other with hardly an inch to spare, then even if you are horizontal and they are vertical, it seems a natural acknowledgment of their superior liberty to make yourself smaller, and I kept my arms straight and close to my sides. To have palms up seemed to be inviting scrutiny, as if palms could, like breasts, be naked. Cautiously enough not to attract attention, I turned my hands over. Palms down. That was better. More private. Behind and around and above my head, surgeons rustled. They gave off whiffs of intensely clean laundry.

The first voice was pointing something out in the glad, pe-
remptory tone of an interesting discovery: "Look here, right
here, see these little pearls, these little pearls? These are
salivary glands. Salivary glands. See?" The second voice said,
"Very cool." *I love to cut* said nothing because, I hoped, she was
concentrating on what she was doing. I understood that while
they were theoretically aware that I could hear every word,
the surgeons believed their *actual* relation to me was the rel-
ation of awake persons to someone who had inexplicably
fallen asleep in their presence. That is, they might be careful
not to jostle or otherwise disrespect my body, which was laid
out right there in my ordinary clothes—that had astounded
me, that it wasn't deemed necessary for me to change into
sterile garb—but whatever respect would ordinarily have been
accorded to my sensibility was nullified by my horizontal
availability to the scalpel. A sleeper keeps breathing, her heart
keeps beating, desire and fear generate images in the sleeper's
brain, but the sleeper needs no acknowledgment from oth-
ers that she exists and in fact such acknowledgment would
be a weird mistake, a failure to recognize the *apartness* of the
sleeper. Their conviction that they were alone and I was *not
there* was so natural-seeming that I began to wonder if I was
supposed to be asleep, but no, I had been informed only local
anesthetic would be given, because I was going to have to be
able to answer questions. When I moved I was told sharply,
in an astounded tone, "Hold still." Just as if this were any other
situation I thought *You asshole* and was sorry, because it feels
dangerous to think *You asshole* about someone concentrating
on the incision she's making in your face. Mostly, people are

aware of anger directed at them; anger begets anger, even if unconsciously. This was *my mouth*. That was a *knife*. My part in making this surgery go well was to imitate the sleeper they were pretending I was, to *not hear* those things that would disturb or scare me, but was I really capable of that? I closed my eyes, I tried to prevent what was coming. It was as if the need to cry fled up from below, from the base of my throat, like champagne bubbles ascending a flute in harmless urgency, as if that wasn't enough the same desire, this time sourced in the darkness of my brain, crowded forward to wet my eyes, and with it came my mother's face, lost to me for years, her face in cat's-eye glasses, and I needed her so badly, the tears started out and ran down. One winkled into my ear, a cold bead coming to rest against, it felt like, the eardrum. "Oh come on— really?" fumed the second voice, and seemed on the verge of reproving me when a huge gloved hand swam across my vision, touching a tissue to my temples where the tears had run down, blotting, and *I love to cut* said, "Better, now?"

My collusion with perfectionism is hard to admit. I would give a lot to be able to portray myself as having bravely fought through to sanity. I yearn to have been wholeheartedly on my own side, but in the contest I'm describing here, in which tolerance for inevitable flaws and errors stares right into perfectionism's yellow eyes and *just says No!*, both sides are equally mine. If I am complicit, it's not with an alien intruder like cancer, but with a phenomenon devised by my own mind, my perfectionism as much *me* as my writing is. More, really,

because when I'm not writing I have no idea what writing is, or is like, but I always know what perfectionism is like, how it feels, what it wants. *It's* not elusive. Conceivably for a person like me, terrified of abandonment, there is reassurance in the ceaseless availability of perfectionism's sabotage.

For a self under threat, perfectionism creates a story. As a child in church I always loved when the minister intoned *Strait is the gate, and narrow is the way.* If the gate was wide, I wouldn't have believed in it for one second. Straitness, narrowness—those I recognized as likely. So it is with the stories perfectionism authors, in which a soul—mine, say—is offered the slimmest possible chance of getting through.

There's a chance, maybe even a good chance, Cognitive-Behavioral or some other form of therapy would have proved more efficacious in ameliorating perfectionism than the talk therapy I loved, possibly I started out on the wrong track and stuck to it too credulously at the moments when greater curiosity regarding alternatives was called for. To write that perfectionism has *taught* me something is to obscure the messiness of my backsliding transit, to write that I've learned to extend a welcome to mishaps, failures, rifts, smudges, to effortfulness in general, to what I'd call, in talking with my students, *process,* is to conceal a thousand, ten thousand, eruptions of repudiation. I worry that to present myself as having made even small gains is an affront to the pain that can animate the question *How do you deal with perfectionism?* To tell the truth: I have written this book not knowing. To the

question *But how did you get this book down on paper if you're not over your perfectionism?* I have only partial, peculiar answers: there are days I'm able to defuse the scathing condemnation perfectionism directs at whatever I'm doing by saying *Sure, okay, this is totally fucked up, but let's just see what happens,* some days when perfectionism lights the flame of *Fort-Da* my inarticulate response goes something like *You are not that interesting,* there are days I can live without the radiant book this one has failed, over and over, to be, the ravishing book now absolutely beyond reach, because it's become this one instead.

As long as the stitches were in I either had to keep my mouth shut or risk their tearing. Even after they came out, the mend was vulnerable, and I was supposed to keep the movement of my mouth to the bare minimum, not to speak or laugh or take any nourishment except through a straw for five weeks, and once the five weeks were over I was left with a vertical hot-pink scratch, about which I told the antiques dealer when we gazed at it together in the mirror, "My face is ruined. My *face.*" She said, "Can we be a little grateful? A little relieved this is the outcome, a small scar? That's going to fade? Get paler and paler till it's barely there?" I said, "Next you'll say *It could have been much worse.* Next you'll say *I could have lost you.*" She said, "No, next I'll say, 'Try to love this incarnation.'"

And I said, "I do."

Acknowledgments

I can't believe my luck in meeting the editor Wendy Lesser when she, I, and *Threepenny Review* were young; this book and its predecessors gained greatly from her genius combination of clarity and ardor.

To Joy Harris, lioness among agents, my forever gratitude.

Thanks to Terry Karten for the keenest subtlety and most graceful editorial guidance.

My thanks to Michelle Latiolais, extraordinary friend, writer, and reader.

My thanks to Amber Oliver, Christine Choe, Robin Bilardello, Joy O'Meara, Trina Hunn, Fritz Metsch, Mary Beth Constant, and everyone at HarperCollins.

Calvert Morgan, for his enormous care and exuberant love of writing.

Adam Schorin for his insight and exceeding generosity.

Kate Larson for kind encouragement.

Julia Meyerson for her jeweler's eye and constancy.

For transformative conversations, my thanks to Jeremy Glazer, to Shannon Pufahl, to Nina Schloesser Tárano, to Ruchika Tomar.

Thanks to Dagmar Logie, Alyce Boster, Christina Ablaza, and Ose Jackson for great kindness and support.

Vincent Scarpa, radiant reader.

Sylvie Lenox for loving the four-legged ones.

Thank you to my son's father for the miles, the years, the beauty. For one winter night's fire in the kiva fireplace.

To Gabriel for the joy.

To Harriet who can be trusted with human hearts.

Wild gratitude to Gloria for every minute.

It gives me pleasure to say: Errors are all mine.

Notes on Sources

Epigraphs

Paul L. Hewitt, Gordon L. Flett, Simon B. Sherry, Marie Hobke, et al. "The interpersonal expression of perfection: Perfectionistic self-presentation and psychological distress." *Journal of Personality and Social Psychology*, July 2003.

Yohji Yamamoto. *The Past, the Feminine, the Vain* in *Talking to Myself.* Kiyokazu Washida, ed. Steidl/Carla Sozanni, 2002.

Virginia Woolf, *To the Lighthouse*, Hogarth Press, 1927.

Other Sources

Nicholas W. Affrunti and Janet Woodruff-Borden. "Perfectionism and Anxiety in Children," *The Psychology of Perfectionism*, Routledge, 2018.

Jay Appleton. *The Experience of Landscape*, John Wiley & Sons, 1995.

John Bowlby. *Attachment*, Basic Books, 1969.
John Bowlby. *Separation: Anxiety and Anger*, Basic Books, 1973.
John Bowlby. *Loss: Sadness and Depression*, Basic Books, 1980.

Freud. "Thoughts for the Time of War and Death," 1915.

Paul L. Hewitt and Gordon L. Flett. "Perfectionism in the Self and Social Contexts: Conceptualization, Assessment, and Association with Psychopathology," *Journal of Personality and Social Psychology*, 1991.

Henry James. "The Art of Fiction," *Partial Portraits*, Macmillan, 1888.

Adam Phillips. "The Perfectionist," *On Balance*, Farrar, Straus and Giroux, 2011.

Sylvia Plath. "Child," *Collected Poems*, HarperCollins, 1992.
Sylvia Plath. "The Munich Mannequins," *Ariel*, 1965.

Kenneth G. Rice, Hanna Suh, and Don E. Davis. "Perfectionism and Emotion Regulation," *The Psychology of Perfectionism*, Routledge, 2018.

Rainer Maria Rilke. "Archaic Torso of Apollo," translated by Stephen Mitchell, poets.org, 2007.

Maurice Sendak. *Where the Wild Things Are*, HarperCollins, 1967.

Joachim Stoeber, Philip J. Carr, Martin M. Smith, and Donald H. Saklofske. "Perfectionism and Personality," *The Psychology of Perfectionism*, Routledge, 2018.

D. W. Winnicott. *Holding and Interpretation: Fragments of an Analysis*, Grove Press, 1994.

D. W. Winnicott. *Home is Where We Start From*, Norton, 1986.

D. W. Winnicott. *Playing and Reality*, Routledge, 1989.

About the Author

ELIZABETH TALLENT is the author of a novel and four story collections. Her work has appeared in the *Threepenny Review*, the *Paris Review*, the *New Yorker*, *Tin House*, and *ZYZZYVA*, as well as in *The Best American Short Stories*, *The Best American Essays*, *The O. Henry Prize Stories*, and *The Pushcart Prize: Best of the Small Presses* anthologies. She teaches in Stanford's creative writing program and lives with her wife, an antiques dealer, on the Mendocino Coast.